THE NATIONAL
BASEBALL
HALL OF FAME
AND MUSEUM

INSIDE THE

Baseball

HALL OF FAME

foreword by

BROOKS ROBINSON

SIMON & SCHUSTER

New York London Toronto Sydney New Delhi

Simon & Schuster
1230 Avenue of the Americas
New York, NY 10020

First Simon & Schuster hardcover edition April 2013

SIMON & SCHUSTER and colophon are registered trademarks of Simon & Schuster, Inc.

For information about special discounts for bulk purchases, please contact
Simon & Schuster Special Sales at 1-866-506-1949 or business@simonandschuster.com.

The Simon & Schuster Speakers Bureau can bring authors to your live event.
For more information or to book an event contact the Simon & Schuster Speakers Bureau at 1-866-248-3049 or visit our website at www.simonspeakers.com.

Designed by Joy O'Meara

Manufactured in the United States of America

10 9 8 7 6 5 4 3 2 1

Library of Congress Cataloging-in-Publication Data

Inside the baseball hall of fame : the national baseball hall of fame and museum / foreword by Brooks Robinson.
p. cm.
1. National Baseball Hall of Fame and Museum—History. 2. National Baseball Hall of Fame and Museum—Pictorial works.
GV863.A1I55 2013
796.3570973—dc23 2012042347

ISBN 978-1-4516-7671-6
ISBN 978-1-4516-7672-3 (ebook)

All photographs courtesy of the National Baseball Hall of Fame and Museum unless otherwise noted.

To baseball's greatest players and heroes,
who created some of our National Pastime's
most memorable moments that will live forever in Cooperstown.

—JANE FORBES CLARK, CHAIRMAN, NATIONAL BASEBALL HALL OF FAME AND MUSEUM

LIST OF ILLUSTRATIONS

(In order of appearance)

INSIDE THE

HALL OF FAME

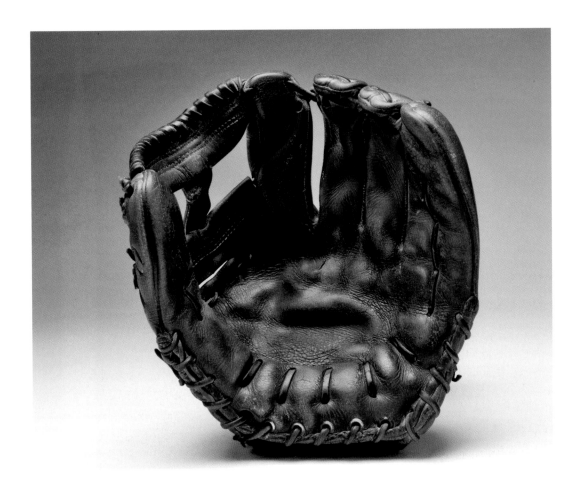

Brooks Robinson 1970 World Series Glove

For fans of the Baltimore Orioles, it was the glove that helped erase memories of the 1969 World Series; for fans of the Cincinnati Reds, it was the mitt that stole their chance at winning the 1970 World Series; for baseball fans everywhere, it represents a magic series of games in which Brooks Robinson displayed some of the best fielding ever seen in postseason play. A series of spectacular plays helped snare victory for the Birds and immortalized Robinson as the Human Vacuum Cleaner at third base. This performance helped Robinson earn the World Series Most Valuable Player Award, along with the Hickock Belt as the top professional athlete in 1970. As noted by Reds skipper Sparky Anderson, "I'm beginning to see Brooks in my sleep. If I dropped this paper plate, he'd pick it up on one hop and throw me out at first."

FOREWORD

Above all else, the National Baseball Hall of Fame stands for excellence.

I was elected to the Baseball Hall of Fame in 1983, and wherever I go, people know me as "Hall of Famer" Brooks Robinson. Carrying that title has been an important part of my life, and it is amazing to see everyone I encounter celebrate the excellence associated with this honor.

One of my life's greatest honors is having a plaque with my name and achievements reside in the hallowed Hall of Fame Plaque Gallery. Of the 18,000 men who have played at the major league level, only about one percent—just over 200 men—have a plaque in Cooperstown. Imagine that: Just one out of every 100 major league players earns election to the Hall of Fame.

I never thought much about being in the Hall of Fame until I was named the Most Valuable Player of the 1970 World Series. That was the point that served as a springboard for my Hall of Fame election. After that Series, I'd hear people say, "Hey Brooks, you're going to the Hall of Fame!" That's when I really started to think it might be a possibility.

Of course, to earn Hall of Fame election you don't just retire and become an inductee. You have to wait five full seasons before you become eligible. Then you have to get at least 75 percent of all ballots cast from the Baseball Writers' Association of America.

Growing up in Arkansas, I had heard of the Baseball Hall of Fame, but I had no idea how you got in there.

In the eighth grade, I had to write about my future vocation. I knew even then that all I ever wanted to do in life was to be a professional baseball player. I even knew many of the events that happened in baseball history early in my life, like Johnny Vander Meer throwing back-to-back no-hitters in 1938, and Babe Ruth hitting 714 career home runs.

When I was 12, I had a paper route that would take me by the house of Bill Dickey. Though he wasn't living there at the time, I used to give his paper a little extra "flip" to make sure it got up there on the porch. I was

saying, "This is for you, Bill Dickey!" I got to know him pretty well when he moved back to Little Rock and started working for Stevens and Company, so I knew that he was headed for the Hall of Fame.

My love for the game was instilled by my dad, who was a terrific semipro player in Arkansas. I used to be a bat boy on several of the teams on which he played. That's where I really developed my enthusiasm for the game, like so many other young boys who grow up loving baseball.

Baseball's popularity all over the globe amazes me, wherever I go in my travels. The best part about it is that everyone has a baseball memory. And it is in Cooperstown that the memories of the game live forever.

The journey to Cooperstown is timeless. It is a ritual passed down from generation to generation, from grandfather to grandson, and from grandson to his sons. And there are plenty of female fans, too. Just as my dad taught me how to love and appreciate the game of baseball, the ability of fans to connect with the game's history in Cooperstown makes the Baseball Hall of Fame a truly special place.

The game of baseball endures. Think about the game closing in on 150 years as a professional sport in this country. Think about the records, the accomplishments, the special moments and players. All of that history has a home in Cooperstown.

Then you think about the icons: Babe Ruth, who is still the greatest name in the his-tory of the sport. He changed our game. Ty Cobb, Joe DiMaggio, Ted Williams . . . They were the stars for their generations. Then, you see the artifacts from the great accomplishments and special moments throughout the game's history—bats, gloves, shoes, jerseys, and more. It sends a chill over me every time I walk through the Museum in Cooperstown.

Of course, some artifacts from my career are in Cooperstown, too—my glove from the 1970 World Series and a home jersey I wore during the 1975 season are two of the several items in the Hall of Fame's collections. Seeing my artifacts brings back a lot of memories. To know that the fans are going to go through the Museum and see items from my career, alongside those from the legends of the game, is a truly amazing feeling.

My experience with Cooperstown has been special from the very beginning. On my first trip, as a member of the Baltimore Orioles to play the Dodgers in the Hall of Fame Game on July 24, 1961, I was on the field when my first son was born. What a thrill it was for me when the public address announcer said, "We congratulate Baltimore's Brooks Robinson on the birth of his son!"

From that special day forward to today, Cooperstown has always had a special meaning for my family and me. As a Hall of Fame member, I make every attempt to return to Cooperstown each summer for Induction Weekend, and I participate in a number of other special events during the year as well, in addition to serving on the board of directors.

There are many emotions at work each time I return to the Hall of Fame. Seeing the excitement of the newest inductees and then visiting with all of the members are among the highlights for me each year. Spending time with each Hall of Fame member brings back a special memory, even the guys you didn't play against, because you know they have all achieved the highest honor in the game.

For me, being a member of the Baseball Hall of Fame means being a part of the best little fraternity on earth. We all have a lot of laughs and great times, and we look forward to welcoming the newest members of the Hall of Fame each year.

The National Baseball Hall of Fame and Museum is one of America's most historic treasures. When you walk through Cooperstown, you can feel the game's past come to life. As you watch a baseball game at any level, you sense that every player is aiming to be the best, knowing that one day he might be good enough to earn a spot among the game's elite as a member of the Baseball Hall of Fame.

It's the Hall of Fame that celebrates the game's excellence. It's the Museum that docu-ments the history of the game's achievements so that we can learn more about our past. And it's the Hall of Fame Library that houses all of the countless stories, photographs, and re-corded history of our National Pastime.

There's no place anywhere in the world like Cooperstown, New York. It is where the game's heart beats the loudest. It is where your memories live on forever.

There is no substitute for making the trip to Cooperstown. But on these pages, you will find magical treasures of baseball history come to life through stunning photography and stories about some of the most compel-ling pieces of the Cooperstown collection.

Enjoy this book as an introduction to the journey to Cooperstown you have yet to make or a souvenir of the pilgrimage you once expe-rienced with someone who shared the passion for the game. Or perhaps it will be a reminder of the countless memories you have created around baseball throughout your life.

For me there will always be one special place to celebrate excellence . . . inside the Baseball Hall of Fame.

—*Brooks Robinson*

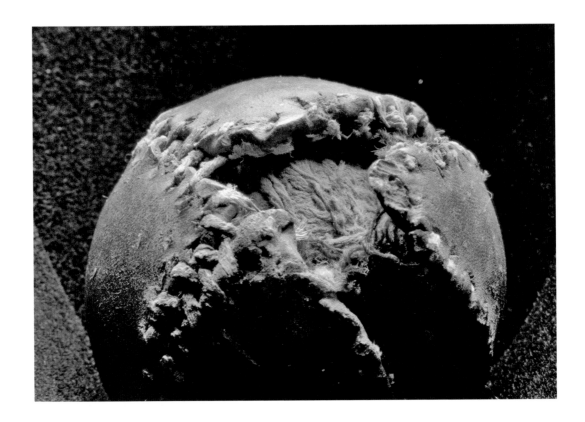

Doubleday Baseball

In April 1935, a farmer living in Fly Creek, a crossroads village three miles from Cooperstown, came across a dust-covered trunk in his attic. In it were the belongings of Abner Graves, who had grown up in Cooperstown a century before, an ancestor of the man who discovered the trunk. The trunk's contents included this undersized, misshapen, and obviously homemade baseball. The locals at the time had no doubt that the baseball once belonged to Graves, who had testified in later life that the game of baseball was invented in Cooperstown by Abner Doubleday. According to Graves, he was one of the schoolboys to whom Doubleday had taught the new game. It soon became known in the area as the Doubleday Baseball. The ball was the first artifact accessioned into the museum and collection.

INTRODUCTION

From its humble beginnings, the National Baseball Hall of Fame and Museum has had the support of baseball's brightest stars, while capturing the hearts of baseball's loving public, bringing the game's most memorable moments to life as if they had just transpired.

It was June 12, 1939, when a grand celebration known as the "Cavalcade of Baseball" came to Cooperstown. On that day, the first four classes of Hall of Fame electees were honored, with 11 members of the inaugural elite having their moment at this newfound "home of baseball."

One of the day's original honorees, Babe Ruth, the game's best-known personality and a titanic American superstar, delivered the perfect sound bite to a jam-packed Main Street and on the national airwaves of NBC Radio, signaling the start of something big on the steps of the tiny one-room museum that rested behind him.

"I hope someday that some of the young fellows coming into the game will know how it feels to be picked in the Hall of Fame," Ruth, who was one of the first five selected for Hall of Fame election in 1936, declared. "I know the old boys back in there were just talking it over, some have been here long before my time. They got on it, I worked hard, and I got on it. And I hope that the coming generation, the young boys today, that they'll work hard and also be on it."

Today, nearly 75 years later, the National Baseball Hall of Fame and Museum is the unmatched symbol for excellence for baseball fans around the globe.

Three institutions under one roof, the National Baseball Hall of Fame and Museum is the equivalent of the Library of Congress and the Smithsonian of baseball, where the breadth and depth of the collections are the benchmarks for its reputation.

For 75 years, the National Baseball Hall of Fame and Museum has existed solely to preserve and conserve baseball's treasures so that future generations can learn from baseball history and reconnect with their own

past over the game that represents our national spirit.

More than 15 million visitors have made the pilgrimage to Cooperstown in search of the game's past, but what they also find more often than not is their own history. The legends, the memories, the dreams of taking to the diamond to fulfill their own childhood aspirations, all combine in this pastoral central New York village to serve as the central nervous system for the collective body of baseball worship.

As American historian and educator Jacques Barzun observed, "Whoever wants to know the heart and mind of America had better learn baseball, the rules and realities of the game—and do it by watching first some high school or small-town teams."

And it is within this small town where the game is treasured the most, where its documentation lives forever, and where emotions are encouraged in celebrating its history, its heart, the soul of the American game.

The statistics of the National Baseball Hall of Fame and Museum are hall-worthy in their own right: 40,000 three-dimensional artifacts, 14,000 hours of recorded media, nearly three million documents contained within its library, and nearly 500,000 photographic images. The collections of Cooperstown are what make the Hall of Fame a priceless and timeless American treasure.

The mission of the National Baseball Hall of Fame and Museum is to foster the appreciation of the historical development of baseball and its impact on our culture by collecting, preserving, exhibiting, and interpreting its collections for a global audience, as well as honoring those who have made outstanding contributions to our National Pastime.

Visitors to Cooperstown experience the Hall of Fame Gallery, featuring the bronze plaques of those who have earned the game's highest honor as a player, manager, executive, umpire, or pioneer.

Through more than 50,000 square feet of public space, they are enlightened with stories of baseball greatness and American cultural representations. The stories of baseball in Cooperstown are more than just exhibits featuring bats, balls, jerseys, and spikes from impressive performances or lifetime achievements. They are essential Americana and they tell us about the role the game has played in shaping the history of our great nation.

But, admittedly, the Cooperstown experience can take visitors only so far. Though the exhibit presentation at the National Baseball Hall of Fame and Museum is unmatched, only roughly 12 to 15 percent of the artifacts in the collections are on display at any given time.

While the most historic and significant treasures are represented on the Museum floor, the depth of the collections also features pieces ranging from the odd (such as the last piece of wood chopped by Cy Young) to the fanciful (the trombone case from the movie *The Natural* that contained Wonderboy, Roy Hobbs's magical bat).

This volume spotlights artifacts throughout the collections, from players, from teams, from milestone moments to more unusual artifacts, all reflective of why we celebrate the history of the sport with such devotion.

Here you will see artifacts that tell deeper stories than just the numbers associated with achievement. Here you will also find items that bring back personal memories, transporting you to a day at the ballpark.

As you turn the pages of *Inside the Baseball Hall of Fame*, relive the game's greatest thrills and experience the passion that drives generations to celebrate our national sport. Enjoy this look *Inside the Baseball Hall of Fame*, and allow your memories to come to life.

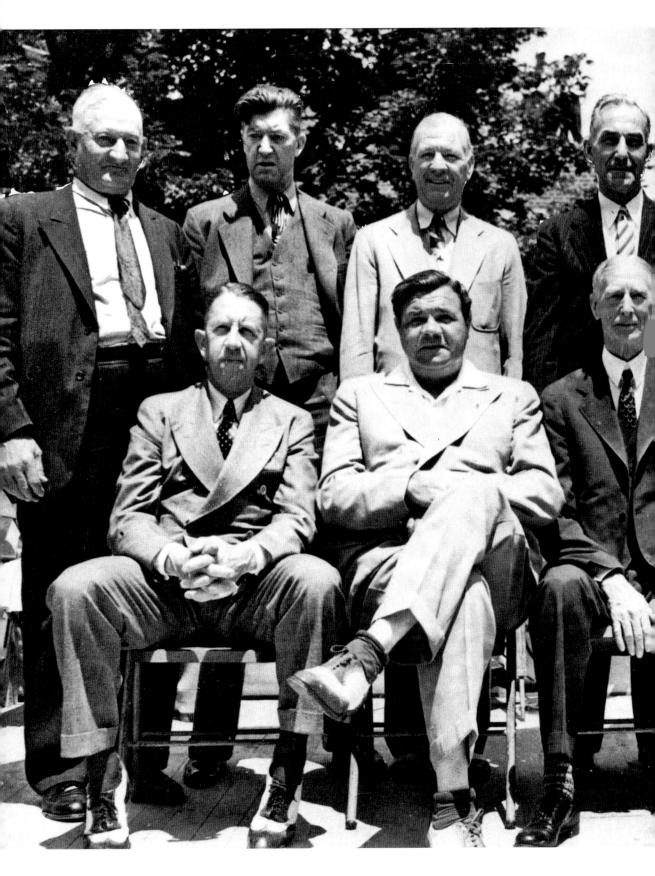

1939 Hall of Fame Induction Ceremony

Many of the greatest figures in the National Pastime's history found their way to the upstate New York village of Cooperstown to witness the first National Baseball Hall of Fame Induction Ceremony on June 12, 1939. On the same day the institution was formally dedicated, 25 electees from the first four induction classes were honored with bronze plaques. Ten of the 11 living members posed for this photo, including (left to right, front) Eddie Collins, Babe Ruth, Connie Mack, Cy Young, (rear) Honus Wagner, Grover Cleveland Alexander, Tris Speaker, Napoleon Lajoie, George Sisler, and Walter Johnson. Ty Cobb, according to reports, was delayed because he was overcome with indigestion en route to Cooperstown and had to stop off at a hospital in nearby Utica. "I was washing up over at Knox College," said Cobb, "the only place in Cooperstown where I could get accommodations—when I heard my name read over the radio. I didn't know the ceremonies began that early. Called out on strikes, I guess."

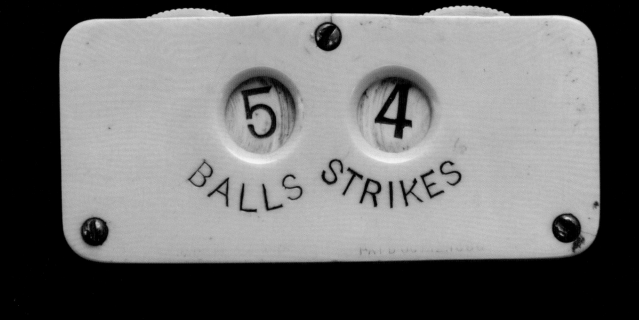

1887 Umpire's Ball-Strike Indicator

"Three strikes and you're out" goes the old saying, and remember, "A walk's as good as a hit." This ball and strike indicator for umpires and official scorers was manufactured for use in 1887—the only season in which it took four strikes to "grab some bench." That season, it also took five balls to earn a walk, and walks actually counted as hits in batting averages—10 men hit over .400 that season, a mark achieved only 35 times in baseball history. The changes were part of an effort to improve the balance between offense and defense—a quest that continues into modern times.

Harvey Haddix Perfect-Game Glove

In perhaps the best major league game ever pitched, Pittsburgh Pirates southpaw Harvey Haddix wore this glove on May 26, 1959, when he pitched 12 innings of history-making baseball before losing a perfect game, no-hitter, shutout, and the win to the host Milwaukee Braves in the 13th, 1–0. In a pitching duel with Lew Burdette, who gave up 12 hits—all singles—in his 13 innings of scoreless ball, Haddix would ultimately throw more perfect innings in a single game than anyone in history. In Haddix's unlucky 13th, Felix Mantilla reached first to lead off the inning when third baseman Don Hoak's throw was ruled an error. After Eddie Mathews sacrificed Mantilla to second and Hank Aaron was intentionally walked, Joe Adcock hit a high slider from Haddix over the right-center-field wall. What should have been a 3–0 final was changed when baserunning confusion led to Adcock's being awarded a ground-rule double.

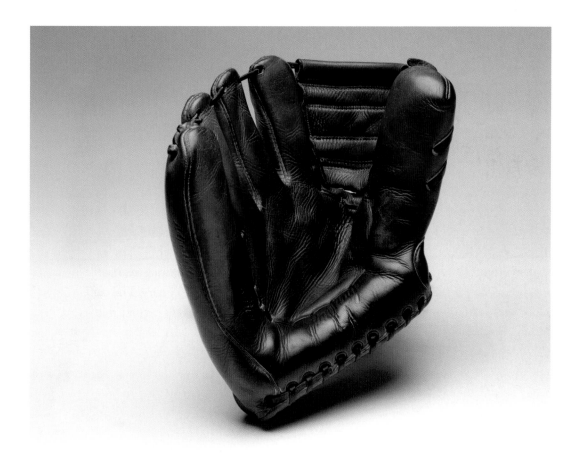

Worcester vs. Cleveland at Worcester Ju...

FIELDING REC'D.			Cleveland		UMPINE,		Bradley								
Put Out.	Ass't.	Err's	NAMES, POSITION AND	No.	1	2	3	4	5	6	7	8	9	10	
4	2	2	1 Dunlap	4	4-3/1			2 foul/1			2 k/1				
			2 Hankinson	5	4-3/2			3/2			3 fly/2				
10	1		3 Kennedy	2	6 fly/3			2 out/3			5 fly/3				
7			4 Phillips	3		6-3/1		9-3/1			2 k/1				
2			5 Shaffer	9		2 foul/2		2 k/2			5-3/2				
	9		6 McCormick	1		4-3/3		3/3			6 fly/3				
1			7 Gilligan	8			8 fly/1		1-5/1			9 fly/1			
	2		8 Glasscock	6			6-3/2		4-3/2			2 k/2			
1			9 Hanlon	7			5-3/3		2 k/3			6-3/3			
24	14	2	Runs,.... Totals,...		0/	0/	0/	0/	0/	0/	0/	0/	0/0/		
		TIME OF GAME: Began, Ended,		Earned Runs, H. M. 1st Base on Err's,											

Struck out by Richmond 5 2 errors by Dunlap

Lee Richmond First Perfect-Game Scorecard

"I do not recall any particular fuss was made about it by any newspaper or set of fans," said Lee Richmond of his perfect game in 1880. *The Dickson Baseball Dictionary* defines a perfect game as "a no-hitter in which all 27 opposing batters fail to reach first base, either by a base hit, base on balls, hit batter, fielding error, or by any other means." It also stipulates that the term was first used by the *Washington Post* in 1909, 29 years after Richmond's game. The 1880 match featured the Worcester Ruby Legs and Cleveland Blues, in what the Worcester *Evening Gazette* described as "a wonderful shut out" and "the best baseball game on record." Richmond provided the best description of the event when he was quoted as saying, "It is a singular thing of that *no-hit, no-run, no-man-reach-first game* in 1880 . . ." As shown on this scorecard, the 45-minute game included at least one defensive gem, when right fielder Lon Knight picked up an assist with an out at first base in the 5th inning.

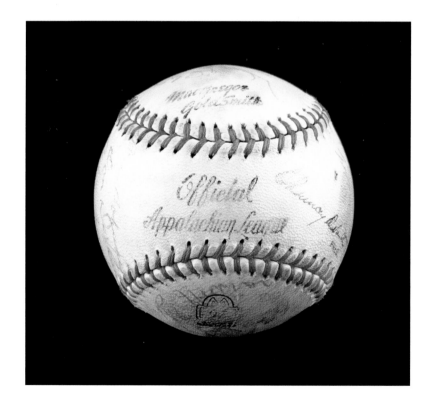

The left-margin scanned card shows:

1880

NG RECORD.

ns 1st B. T'l B.

CORER:

86.4.81

Ron Necciai 27-Strikeout Ball

The name Ron Necciai may not ring a bell, but what he accomplished in a minor league contest on the night of May 13, 1952—setting the professional baseball record for most strikeouts in a nine-inning game with 27—may never be challenged. It took place in a Class D Appalachian League game when the 19-year-old fireballer of the Bristol (VA) Twins tossed a no-hitter against the visiting Welch (WV) Miners. "When the game was over, my catcher Harry Dunlop came over and said, 'Do you know you just struck out 27 batters?' They've been playing this game for 100 years, I figured it had been done before." Necciai would later donate this ball from the game, signed by the members of his team, to the Hall of Fame: "That way everybody can see a piece of history. I wouldn't want it any other way."

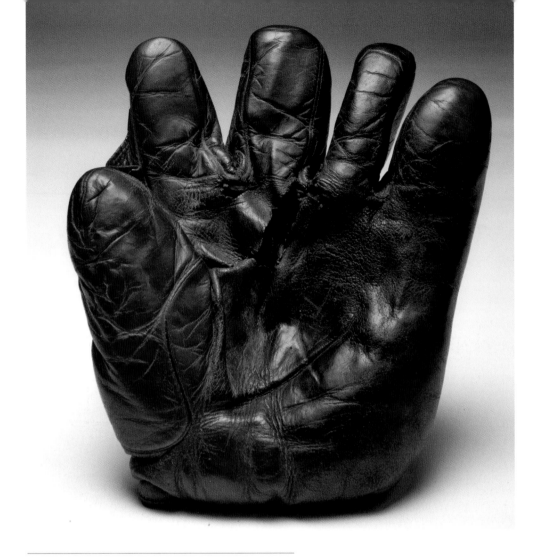

Neal Ball Unassisted-Triple-Play Glove

There are only a handful of big league players who have recorded the rare feat of an unassisted triple play. One of the earliest to accomplish it was Cleveland Naps shortstop Neal Ball against the visiting Boston Red Sox in the first game of a doubleheader on July 19, 1909. In the top of the second inning, in front of some 11,000 fans at Cleveland's League Park, Heinie Wagner, who had led off the inning with a single, stood on second base, and Jake Stahl, who had beat out a bunt, was on first. Hall of Fame pitcher Cy Young had a full count on Amby McConnell, who, on a hit-and-run, sent a line drive up the middle. The five-foot-seven Ball leaped and caught the ball with this glove, quickly stepped on second base to force Wagner for the second out, and tagged Stahl, who was racing from first, to retire the side.

Rick Wise Bat

Not only did Philadelphia Phillies pitcher Rick Wise toss a no-hitter against the host Cincinnati Reds on June 23, 1971, but he used this bat to slug two home runs in the 4–0 victory. The 25-year-old right-hander, whose only imperfection on this day was a one-out walk to Dave Concepcion in the sixth inning, faced just 28 batters against a Reds team that was no-hit only three weeks earlier. Wise, who would finish the season with a career-high six round-trippers, drove in three of Philadelphia's runs with his third and fourth homers of the season. "My first nine years were in the National League—seven with the Phillies and two with the Cardinals—and I had 15 home runs after nine years," Wise recalled. "Then I went to the American League for six years and never picked up a bat again."

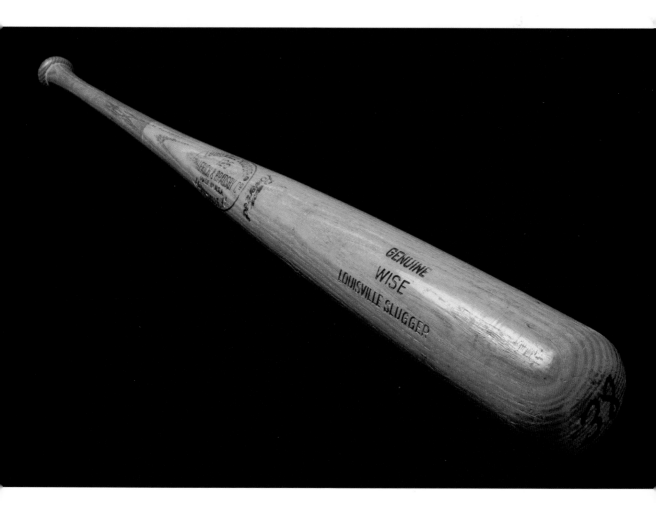

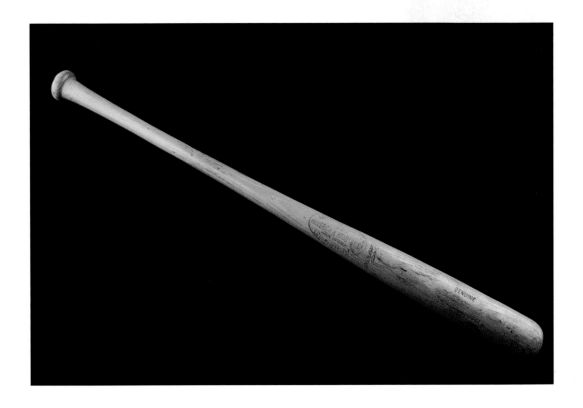

Tony Cloninger Bat

The Atlanta Braves' Tony Cloninger dominated the host San Francisco Giants from the mound, but stunned them at the plate by using this Denis Menke model bat to become both the first National League player and the first big league pitcher to hit two grand slams in one game in a 17–3 rout on July 3, 1966. Cloninger's offensive fireworks began with a drive over the right-center-field fence against Bob Priddy in the first inning, and was followed in the fourth with a four-run shot over the right-field fence off Ray Sadecki. "I was just trying to meet the ball both times and drive in a couple of runs," Cloninger said after the game. "It was a thrill to hit the first grand slam, but the second one was unbelievable." Cloninger, who tossed a complete game victory, added a run-scoring single to become the first major league hurler to account for nine RBI in a single contest.

Nolan Ryan 383rd Strikeout Shoes

Nolan Ryan was an intimidating presence atop the pitcher's mound for more than two dozen big-league seasons. One of the many highlights from Ryan's career occurred when he passed Sandy Koufax for the single-season strikeout record. Then pitching for the California Angels, Ryan wore these shoes on September 27, 1973, when he whiffed 16 Minnesota Twins over 11 innings in his final start of the season to reach 383 strikeouts. The 26-year-old pitcher broke Koufax's record of 382, set back in 1965. "I wanted the strikeout record," Ryan said, "but I wanted most of all to prove I was a winning pitcher." Ryan won the game, 6–5, to end his season with a 21-16 record. After the record-setting game, Angels general manager Harry Dalton quipped, "They ought to resurrect Cy Young and give him the Nolan Ryan Award."

Nolan Ryan No-Hit Caps

In his 27 years on the mound, no pitcher was more intimidating than Nolan Ryan. Tigers outfielder Dick Sharon called him "baseball's exorcist," elaborating, "He scares the devil out of you." The Ryan Express shattered Hall of Famer Sandy Koufax's record of four no-hitters with seven of his own, en route to 324 wins and 5,714 strikeouts in his illustrious career. Nolan Ryan wore these seven baseball caps in his seven no-hitters; his first, on May 15, 1973, at age 26, while pitching for the California Angels. His final, and arguably most impressive, no-hitter came nearly 18 years later, at age 44, on May 10, 1991, while pitching for his home state's Texas Rangers.

Pedro Martinez 3,000-Strikeout Jersey

"I live in a box, what can I say." Those were the words of New York Mets backstop Paul LoDuca in 2007 upon catching Pedro Martinez's 3,000th strikeout and promptly rolling the ball toward the infield, then jogging off the field. While LoDuca may not have realized the significance of the moment, it wasn't lost on Pedro, who immediately retrieved his memento. LoDuca wasn't the only Met who was unaware of the moment. Mets manager Willie Randolph and pitching coach Rick Peterson had no idea of the milestone they had witnessed. Teammate Tom Glavine said he didn't know about the milestone Martinez was chasing until only 15 minutes before game time. Upon recording strikeout number 3,000, Pedro joined Randy Johnson and Nolan Ryan in an elite group of 3,000-strikeout pitchers with more Ks than innings pitched.

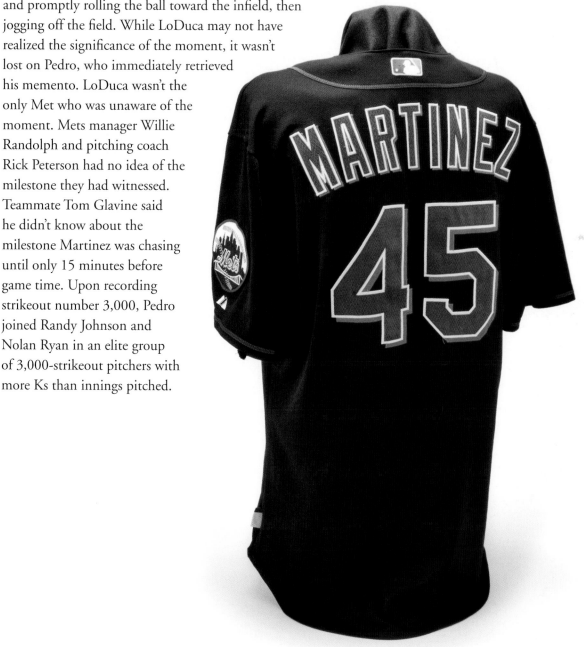

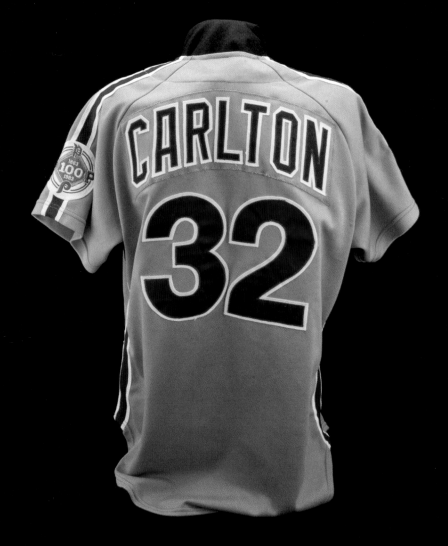

Steve Carlton 300-Win Jersey

Though Steve Carlton remained silent after his 300th career victory, he let his pitching performance do all the talking. The famed southpaw hurler, nicknamed Lefty, wore this Philadelphia Phillies polyester road jersey when he became the 16th pitcher to reach the milestone in a game against the host St. Louis Cardinals before a crowd of 27,266 at Busch Stadium on September 23, 1983. In the 6–2 triumph, the 38-year-old former Card went eight innings, allowed seven hits, struck out 12, walked one, and drove in the first run of the game with a second-inning single. While Carlton had refused to speak to the press dating back to 1979, his manager, Paul Owens, said afterward, "Winning 300 is just a statistical symbol of his place in baseball history. He'll go down as one of the great pitchers in history." Carlton, who helped his team capture that year's National League pennant, finished the regular season with 15 wins and a league-high 275 strikeouts.

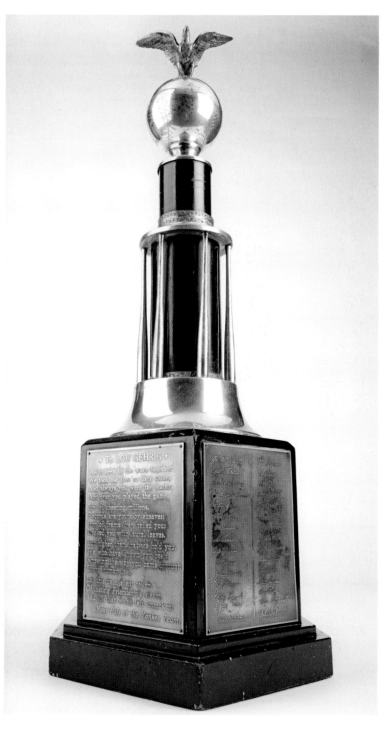

Lou Gehrig
Appreciation Day Trophy

On July 4, 1939, Lou Gehrig Appreciation Day, the longtime Yankee first baseman uttered the now famous words at a home plate ceremony at Yankee Stadium: "Today I consider myself the luckiest man on the face of the earth." Gehrig had been forced to retire as a player two weeks earlier due to his being diagnosed with amyotrophic lateral sclerosis, the disease that today bears his name. Arguably the most cherished item Gehrig was given this day was this trophy from his teammates. On one side of the trophy were the names of all his current teammates; on the other side a poem written by *New York Times* sports columnist John Kieran. According to Kieran, one day Gehrig pointed to the trophy from his teammates and said, "You know, some time when I get—well, sometimes I have that handed to me—and I read it—and I believe it—and I feel pretty good."

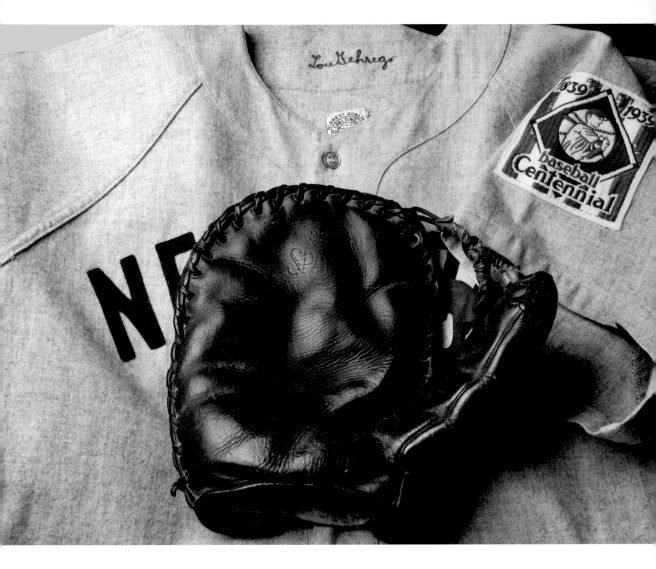

Lou Gehrig Glove and Jersey from 1939

"Fans, for the past two weeks you have been reading about the bad break I got. Yet today I consider myself the luckiest man on the face of the earth. I have been in ballparks for seventeen years and have never received anything but kindness and encouragement from you fans," said Lou Gehrig in his farewell address on July 4, 1939. Gehrig left the game with the same grace and dignity that he displayed on the diamond. His 17-year career at first base is among the finest of all time, earning him a place in the Cooperstown pantheon via special election just after his death. This glove and jersey from his final season in the majors serve to remind us of this special player. According to his colleague Sam Jones, "Lou was the kind of boy that if you had a son, he's the kind of person you'd like your son to be."

Eleanor Gehrig Bracelet

"Dear Judge Landis: I am enclosing a picture of a bracelet I had made for Mrs. Gehrig. It is made up of all my World's Series rings and All-Star Game emblems." Gehrig wrote to Commissioner Kenesaw Mountain Landis in November 1937, seeking to have that year's ring delivered to him in "charm" form instead of as a ring. Gehrig presented the bracelet to Eleanor Twitchell Gehrig on their fourth anniversary, September 29, 1937. The bracelet eventually included seven World Championship emblems (including 1939, when he did not play in the Series), six All-Star Game emblems, two each for MVP Awards and the *Sporting News* MVP Awards, and one representing *Rawhide*, the 1938 film in which he appeared. Teresa Wright wore the bracelet in the film *Pride of the Yankees* when she portrayed Eleanor. On the back of the central charm, Lou had engraved: "To Eleanor, with all my love forever, Lou, Sept 29, 1937." Mrs. Gehrig left the bracelet to the Hall of Fame upon her death.

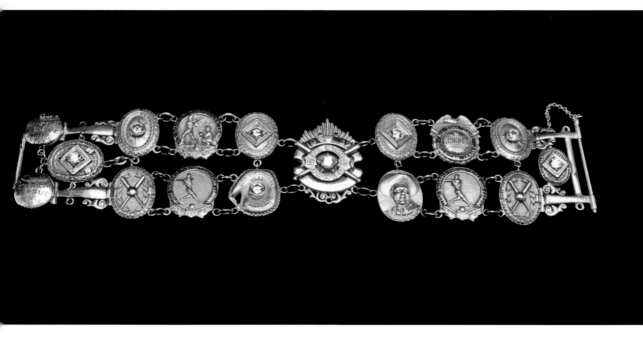

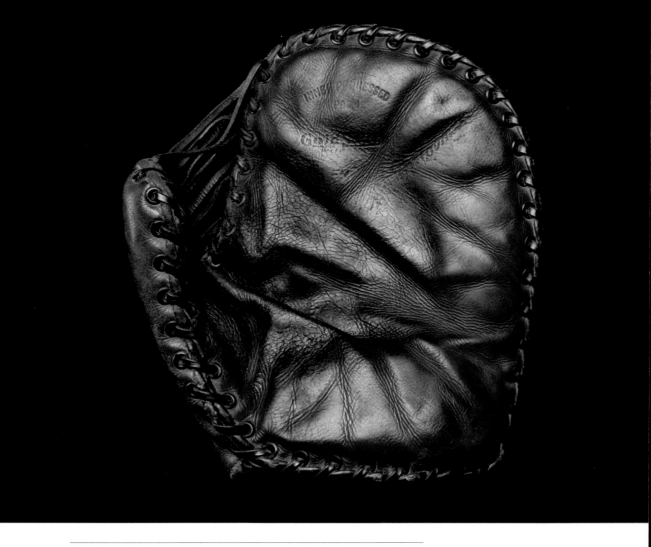

Frank McCormick First Baseman's Mitt from 1940

Born and raised in the same section of Manhattan as Lou Gehrig, Frank McCormick failed several tryout camps. He drove to a Cincinnati Reds camp in West Virginia, sleeping in his car to save money, and was offered a contract with the Beckley Black Knights of the Middle Atlantic League (Class C) in 1934. He would work his way through the minors, earning a permanent spot with the Reds in 1937. A major leaguer for 13 years, mostly with the Reds, McCormick was selected to eight All-Star teams and won the National League MVP in 1940, the year he used this glove to play in all 155 Reds games. "I guess I was cut out to be a ballplayer. There never was a time I can remember when I wasn't crazy to play. Lou Gehrig came from Yorkville too, and his success was an incentive to all us kids," said McCormick. No doubt Gehrig would have been proud.

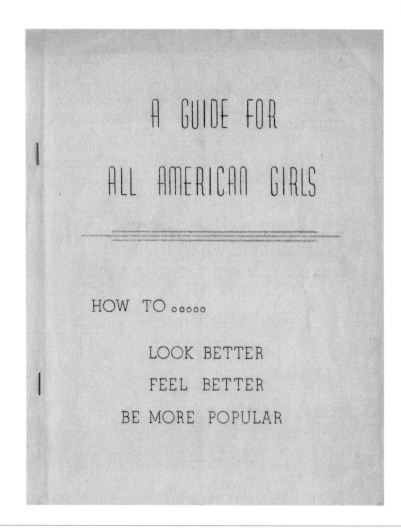

A Guide for All American Girls (AAGPBL Deportment Manual)

Fran Janssen, a pitcher, manager, and chaperone in the All-American Girls Professional Baseball League, the subject of the 1992 film *A League of Their Own*, owned this 11-page manual, which served as her behavior guide from 1948 to 1952. The AAGPBL, active from 1943 to 1954, was managed by men who felt that it was important for the players to project a feminine, ladylike deportment off the field while playing serious baseball on it. The manual contains suggestions on hair, makeup, dress, diet and exercise, general etiquette, and dealing with the expectations of fans and the media. It also contends that baseball can build confidence, leadership, initiative, and strength in young women. "We hand you this manual to help guide you in your personal appearance. We ask you to follow the rules of behavior for your own good as well as that of the future success of girls' baseball," says the guide.

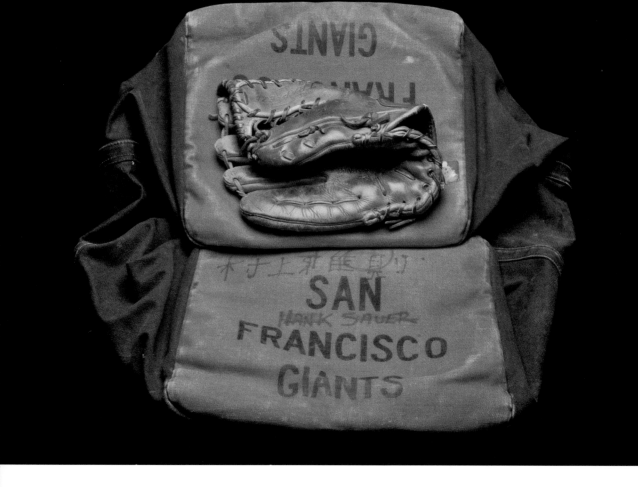

Masanori Murakami Glove and Travel Bag

In recent years Japanese-born players such as Ichiro Suzuki, Hideo Nomo, Hideki Matsui, and Yu Darvish have populated big league rosters, but when southpaw pitcher Masanori Murakami saw action with the San Francisco Giants in 1964 and '65 he was breaking new ground. The native of Otsuki, Japan, who donated this glove and travel bag used during his short big league tenure, soon distinguished himself after arriving in the United States at 19 years old. Though a contract dispute would force Murakami back to Japan, where he enjoyed a long and productive career, he still wondered what might have been. "I wish I could have stayed in America for a few more seasons to see what I could have done over a longer period of time," he said. "But I attribute my success in baseball to my experiences in the States. It was such a great thrill, and people were so kind to me."

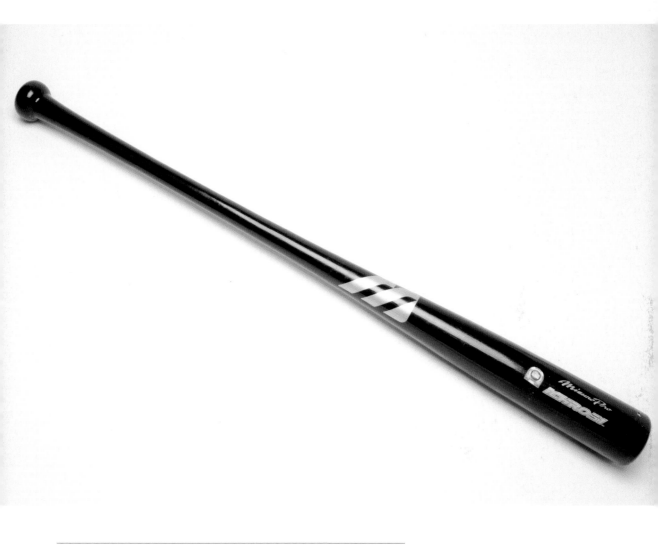

Ichiro Suzuki Bat from Record-Setting 262nd Hit

After accumulating 1,278 hits for the Orix Blue Wave in the Japan Pacific League, Ichiro Suzuki took his game to America at age 27. After the 2000 season the Blue Wave used the posting system to sell Ichiro to a Major League Baseball team, and the Seattle Mariners, owned at the time by a Japanese company, the Nintendo Corporation, won the bidding with a posting fee in excess of $13 million. In 2004, Ichiro won his second American League batting crown with a .372 average and posted his fourth consecutive 200-hit season when he connected for his 200th hit of the season, a seventh-inning home run off Royals lefty Jeremy Affeldt on August 26. Ichiro collected 62 more hits in the final six weeks of the season, the modern season record.

TAKE ME OUT TO THE BALL GAME

BY JACK NORWORTH

KATIE CASEY WAS BASE·BALL MAD
HAD THE FEVER AND HAD IT BAD,
JUST TO ROOT FOR THE HOME ~~TEAM~~ TOWN CREW
EVERY SUE — KATIE BLEW
ON A SATURDAY, HER ~~FRIEND JIM~~ YOUNG BEAU
CALLED TO SEE IF SHE'D LIKE TO GO
TO SEE A SHOW BUT MISS ~~CASEY~~ KATE SAID NO,
I'LL TELL YOU WHAT YOU CAN DO —

TAKE ME OUT TO THE BALL GAME
TAKE ME OUT ~~TO~~ WITH THE ~~PARK~~ CROUD
BUY ME SOME PEANUTS AND CRACKER JACK
I DON'T CARE IF I NEVER GET BACK
LET ME ROOT, ROOT, ROOT FOR THE HOME TEAM,
IF THEY DON'T WIN ITS A SHAME,
FOR ITS ONE, TWO, THREE STRIKES YOUR OUT
AT THE OLD BALL GAME

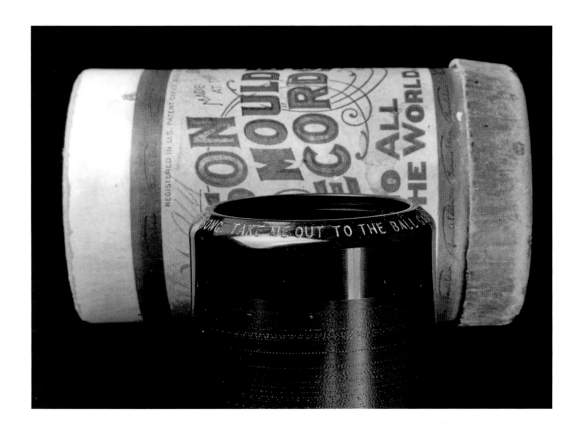

Handwritten Lyrics and Wax Cylinder Recording of "Take Me Out to the Ball Game"

Songwriter Jack Norworth handwrote these lyrics to "Take Me Out to the Ball Game" and presented them to the Hall of Fame in 1953, 45 years after the song's debut. Whether this is the actual rough draft of the manuscript is questionable, but it is still the song in the cowriter's own hand. (The music was penned by Albert Von Tilzer.) Published in May 1908, by November the song was a top-ten hit for three artists—the Haydn Quartet, Harvey Hindermeyer, and Edward Meeker. Meeker's Edison wax cylinder recording, shown here, peaked at number five on the charts, while the Haydn Quartet hit number one, and Hindermeyer rose to the number three spot. Cylinders were popular in the late nineteenth and early twentieth centuries, before being replaced by flat records.

Harry Caray's Eyeglasses

"All right! Lemme hear ya! Ah-One! Ah-Two! Ah-Three! Take . . . me out to the ball game . . ." So began the seventh-inning stretch at every Chicago Cubs game broadcast by Harry Caray between 1982 and 1997. It was across town at Comiskey Park, though, where the singing tradition began in the mid-1970s, when Caray worked for the White Sox, after his long tenure with the St. Louis Cardinals from 1945 to 1969. In 52 years in the booth, Caray was beloved, calling them as he saw them from a "man on the street" point of view. He made a spectacle of himself and his larger-than-life personality, donning these oversized black glasses as a signature trademark. The glasses were donated to the Hall after his death in early 1998—a season in which the Cubs wore a memorial patch on their sleeves in his honor.

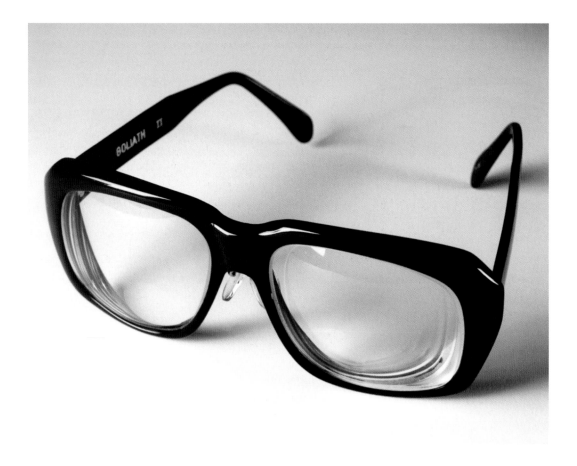

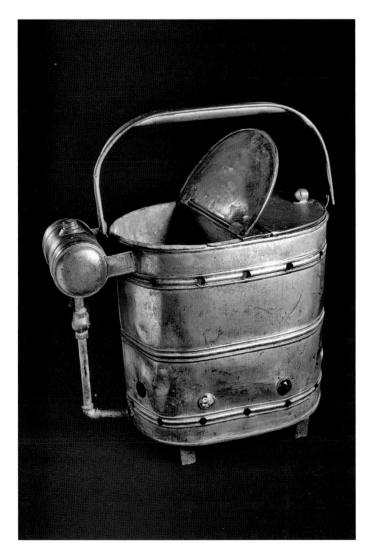

Hot Dog Vending Bucket, circa 1910

"A hot dog at the ball park is better than a steak at the Ritz," said Humphrey Bogart. Whether calling them hot dogs, wieners, frankfurters, or red hots, Americans have been consuming them in massive numbers at stadiums across the nation since the turn of the twentieth century. Thought to have been introduced during the 1904 World's Fair in St. Louis, the delectable delight quickly made its way into baseball, and fans now consume in excess of 20 million every year. Today fans can select from a variety of foods, but the hot dog remains the favorite. In the early 1900s vendors delivered them in buckets like this. As one executive noted, "Times and fashions may change, but hot dogs are the consistent winner—or wiener."

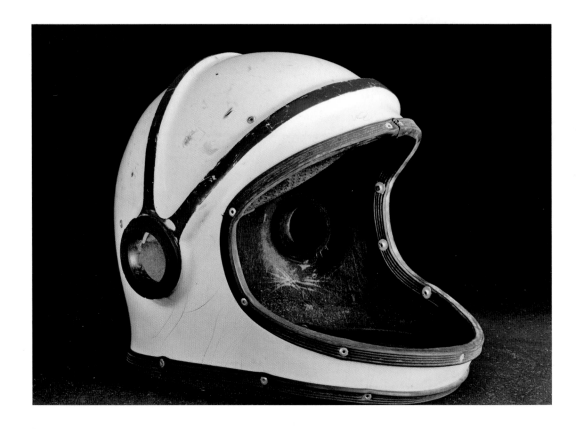

Houston Astros Groundskeeper Helmet

Houston, we have baseball! Major League Baseball arrived in Texas when Houston was granted an expansion team, the Colt .45s, in 1962. While suffering through the usual growth pangs of a new franchise, the players also dealt with heat, humidity, mosquitoes, and even the occasional rattlesnake at Colt Stadium. These problems were solved with the construction of Harris County Domed Stadium. Better known as the Houston Astrodome, it was called the Eighth Wonder of the World when it opened in 1965. Taking advantage of its connection to NASA's Houston Space Center, the team was rechristened the Astros in 1965, and the grounds crew dressed as astronauts. This helmet was used in 1965, and reissued for use again in 2010. The inspiration of owner Judge Roy Hofheinz, the Astrodome was America's first domed sports stadium, and with its four-story-tall "Astrolite" scoreboard, it became as much of an attraction as the team itself.

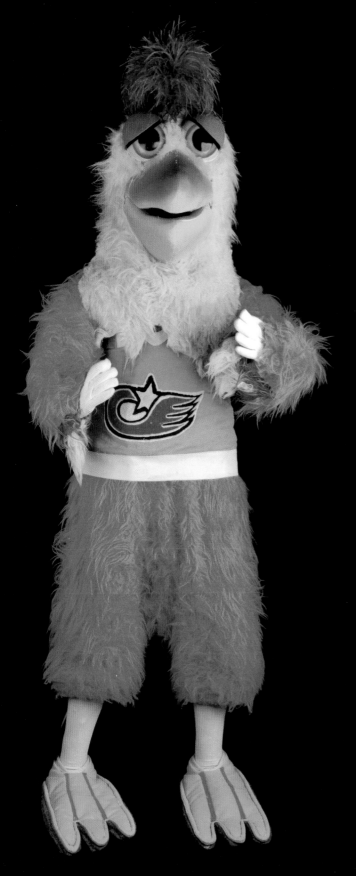

San Diego Chicken Costume

The Famous Chicken, known originally as the San Diego Chicken, wore this costume for more than a few of his 8,500-plus appearances at baseball, basketball, hockey, and football games. The chicken was born in 1974 when radio station KGB needed someone to wear a chicken costume and hand out Easter eggs. Ted Giannoulas, who was small enough to climb inside, used a gift for physical comedy that earned him comparisons to Charlie Chaplin, Harpo Marx, and Donald Duck. His influence is astonishing, as nearly every major and minor league sports franchise in America now has a furry mascot of its own. In San Diego, the Famous Chicken has been declared a "hysterical landmark." *(Photograph © TFC, Inc.)*

Fingerless Glove

Babe Ruth said, "I won't be happy until we have every boy in America between the ages of six and sixteen wearing a glove and swinging a bat." In the decade of Babe Ruth's birth, the 1890s, not all major league players were wearing gloves on the field of play. In fact, when the National League began play in 1876, it was not common practice for players in the field to wear gloves at all. The gloves of the late 1800s were nothing like we have today. Instead of large, well-padded gloves with webbing, they were small pieces of leather that offered only minimal protection. This right-handed leather fingerless glove is an example of the type of glove used by ballplayers in the late nineteenth century.

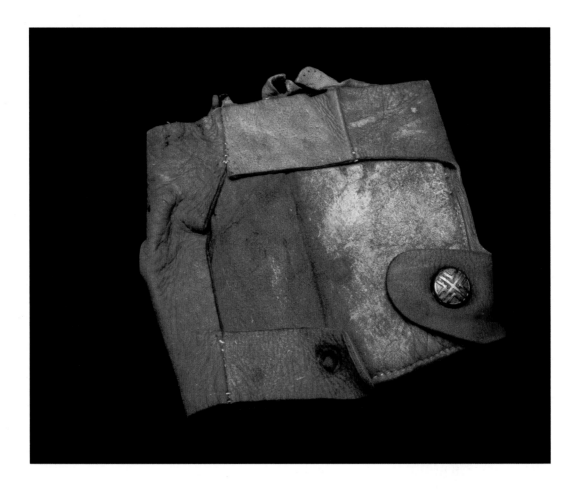

Shoeless Joe Jackson Shoes

Forever known as "The Black Sox," as many as eight members of the heavily favored Chicago White Sox, including Shoeless Joe Jackson, accepted money from gamblers in exchange for their complicity in throwing the 1919 World Series to the Cincinnati Reds, or were aware of the situation and did not report it. News of the scandal eventually rocked the baseball world, and those eight men were suspended from baseball for life. This pair of leather, low-top baseball shoes was worn by Shoeless Joe Jackson, the most famous of the "eight men out." Legend has it that Jackson got his nickname from Greenville, South Carolina, newspaper writer Scoop Latimer because during a game in Greenville in 1908, Jackson's feet blistered when he tried to break in a new pair of shoes. The next day, rather than sit out, with his feet still in pain, Jackson played the game (or a portion thereof) barefoot.

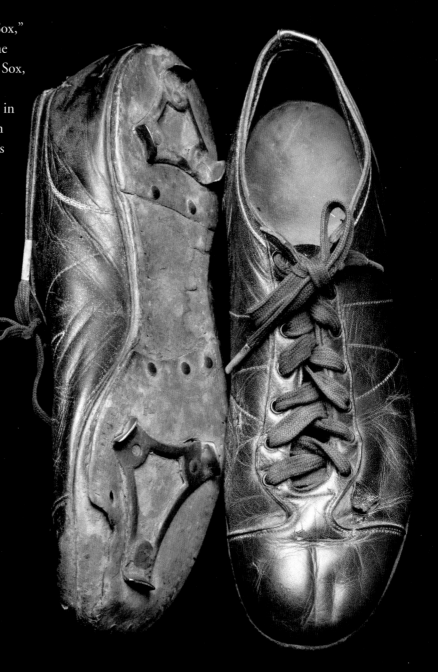

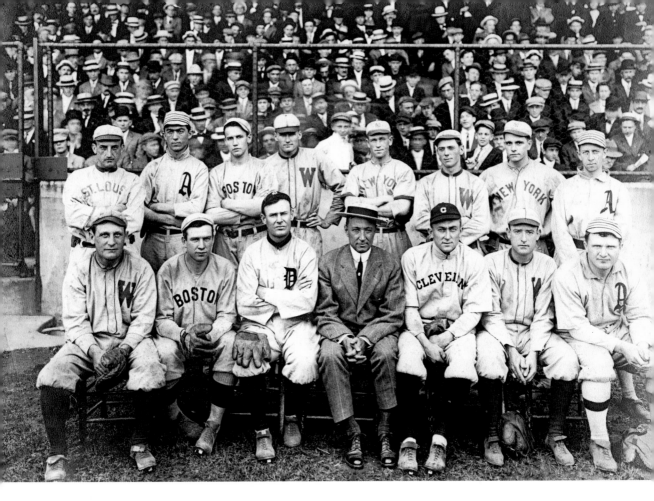

Addie Joss American League All-Stars Photo

Many fans believe that the All-Star Game began in 1933, but the current Mid-Summer Classic has roots that trace to an earlier event. This photo is from a game held to benefit the family of one of baseball's all-time great hurlers, Addie Joss. Held on July 24, 1911, in Cleveland, this game is widely regarded as baseball's first "All-Star" game. Joss played for nine seasons, amassing a career record of 160–97, with a sparkling 1.89 ERA. He died suddenly after a battle with tubercular meningitis at 31 years of age. The game featured a team of American League All-Stars taking on Joss's own Cleveland Naps. Pictured here is the visiting American League All-Star team: standing, L-R: Bobby Wallace (SS), Frank Baker (3B), Joe Wood (P), Walter Johnson (P), Hal Chase (1B), Clyde Milan (CF), Russell Ford (P), Eddie Collins (2B). Seated, L-R: Germany Schaefer (1B), Tris Speaker (CF), Sam Crawford (RF), Jimmy McAleer (mgr.), Ty Cobb (OF), Gabby Street (C), and Paddy Livingston (C). The American League contingent bested the Naps that day by a score of 5–3, and in the process raised nearly $13,000 for Joss's family.

Sam Rice Sweater

The postseason of the 1924 baseball season was just as busy with travel and ball playing as the regular season for Sam Rice. After leading the Washington Senators to their first, and only, World Series Championship, Rice traveled to Montreal, Canada, to join members of the Chicago White Sox and New York Giants as a last-minute replacement for their planned winter tour of Europe. Although the tour was not a financial success, it did bring our National Pastime to an area of the world where it was not regularly played, and provided the players with a chance to act as both tourists and ambassadors for the country. Rice wore this dark red wool knit Spalding White Sox sweater during his time in Europe.

1933 National League All-Star Jersey—Frankie Frisch

In today's All-Star Game, players wear the jersey of the team for which they regularly play, but that was not the case for the National League squad during the inaugural Mid-Summer Classic. This jersey was worn by Frankie Frisch in his first All-Star Game, July 6, 1933, at Comiskey Park in Chicago. This short-sleeved, button-front uniform shirt is gray with navy blue felt "National League" appliquéd on the front and navy piping around the collar, down the placket, and around the sleeve ends. A felt navy "2" is appliquéd on the reverse. The Cardinals second baseman batted second for the visiting National League and went two for four with a home run in the National League's 4–2 loss. The first All-Star match was played in two hours and five minutes before 47,595 fans. Counting players, managers, and umpires, it featured 21 future Hall of Fame inductees.

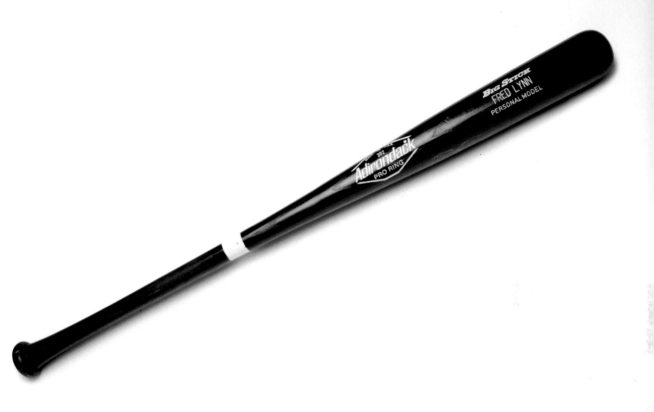

Fred Lynn All-Star Grand Slam Bat

The American League All-Star team's streak of 11 consecutive losses to their National League rivals came to an end in 1983, when California Angels outfielder Fred Lynn's history-making moment contributed to a 13–3 victory at Chicago's Comiskey Park on July 6. Using this Adirondack bat, the lefty-swinging Lynn hit the first grand slam home run in the 50-year history of the Mid-Summer Classic, a third-inning shot into the right-field stands off San Francisco Giants southpaw hurler Atlee Hammaker before a capacity crowd of 43,801. "Hammaker had me two strikes," said Lynn, the game's unanimous MVP choice. "I choked up a bit and spread my stance. I didn't want to strike out. They had walked [Robin] Yount to get to me. When I hit the ball, I knew it was a home run. It was a breaking ball up and that's where I can hit it. I was elated. It was the most emotion I've shown."

Pitching Rubber from First Interleague Game, June 12, 1997

Major League Baseball entered a new era on June 12, 1997, with the first game featuring regular-season interleague play, matching the visiting San Francisco Giants against the Texas Rangers at The Ballpark in Arlington. Before this innovation, the only time that players from the American and National Leagues met during in-season competition was the annual All-Star Game and the World Series. Baseball traditionalists, and there were many, adamantly opposed the concept, dismissing these games as exhibition contests. However, it did not take long for fans to develop an appreciation for the opportunity to see great players from both leagues, a privilege that had previously been denied to those who didn't live in two-team cities. This is the pitching rubber from that first interleague game, which the Giants won 4–3.

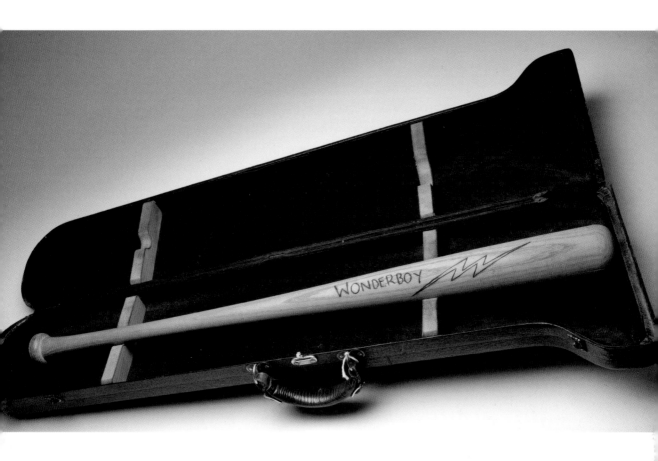

Wonderboy Bat and Trombone Case

"And then when I walked down the street people would've looked and they would've said there goes Roy Hobbs, the best there ever was in this game." This is the black trombone case used by Robert Redford in the 1984 film *The Natural* to carry his magical homemade bat, "Wonderboy." Based on the 1952 novel of the same name by Bernard Malamud, the film features Redford as Roy Hobbs. Hobbs is a naturally gifted ballplayer who travels to Chicago for a tryout with the Cubs. The story takes an unexpected turn when Hobbs is gunned down by a mysterious woman. It is almost certain that this story was inspired, at least in part, by similar real-life incidents involving Phillies star Eddie Waitkus and Cubs shortstop Billy Jurges. While the outcomes of the book and the film are quite different, the movie has become a fan favorite.

Spalding World Tour, 1888–89

"In order to further promote the interests of Base Ball, a few gentlemen from Chicago, undertook to establish the National Game of America on foreign soil." So begins the diary of Jimmy Ryan, Chicago White Stockings outfielder extraordinaire. Ryan's team, now known as the Cubs, was led by owner Albert Spalding on a world tour that began on October 20, 1888, in Chicago, headed west by train and ship, visiting and/or playing games in the Sandwich Islands (now Hawaii), New Zealand, Australia, Ceylon (now Sri Lanka), Egypt, Italy, France, England, Scotland, and Ireland before returning to Chicago via the East Coast on April 21, 1889. The White Stockings were accompanied by the All-America team, a hand-picked group of opponents. The trip featured visits to temples, mosques, and the Vatican, as well as the Sphinx and pyramids, the Coliseum, and Pompeii. There were many banquets over the course of the tour. These included formal dining-car meals on the opening leg from Chicago to Denver, whose menu is shown here. Ryan's diary is an incredible primary source on perhaps the grandest baseball adventure of all-time.

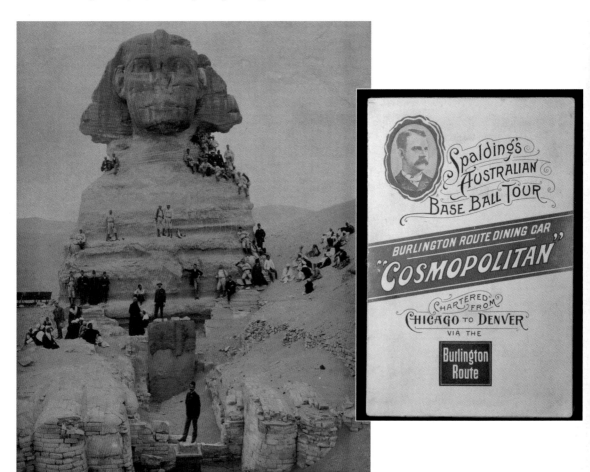

Before rings became the standard award given to championship teams, medals were common. This is a medal given by actress Helen Dauvray to members of the National League's Detroit Wolverines in recognition of their winning the National League/American Association World's Championship Series of 1887. The medal displays the name "Detroits" above a pair of crossed bats and three baseballs. Engraved on the medal is "First Winner of the Dauvray Cup." Whereas the medals were awarded to the individual players on the team, Dauvray also commissioned and awarded a loving cup, named after herself, to the team. Players took turns with the cup throughout the off-season, and the cup remained with the team during the following season. That same year that the Dauvray Cup was initially awarded, Ms. Dauvray also married one of the nation's top baseball players, Hall of Famer John Montgomery Ward.

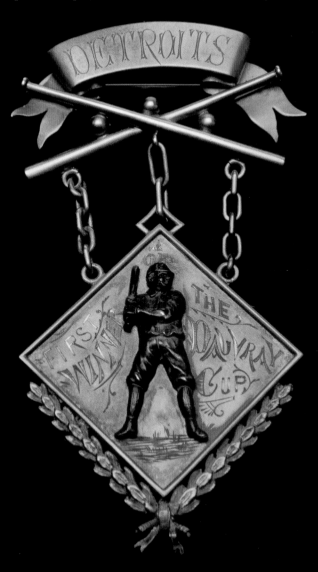

Temple Cup

It was common for unofficial postseason championship series to be played between the American Association pennant winner and the National League pennant winner in the nineteenth century. Due to the demise of the AA after the 1891 season, the practice was abandoned. William C. Temple, the Pittsburgh Pirates owner, felt his team missed out on an opportunity to play postseason baseball after finishing second in the NL's 1893 season. For $800, quite a sum at the time, Temple commissioned the creation of a sterling silver cup, which was engraved "National League of Professional Base Ball Clubs." From 1894 through 1897, the first- and second-place teams in the league competed for the "Temple Cup" in a postseason series. The winning team's name was then engraved on the cup. Ironically, Temple's Pirates never had the opportunity to compete for the Cup that he commissioned.

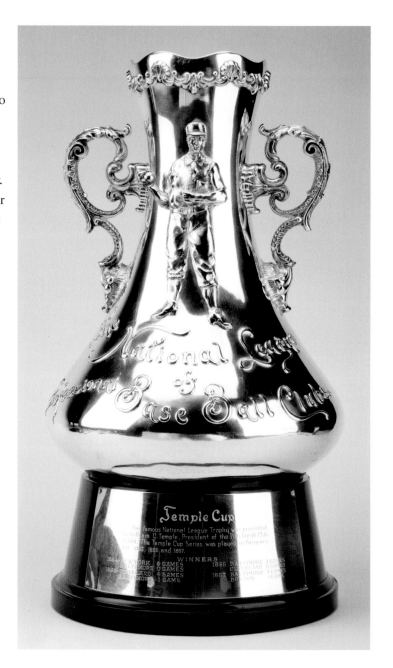

World Series Scorecard,
Final Game, October 13, 1903

Scorecards are like snowflakes—
no two are exactly the same. Teams
and fans have kept various types of
scorecards since the game's earliest
days, and the library collection at
the National Baseball Hall of Fame
holds thousands of samples, each
representing the first draft of history
for that particular event. This image
shows the scorecard from Game 8
of the best-of-nine 1903 World
Series, the deciding matchup
between the visiting Pittsburgh
Pirates and the Boston Red Sox
at Boston's Huntington Avenue
Grounds. On October 13, 7,455 fans
showed up to watch Boston pitcher
Bill Dinneen toss a four-hit shutout
to notch the victory for the Sox in
a game that moved quickly, lasting
1:45. Baseball's first World Series
was a contest between the league
champions, independently arranged
by the two owners, but proved to be
of so much interest that the Series
became a permanent fixture of the
sport in 1905.

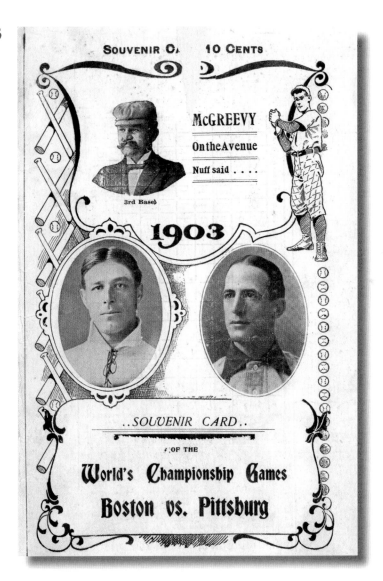

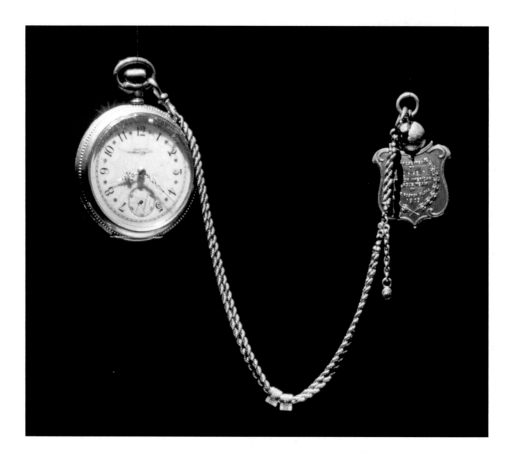

Freddy Parent Watch Fob

Alfred Joseph "Freddy" Parent was the first Boston Red Sox shortstop. A solid fielder and slap hitter, Parent was also adept at running the bases. He was the Red Sox starting shortstop in 1903, the year that Boston won Major League Baseball's first World Series, and at the time of his death in 1972 was that World Series' last surviving player. Nearly two decades before the practice of major league teams' providing their players with World Series rings, diamond stick pins, watch fobs, and pocket watches were given out to commemorate winning the Fall Classic. This gold watch fob is inscribed on the obverse: "Boston American League Team / World's Champions 1903" and the reverse is engraved: "Presented to Fred Parent SS Boston American League Team by The Boston Globe 1903."

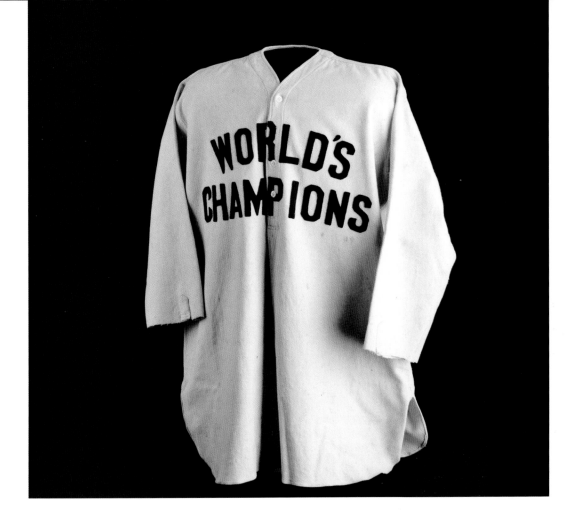

1906 World's Champions Jersey

Outfielder George Browne played twelve seasons in the majors with seven different teams, his longest stay being with manager John McGraw's New York Giants. In 1905, the Giants won the second World Series, defeating Connie Mack's Philadelphia Athletics, four games to one. In 1906, not wanting anyone to be in doubt of their status, and hoping to put the junior circuit in its place, Giants jerseys reflected as much, stating "World's Champions" across the front. George Browne wore this cream-colored pullover uniform shirt that season. The movie *Field of Dreams* brought a ballplayer named Archibald "Moonlight" Graham to the consciousness of millions of baseball fans, despite his having played only one inning of one game in his major league career. It was George Browne whom Moonlight Graham replaced in that one inning.

1910 Athletics Desk Set

Why do the Oakland A's have an elephant as a logo? In 1902, John McGraw told reporters that Philadelphia Athletics owner Ben Shibe and manager Connie Mack "had a big white elephant on their hands." Mack fired back: "McGraw says that the Athletic club is a white elephant; that it is not making any money, and that its principal stockholder has had all he wants of it. I will bet McGraw $1000 that the Athletics did make money last year, and are making money this year." Mack adopted the white elephant as a logo in defiance of McGraw, presenting the Giants manager with an elephant figurine before the 1905 World Series, which the A's lost to the Giants. By 1910, the "white elephants" had won the World Series.

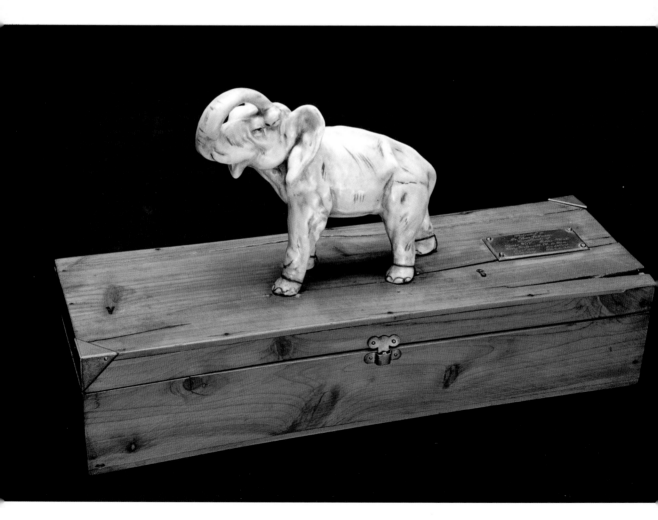

Base from 1948 World Series

The 1948 Cleveland Indians enjoyed one of the finest seasons experienced by a major league club, and they carried this momentum into the World Series, beating the Boston Braves four games to two. Pitching would be the predominant factor as fans were able to watch future Hall of Famers from both squads, including Bob Feller, Bob Lemon, Satchel Paige, and Warren Spahn. As with almost every World Series, there was a disputed call, which occurred in Game 1 when Bob Feller worked with Lou Boudreau on a second base pick-off play of Phil Masi. Called safe over the protests of Boudreau, Masi would score the only run of the game, giving the Braves a lead over the Indians. The Tribe would overcome the deficit, finishing off the Series in six games.

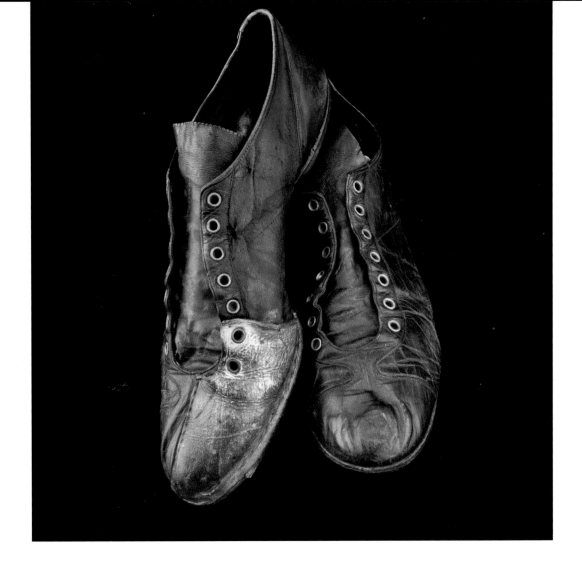

Bob Feller Shoes from 18-Strikeout Game

Cleveland Indians legend Bob Feller ended the 1938 season in dramatic fashion. The 19-year-old fanned 18 to set a new nine-inning major league record against the visiting Detroit Tigers in the first game of an October 2 doubleheader. Despite the mound heroics while wearing these leather shoes, "Rapid Robert"—who also gave up seven hits, walked seven, and hit a batter in his complete game effort—took the loss in a 4–1 final. "I did have it out there today. But doggone!" said the youngster from Van Meter, Iowa, as the Indians' trainer began rubbing his right arm after the game. "Doggone it that I didn't have a little more control. . . . Wait till I get to be 22 or 23. I won't tire then."

Dizzy Dean Stetson Hat

Dizzy Dean was a talented right-handed pitcher who epitomized the famed St. Louis Cardinals' "Gashouse Gang" of the 1930s. After his athletic career was shortened due to injury, the folksy and eccentric character embarked on a memorable baseball broadcasting career in which he often angered English teachers (using "slud" for slid) and would entertain the audience with his rendition of the song "Wabash Cannonball." On the radio since 1941, Dean also made his mark on television, wearing a white Stetson, beginning in 1953. Dean's *Game of the Week* broadcasts became so popular that reportedly 75 percent of the televisions in use were tuned to him. After Dean died in 1974, his wife gave this signature Stetson to his longtime friend and broadcast partner, Gene Kirby, who later donated it to the Hall of Fame. "Dean became a legend to literally thousands of people who didn't know if he threw right-handed or left-handed. And didn't care," said former broadcast partner Buddy Blattner.

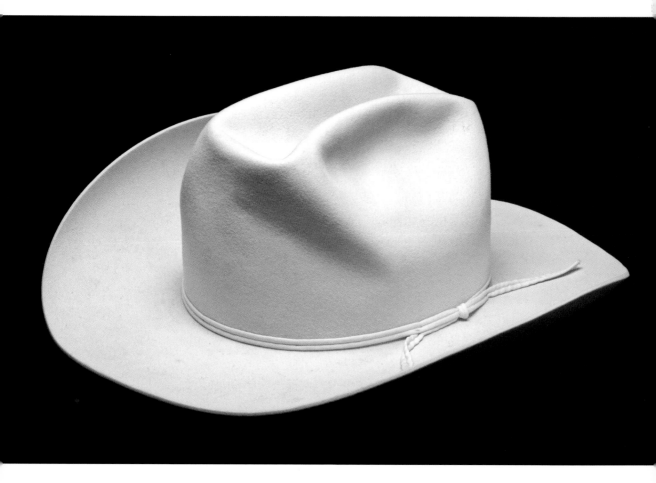

Dizzy Dean 1934 Jersey

During the 1930s the St. Louis
Cardinals were cultivating a loyal
fan base across the country,
and the famed Gashouse Gang
did everything possible to
entertain its supporters.
Not only did the Cardinals
provide solid baseball on
the field, but their practical
jokes and general mayhem
in the clubhouse gave
fans something to smile
about during the Great
Depression. Their leader
was Jay Hanna "Dizzy"
Dean, who wore this
jersey in 1934, the year he won
30 games, with a 2.66 ERA, and
earned the National League MVP
Award. "When ole Diz was out
there pitching it was more than just
another ball game. It was a regular
three-ring circus, and everybody
was wide awake and enjoying being
alive," said fellow teammate and
clubhouse conspirator Pepper Martin.

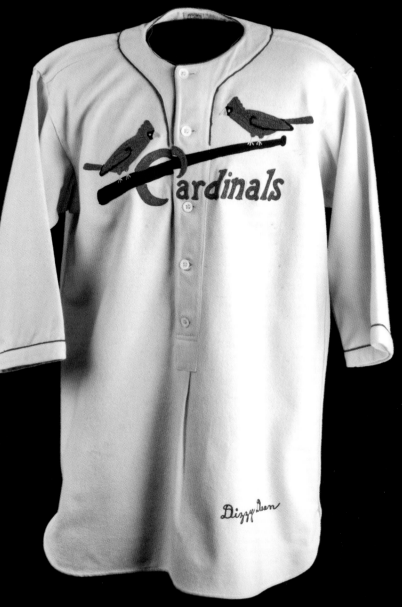

Mark Whiten Batting Helmet

Outfielder Mark "Hard Hittin'" Whiten lived up to his nickname, while wearing this batting helmet, when he hit four home runs and drove in 12 runs for the visiting St. Louis Cardinals in the second game of a doubleheader against the Cincinnati Reds on September 7, 1993, tying Hall of Famer Jim Bottomley's record for RBI in a game and becoming the 12th big leaguer to hit four homers in a game. Whiten also tied Nate Colbert's major league record of 13 RBI in a doubleheader, which Colbert had set while with the San Diego Padres in 1972. "I don't even have words to explain it, just amazement, I guess," Whiten said after the day's action. A switch-hitter, Whiten hit all four of his homers left-handed to lead the Cards to a 15–2 victory.

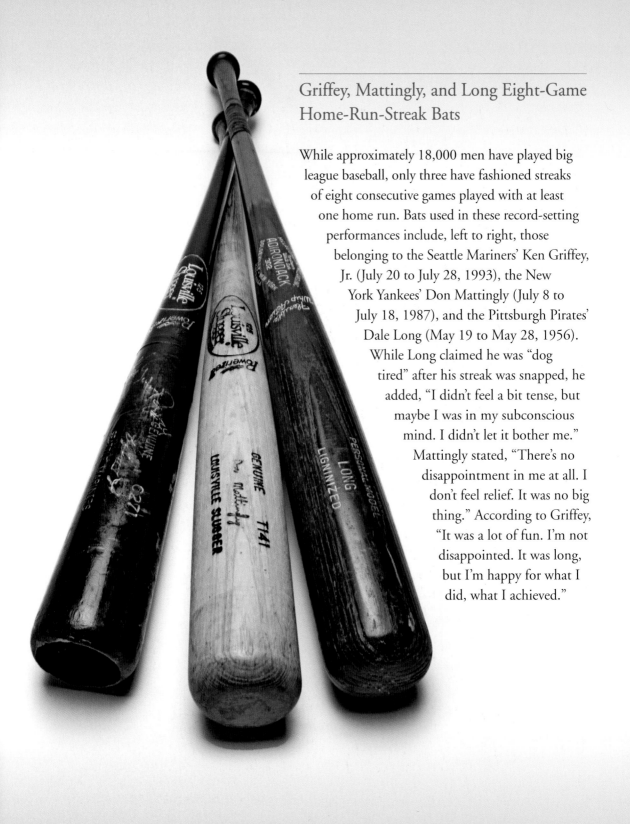

Griffey, Mattingly, and Long Eight-Game Home-Run-Streak Bats

While approximately 18,000 men have played big league baseball, only three have fashioned streaks of eight consecutive games played with at least one home run. Bats used in these record-setting performances include, left to right, those belonging to the Seattle Mariners' Ken Griffey, Jr. (July 20 to July 28, 1993), the New York Yankees' Don Mattingly (July 8 to July 18, 1987), and the Pittsburgh Pirates' Dale Long (May 19 to May 28, 1956). While Long claimed he was "dog tired" after his streak was snapped, he added, "I didn't feel a bit tense, but maybe I was in my subconscious mind. I didn't let it bother me." Mattingly stated, "There's no disappointment in me at all. I don't feel relief. It was no big thing." According to Griffey, "It was a lot of fun. I'm not disappointed. It was long, but I'm happy for what I did, what I achieved."

Stan Musial Jersey

Teammate Joe Garagiola once joked that Stan Musial "could have hit .300 with a fountain pen." The longtime St. Louis Cardinals great punished National League hurlers over a 22-year career that included 3,630 hits, 475 home runs, and a .331 average with seven batting crowns. "The Man" wore this cotton home jersey in 1952 when he captured his sixth hitting crown, and third straight, with a .336 mark as well as topping the Senior Circuit with 42 doubles and 105 runs scored. Despite his stellar offensive numbers, the Donora, Pennsylvania, native with the unique lefty swing lamented his campaign in an interview after the Redbirds' final regular-season contest, explaining, "I had a bad year. My timing was off during the season. I wish I could have done better. I would have been able to help the team more if I had hit my stride."

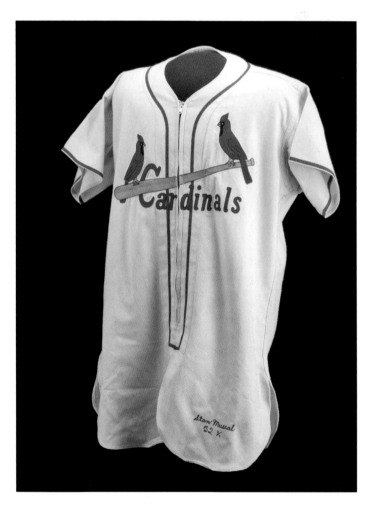

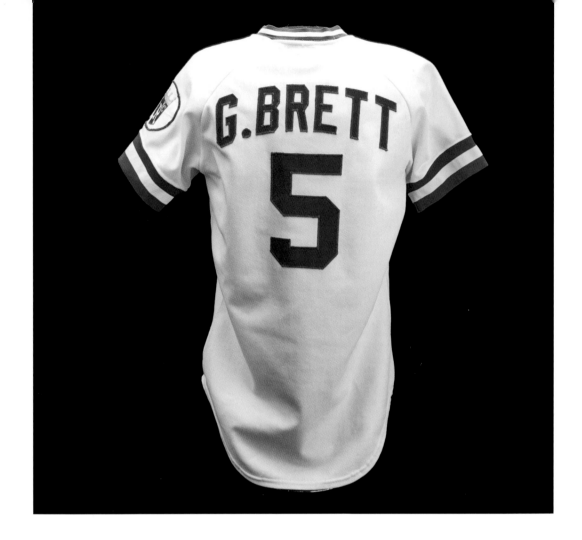

George Brett Jersey

Mention the Kansas City Royals and one of the first names that springs to mind is George Brett, the longtime third baseman who spent his entire 21-year career with the franchise. Holder of many of Kansas City's career offensive marks, while wearing this home jersey in 1980 he had one of his most remarkable seasons, capturing the nation's attention throughout the summer as he flirted with a .400 batting average. Though the 27-year-old Brett slowed down over the final few weeks, he finished with a .390 average—the highest in the big leagues since the Red Sox' Ted Williams batted .406 in 1941. "Regardless of what I hit this year, they're going to say the pressure got to me," Brett would later say. "It's not fair. People are going to say, 'He failed.' I set out this year to try to hit over .300, to drive in 100 runs, and to help our team win the division. I've done every one of those things."

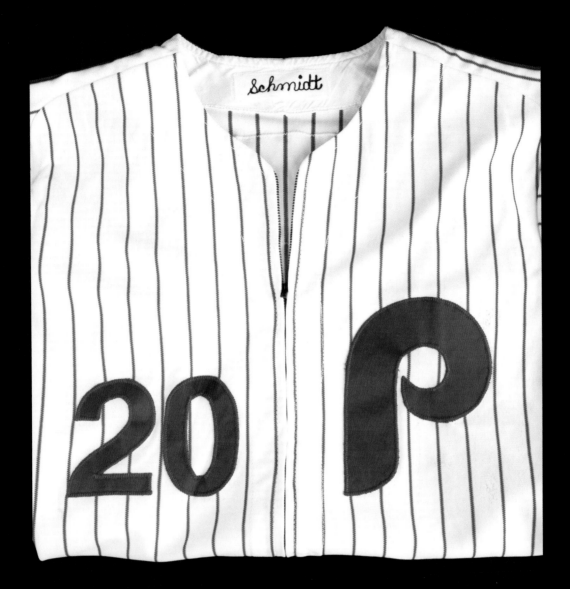

Mike Schmidt Jersey

During 18 seasons spent with the Philadelphia Phillies, Mike Schmidt established a new standard for big league third basemen with his powerful bat and defensive prowess. In the midst of that remarkable career, in which he won three National League Most Valuable Player awards, 10 Gold Gloves, and eight home run titles, he wore this home jersey during the 1982 season, in which he led the NL in slugging (.547), on-base percentage (.403), and walks (107). "The greatest misconceptions are that it probably came easy, that I didn't work very hard," Schmidt once said. "But if time and effort were measured by the amount of dirt on your uniform, mine would have been black. You would have never been able to see the numbers." The 12-time All-Star, elected to the Baseball Hall of Fame in 1995, finished with 548 career home runs.

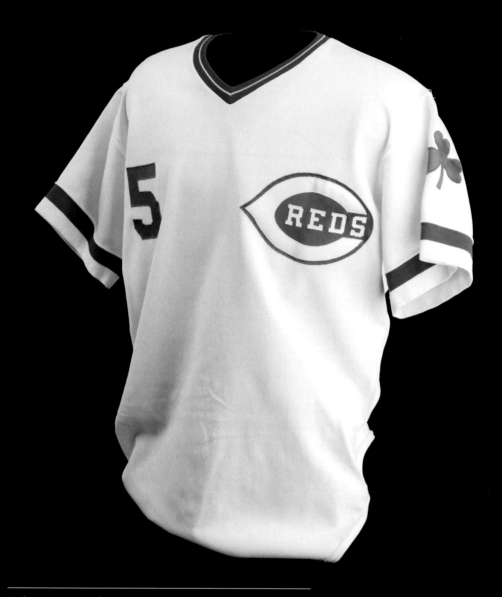

Johnny Bench St. Patrick's Day Jersey, 1978

In the expansion era, teams have used alternate uniforms for a variety of reasons from turn-back-the-clock promotions to turn-ahead-the-clock promotions. One of the more popular alternate uniforms that clubs use is a green uniform worn exclusively on St. Patrick's Day. During spring training 1978, Cincinnati Reds backstop Johnny Bench wore this green Reds white pullover jersey, with green piping, green lettering, a green shamrock on the left sleeve, and his traditional number 5 on the back. One of the most prolific catchers in the game's history, on both offense and defense, Bench clubbed 389 home runs in his career and was a two-time National League MVP. He was inducted into the National Baseball Hall of Fame in 1989.

Harry Wright Hunting Knife

Harry Wright was a legendary nineteenth-century baseball figure, who, though born in Sheffield, England, in 1835, came to be known as "The Father of Professional Baseball." Wright was renowned for organizing, managing, and playing center field for the famed 1869 Cincinnati Red Stockings, the game's first all-professional team, which went undefeated in 60 games. A skilled cricket player, he was a natural athlete who also enjoyed the outdoors. According to one of Wright's sons, the happiest moments in his life were the times spent hunting in the woods with his father. This ten-and-three-quarter-inch-long hunting knife with a cracked deer antler handle was manufactured in London and is inscribed on the blade in script lettering "H. C. Wright." It was donated to the Hall of Fame by a Wright relative in 1996.

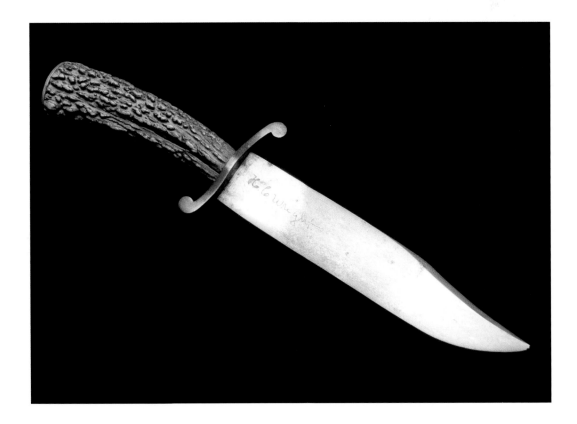

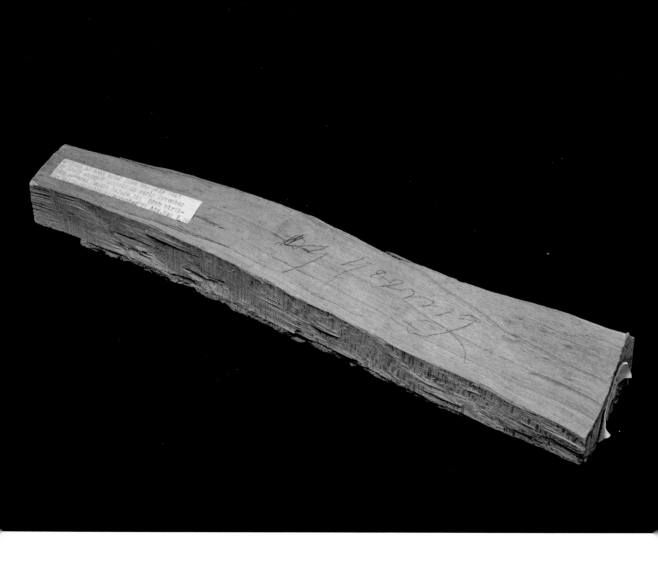

Cy Young Split Wood with Autograph

Though the great Cy Young finished his remarkable big league pitching career with a record 511 victories, famous throughout the land for his diamond exploits, he would always return to his native Ohio, where he was born and raised on a farm. And so it was that the fabled right-handed hurler, decades after he retired from the game in 1912 at the age of 45, found himself back in the state of his birth at the age of 87. This 14-and-a-half-inch-long stick of wood was the result of Young's 1954 visit to the home of William Shelton in Akron, Ohio. The note attached reads: "A piece of wood taken from the pile that Cy Young chopped himself in early November 1954 several months before his 88th birthday and personally autographed by him Nov. 8, 54." Young passed away a year later, on November 4, 1955, at the age of 88.

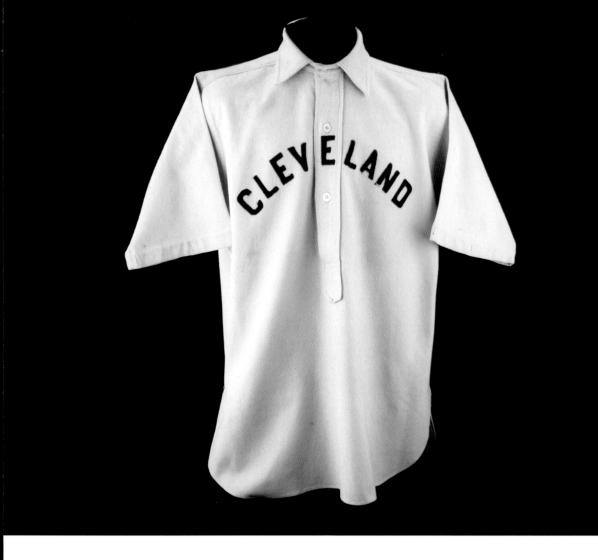

Cy Young Cleveland Jersey

Denton True Young earned the nickname Cy because a teammate once commented that his throwing motion looked like a cyclone. Young holds one of baseball's unbreakable records—511 wins. He wore this jersey while pitching in an era when there were no five-man rotations, setup men, left-handed specialists, or closers. The pitcher was expected to finish what he started, and do it all again two days later. Late in life Young explained, "Too many pitchers, that's all, there are just too many pitchers. Ten or twelve on a team. Don't see how any of them get enough work. Four starting pitchers and one relief man ought to be enough. Pitch 'em every three days and you'd find they'd get control and good, strong arms."

Rube Waddell Glove from 20-Inning Game

An Independence Day marathon that took place more than 100 years ago featured an American League matchup between Boston's Cy Young and Philadelphia's Rube Waddell, a pair of Hall of Fame hurlers who would each go the distance in a then-record 20-inning affair. In the July 4, 1905, contest, the second game of a doubleheader at Boston's Huntington Avenue Baseball Grounds, Waddell wore this glove en route to the 4–2 victory, holding the home team scoreless for 19 frames after giving up a pair of first-inning runs. "The fact that it was the Fourth of July kept me going," Waddell said. "I guess the shooting of revolvers, and the fireworks, and the yelling made me pitch better." Young gave up only two earned runs, a two-run homer in the sixth inning, before losing the game on two unearned runs in the twentieth. He would later say, "For my part, I think it was the greatest game of ball I ever took part in."

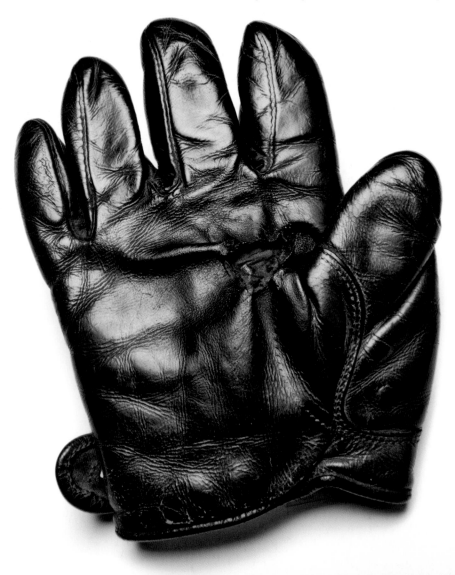

Dave Koza Baseball from 33-Inning Game

In a game that featured future Hall of Famers Cal Ripken, Jr., and Wade Boggs, career minor leaguer Dave Koza would prove to be the hero when he hit this ball for a single in the bottom of the 33rd inning on June 23, 1981—the longest game in professional baseball history. The International League contest between the Rochester Red Wings and Pawtucket Red Sox began on the night of April 18, and 8 hours 7 minutes later, at 4:07 a.m., the game, tied at 2–2 after 32 innings, was postponed. Resumed some two months later, it ended after just 18 minutes when Pawtucket's Koza slapped a 2–2 curve from Cliff Speck into left field with no outs and the bases loaded to score Marty Barrett. "I've had fantasies like all the other guys that I'd be the one to win it," Koza said afterward.

Governors' Cup Trophy

Since 1933, the champion of the International League playoffs has been awarded the Governors' Cup. Frank "Shag" Shaughnessy, then general manager of the Montreal Royals and later league president from 1936 until 1960, introduced the idea of a multiteam postseason. The squad that came out victorious was awarded the Governors' Cup trophy, designed by then International League Supervisor of Umpires W. B. Carpenter, a silversmith. The trophy was sponsored by the governors of New York, New Jersey, and Maryland, as well as the lieutenant governors of the Canadian provinces of Quebec and Ontario—home to the eight International League teams at the time (Albany, Baltimore, Buffalo, Jersey City, Montreal, Newark, Rochester, and Toronto). After 55 years, the original, which was baseball's oldest rotating trophy at the time, was donated to the National Baseball Hall of Fame following the 1988 season. Today, a new trophy continues to be awarded to the champion of the Governors' Cup Playoff Series.

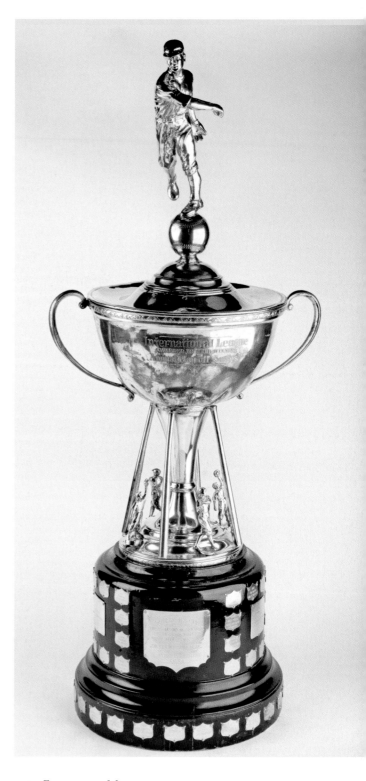

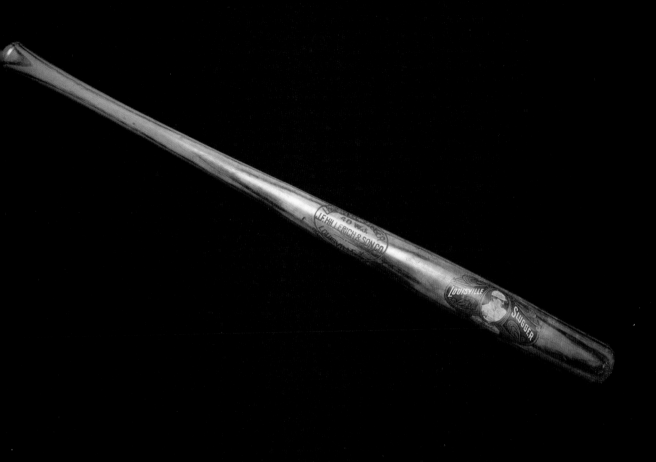

Tris Speaker Decal Bat

Today the likenesses of ballplayers can be found everywhere from drinking cups to video games to baseball bats. In 1912, finding your favorite player's likeness on anything but a baseball card was rare. This bat, manufactured between 1911 and 1913 by JF Hillerich & Son Co., the predecessor to Hillerich and Bradsby, the company that produces the Louisville Slugger, featured the image and name of Tris Speaker on the barrel. Speaker was a superb hitter, finishing his career with 3,514 hits and a .345 batting average. He was also a terrific fielder who still holds the major league record for most career assists and the American League record for most career putouts. Teammate Duffy Lewis praised his defensive prowess: "[Tris] Speaker was the king of the outfield. It was always 'Take it,' or 'I got it.' In all the years we never bumped each other."

Nap Lajoie Jersey

One of the best second basemen the game has ever seen, Napoleon Lajoie enjoyed a stellar 21-year big league career. Though he topped the .300 mark 16 times, his most memorable campaign came in 1910 when the Cleveland star, while wearing this home jersey, famously battled Detroit's Ty Cobb for the American League batting crown. With a new Chalmers automobile at stake, it came down to the last day of the season. Cobb sat out, thinking his lead was insurmountable, while Lajoie, in a doubleheader at St. Louis, first tripled, then bunted for seven singles. It was initially thought Lajoie had edged the "Georgia Peach," but while a league investigation approved the legitimacy of the 8-for-8 day, a later rechecking of the season's records would give Cobb the title—.384944 to .384948. Ultimately, Chalmers would deliver cars to both players. Decades later, research showed that Lajoie had in fact won the batting crown with a .384 average compared to Cobb's .383.

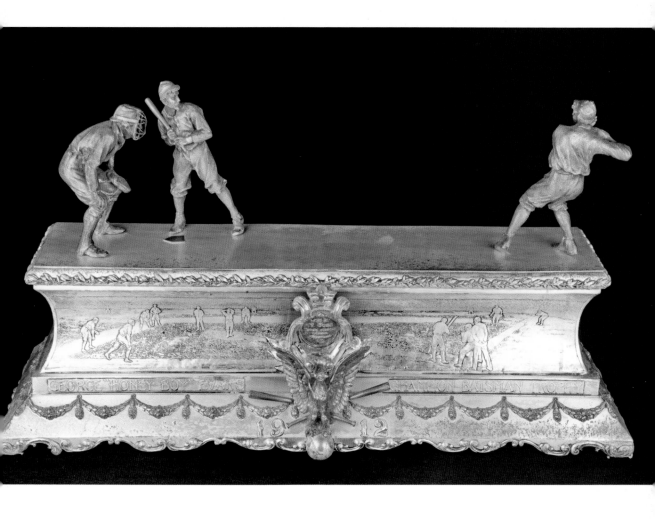

Honey Boy Evans Trophy Won by Ty Cobb, 1912 Batting Title

Given to Ty Cobb in honor of his winning the 1912 batting title, this was Cobb's fourth straight, and final, "Honey Boy" Evans trophy. Silver plated and bronze with a rectangular base, the trophy is emblazoned "George 'Honey Boy' Evans, Champion Batsman Trophy, 1912." An eagle perched atop a baseball with crossed bats behind is affixed to the front bottom center of the base. On the widest part of the base in the front, an image of a game in progress is etched. Protruding from the center front is a silver shield plaque with scrolling around edges, reading: "Won by Ty Cobb Detroit American League Percentage .410." Star of song and stage George "Honey Boy" Evans commissioned this trophy, created by Dieges & Clust, each year from 1908 to 1912 for the league's top hitter. The Welsh-born entertainer became a huge baseball fan; his best-known work is the classic song "In the Good Old Summer Time."

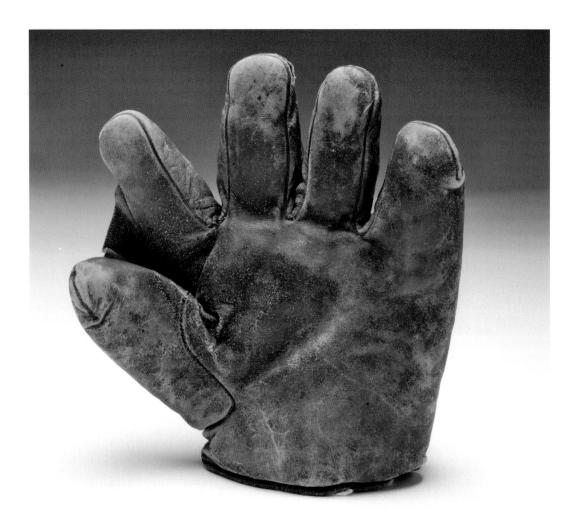

Ty Cobb Glove

General Douglas MacArthur stated, "Few names have left a firmer imprint upon the stages of the history of American times than that of Ty Cobb. For a quarter of a century his aggressive exploits on the diamond, while inviting opposition as well as acclaim, brought high drama. This great athlete seems to have understood from early in his professional career that in the competition of baseball, just as in war, defensive strategy never has produced ultimate victory." Cobb could do it all. He was elected to the National Baseball Hall of Fame inaugural class in 1936. Cobb later explained why he played the game: "The great trouble with baseball today is that most of the players are in the game for the money and that's it, not for the love of it, the excitement of it, the thrill of it."

Ty Cobb Humidor

"Baseball is a red-blooded sport for red-blooded men. It's no pink tea, and mollycoddles had better stay out. It's a struggle for supremacy, a survival of the fittest." This quotation, from Ty Cobb, is more apt to apply today to American football than to our National Pastime. This football humidor, belonging to Cobb, was autographed by two of football's most legendary coaches, Knute Rockne and Pop Warner. Many would argue that Cobb played the game of baseball with the mentality of a football player. Branch Rickey noted "[Ty] Cobb lived off the field as though he wished to live forever. He lived on the field as though it was his last day." Baseball was a bit different, as Cobb described: "When I began playing the game, baseball was about as gentlemanly as a kick in the crotch."

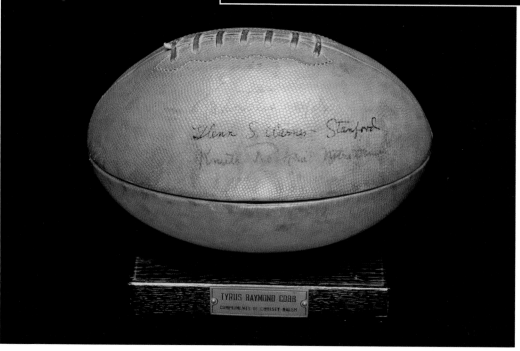

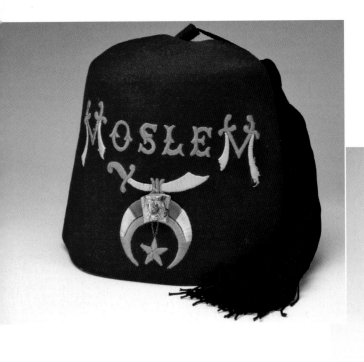

Ty Cobb and Rogers Hornsby Fez Hats

Two of the greatest hitters the game has ever seen, Ty Cobb and Rogers Hornsby, were both members of the Free and Accepted Masons, and became involved in two of their appended bodies, the Ancient Arabic Order of the Nobles of the Mystic Shrine (Shriners) and the Ancient Egyptian Order of Sciots (Sciots). These fezzes represent their participation in these organizations. Shriners and Sciots donate much of their time and money to charitable organizations. In their careers, the two combined for 18 batting titles and five seasons batting .400 or greater. Ty Cobb was a member of the Hall of Fame's first class, 1936, while Hornsby, who didn't retire until after the 1937 season, was elected in 1942.

Grover Cleveland Alexander Jersey

Hall of Famer Carl Hubbell recalled, "Alex was at the end of his career with the St. Louis Cardinals when I first saw him pitch. He was over 40 and his stubborn refusal to adhere to common sense training rules had finally caught up with him. Even with the end in sight, he was still the Man. He never lost that smooth, easy way of throwing, and I could believe it when they told me he never threw a pitch above the batter's waist. His control was amazing." It was in 1927, the year after leading the Cardinals to their first World Series Championship, that "Old Pete" wore this St. Louis Cardinals Worlds Champions jersey. He retired with a remarkable 373 victories.

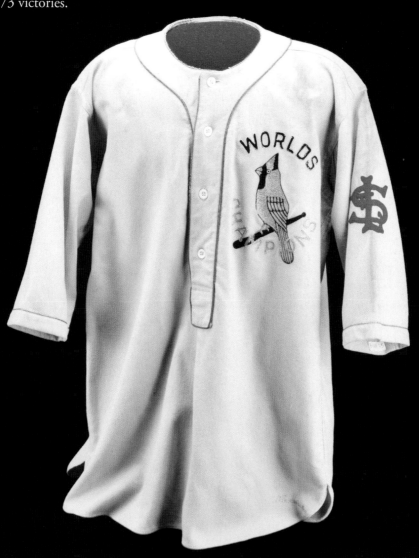

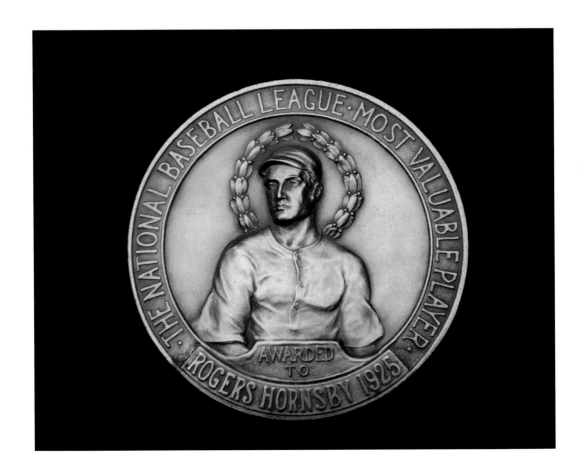

National League MVP Medal Awarded to Rogers Hornsby, 1925

"The Rajah" brought home this hardware for his NL MVP season for the St. Louis Cardinals in 1925. The second baseman repeated his 1922 feat of winning the Triple Crown, leading the NL in batting average (.403), home runs (39), and runs batted in (143). Amazingly, none of these three numbers represented a career high for Hornsby. While he did not lead the league in any other category, he also racked up 203 hits, 133 runs, 41 doubles, and 10 triples. That season allowed Hornsby to do something no other player has ever approached—he hit .402 over a five-season span, topping that magic number three times and hitting .384 and .397 in the other two campaigns. In that five-year period, he also averaged 29 home runs and 120 runs batted in. Hornsby would win a second MVP award in 1929 while playing for the Chicago Cubs.

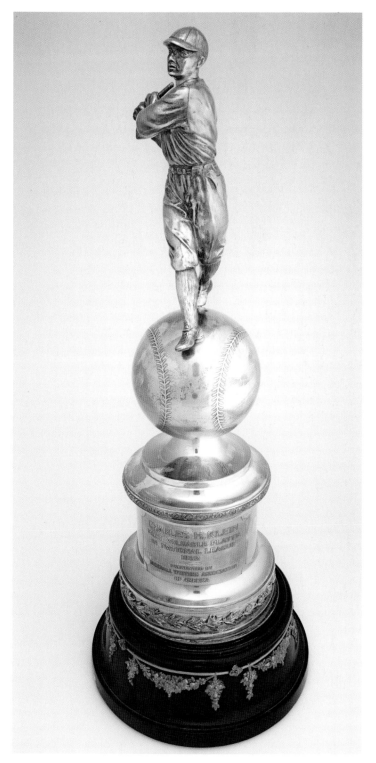

Chuck Klein 1932 National League MVP Trophy

"This season may see Chuck Klein climb right to the top among National League outfielders," wrote 1973 J. G. Taylor Spink Award winner John Kieran before the start of the 1932 baseball season. "He has a liberal supply of confidence and is not one of those who weaken 'in a clinch' as the ball players call it." Kieran proved prophetic as Klein, among the best sluggers ever to don a Philadelphia Phillies uniform, was named that year's NL Most Valuable Player by the Baseball Writers' Association of America after leading his league in hits, runs, home runs, slugging percentage, and stolen bases. As a result, the right-fielder was awarded this two-foot-tall silver MVP trophy. "He's the greatest player because he can do everything that all the other stars do," said Phillies team president Gerry Nugent following the '32 season. "He is a great hitter, a fine fielder, can throw with the best, run the bases and has a good head."

John Kieran Typewriter

John Kieran initially became famous as a panelist on the long-running 1940s radio program *Information, Please.* He wrote more than a dozen books, was an award-winning naturalist and bird-watcher, and was generally considered to be a human encyclopedia. In sports, Kieran came to the public's attention penning the "Sports of The Times" column for the *New York Times* from 1927 to 1943. A recipient of the 1973 J. G. Taylor Spink Award, which recognizes a sportswriter "for meritorious contributions to baseball writing," Kieran used this manual Underwood typewriter during his long and illustrious career. Among his favorite topics was Lou Gehrig, about whom Kieran once wrote, "He was there every day at the ballpark bending his back and ready to break his neck to win for his side. He was there day after day and year after year. He never sulked or whined or went into a pout or a huff. He was the answer to a manager's dream."

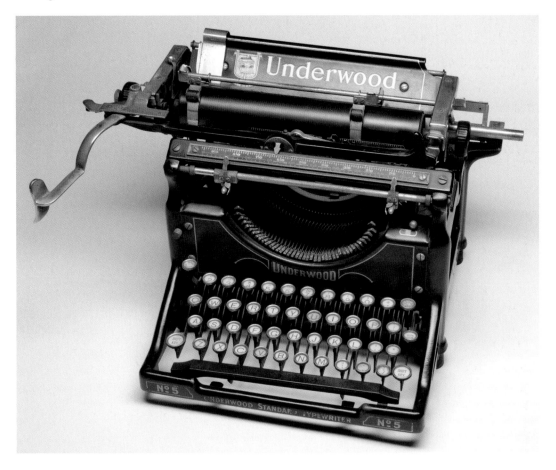

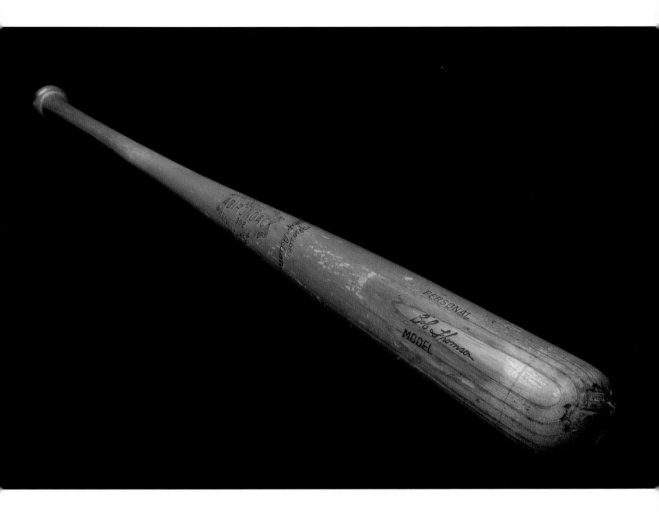

Bobby Thomson "Shot Heard Round the World" Bat

Is there a more famous call in all of sports than Russ Hodges's "The Giants win the pennant, the Giants win the pennant!"? Bobby Thomson used this Adirondack 302 "Flexible Whip Action" bat, made by McLaughlin Millard Inc., to hit his famous "Shot Heard Round the World." It is a personal Bobby Thomson model bat with the number 110 engraved in the barrel. There is a split in the wood grain on the barrel, opposite the name. Thomson hit the famous ninth-inning home run off Ralph Branca at New York's Polo Grounds on October 3, 1951, to propel the Giants over their rival Brooklyn Dodgers into the World Series. It would come to light about a half-century later that the Giants were stealing signs and Thomson hit the home run knowing which pitch was coming.

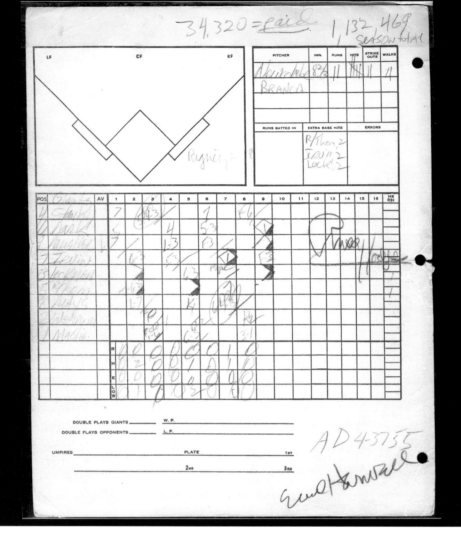

Russ Hodges Scorecard for Bobby Thomson Home Run

Bobby Thomson's dramatic home run to win the playoffs for the New York Giants in 1951 is one of the greatest moments in the game's history. Its fame was further enhanced by Russ Hodges's radio call. Hodges yelled into the microphone, "The Giants win the pennant, the Giants win the pennant, the Giants win the pennant!" Hodges was so excited by developments on the field that he forgot to enter the home run onto his sheet. It is interesting to note that a promising rookie named Willie Mays was due up next, batting seventh that day. He would soon move up in the batting order. Hodges and his radio booth partner Ernie Harwell would later sign this historic document before its entry into the Hall of Fame archive.

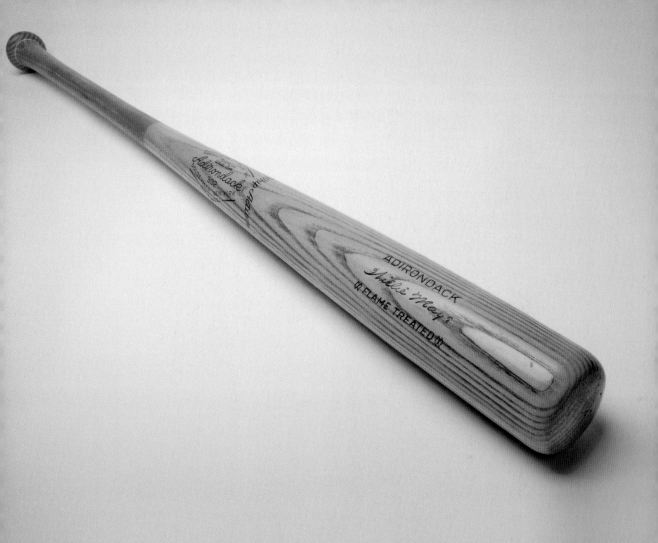

Willie Mays 512th Home Run Bat

Willie Mays admitted afterward that the pressure was getting to him, but when he finally smacked his then–National League record 512th career home run using this bat on May 4, 1966, he was happy to get it over with. "Sure, I was pressing for No. 512. I couldn't get it out of my mind and nobody would let me forget it," he said. "Every day I've been trying to get it over with so I could go back to playing baseball." The historic homer, which broke Mel Ott's Senior Circuit record, helped the San Francisco Giants defeat the visiting Los Angeles Dodgers, 6–1. Facing lefty Claude Osteen with two outs in the fifth inning, Mays sent the first pitch he saw 380 feet over the right-field fence to end a nine-day homerless streak. Mays would finish his career with 660 homers.

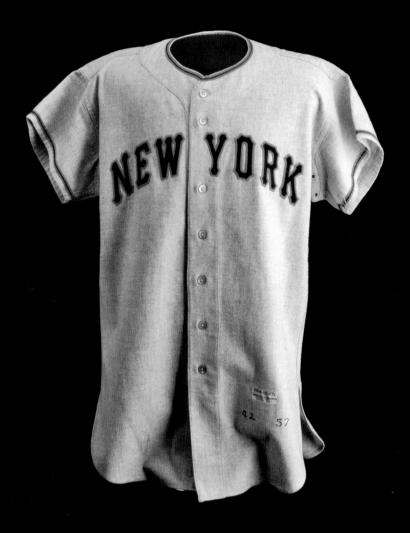

Willie Mays Jersey

The 1957 baseball season was a pivotal one in the game's history, as it was the final opportunity to witness the New York Giants and Brooklyn Dodgers before they began a westward expansion of the major leagues. In his final season calling the Polo Grounds home, Giants center-fielder Willie Mays wore this home jersey while thrilling fans with his five-tool talent. That season, the 26-year-old "Say Hey Kid" led the NL in triples (20), stolen bases (38), and slugging (.626). He also scored 112 runs, knocked in 97, connected for 35 home runs, and batted .333. In fact, Mays became the first National Leaguer to hit 20 or more doubles, triples, and home runs in one season. "He and Joe DiMaggio are the greatest center-fielders I ever saw," said Hall of Famer Frankie Frisch that season. "I would pay money just to see [Mays] play. He brings back the old days for a fellow like myself."

Willie McCovey Jersey and Bat

During a 1980 ceremony honoring Willie McCovey held a few months after he retired as a player midway through the year, the six-foot-four San Francisco Giants first baseman re-marked, "Who said dreams don't come true? When I was a little boy, I constantly dreamed of becoming a major league player. Not only did it come true, but I had the good fortune of living the dream for 22 wonderful years." McCovey wore this Giants home jersey with the familiar 44 in his final big league season, while the bat was used in 1979 to hit his 520th major league home run. When McCovey, one of the few players to appear in four decades, left the game, the former Rookie of the Year (1959), Most Valuable Player (1969), and Comeback Player of the Year (1977) was tied with Ted Williams for eighth on the all-time home run list (521), and he held the National League record for grand slams (18) and most home runs by a first baseman.

Herman Goldberg 1936 Olympic Uniform, Ball, and Ticket

"Baseball—Das Nationalspiel Der Amerikaner." So reads a German magazine headline dating from the 1936 Olympics in Nazi Germany. This jersey was worn by 20-year-old catcher-outfielder Herman Goldberg of Brooklyn, New York. Goldberg was one of a handful of Jewish athletes on the U.S. Olympic team, competing under the lengthening shadow of Adolf Hitler and his anti-Semitic regime. Though he received no ill treatment at the hands of Germans, a great deal of propaganda was given to the visiting athletes. The exhibition intrasquad game was played at night before an estimated 90,000 to 125,000 onlookers at the Olympiastadion, the main Olympic venue in Berlin. The crowd was unfamiliar with the game, so high popups were cheered loudly, while extra-base hits drew little reaction. Mr. Goldberg donated his jersey in 1949. He later served as assistant secretary of education for the United States.

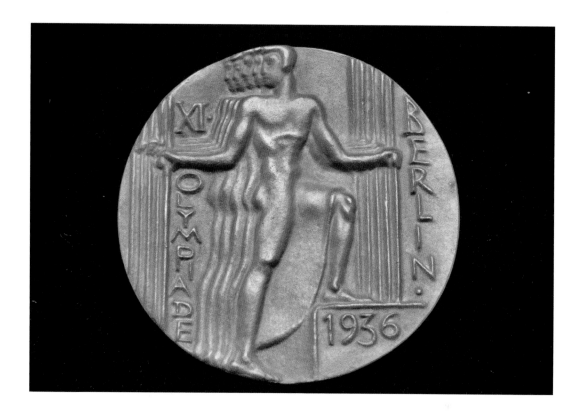

Participation Medal for 1936 Berlin Olympics

Designed by sculptor Otto Placzek, this participation medal was given to members of the two American teams who played a demonstration game of baseball during the 1936 Olympic Games in Berlin. The teams were known as the Olympics and the "Weltmeisters," or "world champions." The medal was donated by the son of coach Harry Wolter, who earned this role by serving as baseball coach at Stanford University for 26 years. Before that, he had played for six teams in the major leagues between 1907 and 1917. Before the game, the players were approached by several German generals, with instructions not to hit the ball toward Hitler's luxury box in right field. "Being Americans," commented one player, "you never saw so many line drives hit to right in warmups." The Weltmeisters won, 6–5.

Moe Berg Presidential Medal of Freedom

Casey Stengel is reported to have said, "Berg can speak eight languages, but he can't hit in any of them." Major league catcher Moe Berg might not have turned his linguistic talents into base hits, but they were of service to his country during World War II when he worked with Wild Bill Donovan and the Office of Strategic Services as an American spy. Berg served in multiple European countries and was deeply involved with espionage activities related to the German atomic bomb program. After the war, Berg transferred to NATO's Advisory Group for Aeronautical Research and Development. He was awarded this Presidential Medal of Freedom in 1946, an honor that has been given to just a few ballplayers, including Hank Aaron, Roberto Clemente, Joe DiMaggio, Stan Musial, Buck O'Neil, Frank Robinson, and Ted Williams. Moe Berg may not be in the National Baseball Hall of Fame, but he is the only player honored in the CIA Hall of Fame.

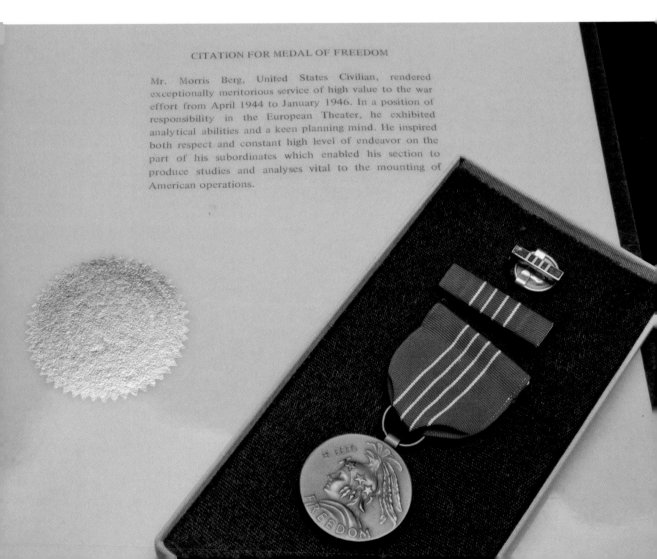

CITATION FOR MEDAL OF FREEDOM

Mr. Morris Berg, United States Civilian, rendered exceptionally meritorious service of high value to the war effort from April 1944 to January 1946. In a position of responsibility in the European Theater, he exhibited analytical abilities and a keen planning mind. He inspired both respect and constant high level of endeavor on the part of his subordinates which enabled his section to produce studies and analyses vital to the mounting of American operations.

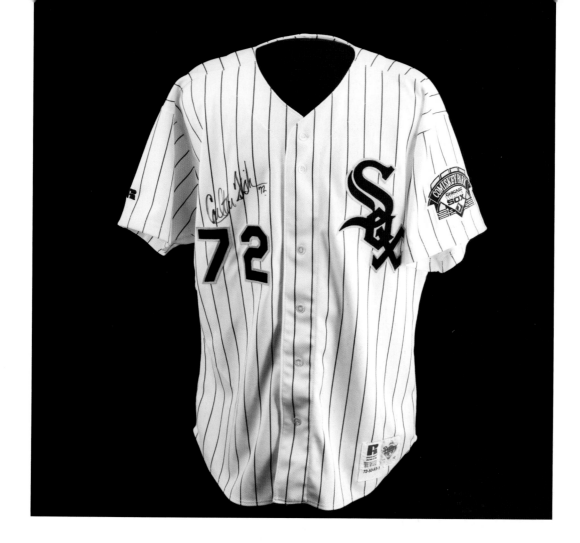

Carlton Fisk Final-Game Jersey

In what would prove to be his final major league game in a distinguished 22-season career, 45-year-old Carlton Fisk of the Chicago White Sox would catch his record-setting 2,226th game on June 22, 1993. Wearing this White Sox home jersey on Carlton Fisk Night, "Pudge," with his wife, children, and parents in attendance, surpassed longtime backstop Bob Boone's mark, established only three years earlier. "To have this happen tonight is beyond words," said Fisk, after playing eight innings in Chicago's 3–2 win over the visiting Texas Rangers. "But it didn't happen by accident. I worked very hard. It doesn't happen like falling out of a tree, but it takes endurance and perseverance. I've been lucky." Another catcher nicknamed "Pudge," Ivan Rodriguez, as a member of the Houston Astros, surpassed Fisk's record for the most games caught in major league history on June 17, 2009.

Ivan Rodriguez Chest Protector

Thanks to his leadership, inspired play both offensively and defensively, and potent arm, Ivan Rodriguez, a 14-time All-Star and 13-time Gold Glove winner, is considered to be one of the top backstops in the National Pastime's long history. " 'Pudge' is going to go down as one of the greatest catchers to ever play," said longtime New York Yankees shortstop Derek Jeter. "We used to play against him, and he basically just shut the running game down. You didn't even think about running on him; there haven't been too many catchers that could change the game like that." I-Rod, who spent a 21-year big league career mainly with the Texas Rangers, wore this chest protector during the 1997 and '98 seasons, a period in which he was in the midst of winning 10 consecutive Gold Glove Awards. By the time he retired following the 2011 season, Rodriguez had played 2,427 games behind the plate, more than anybody in baseball history.

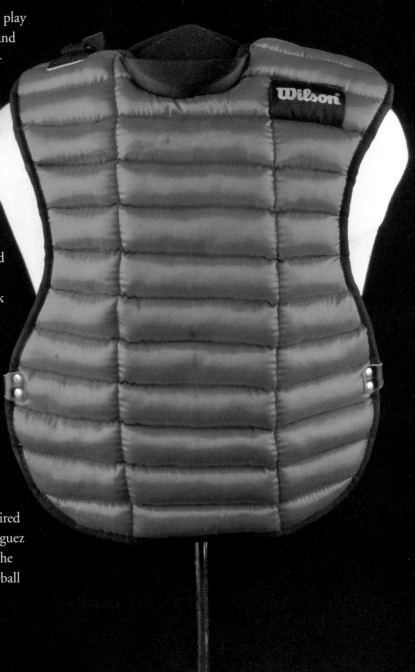

Christy Mathewson Uniform

One of the greatest pitchers in the National Pastime's long history, Christy Mathewson wore this wool/cotton blend jersey during a brilliant diamond career that included 373 victories over 17 big league seasons spent mainly with the New York Giants. Donated by a family friend of Matty's in 1953, with no apparent team logo or markings, it was originally thought to have been worn by "Big Six" during his sandlot days. Recently, a thorough examination discovered markings that showed the jersey once had the felt letters "NY" across the chest. This new information, in addition to the Spalding manufacturer's label, helped pinpoint the jersey as one from 1905, the campaign in which Mathewson led the National League in wins, ERA, shutouts, and strikeouts, as well as tossing three shutouts against the Philadelphia Athletics during the Giants World Series victory.

Miller Huggins Sweater

While he gained fame as skipper of the powerful New York Yankees teams of the 1920s, the five-foot-six Miller Huggins, nicknamed "The Mighty Mite," began his big league career as a heady second baseman with both the Cincinnati Reds and St. Louis Cardinals during the first two decades of the twentieth century. He became a player-manager with the Cards in 1913 and would lead the franchise for five years. "Hug" wore this wool cable-knit sweater, circa 1916, during his time with the team. Eventually he would lead the Yanks to six pennants and three World Series titles. Upon Huggins's untimely death at the age of 51 in 1929, longtime manager of the New York Giants John McGraw said, "There was one great little fellow. A great fighter, but always fair and sportsmanlike. I always entertained the highest regard for Miller Huggins as an able leader and as a man."

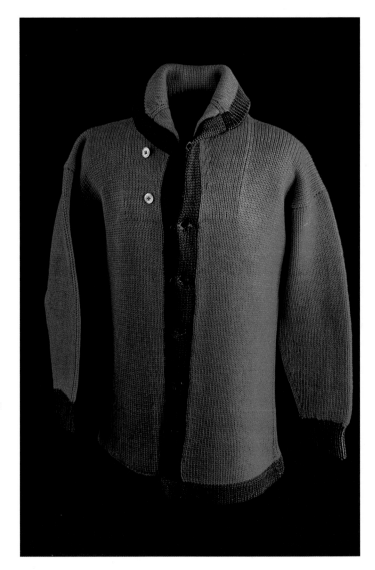

Nellie Fox Jersey

While most of today's big league players sport a uniform with their name emblazoned across the back, the practice first began with the 1960 Chicago White Sox under the direction of enterprising owner Bill Veeck. "I was up at Minneapolis at a basketball game," Veeck recalled. "They had the players' names on warm-up jackets, but not on uniforms. I asked why . . . then it occurred to me that baseball people didn't use names on uniforms." That first season the ChiSox' new experiment took place with only their gray uniforms used on the road, like this jersey worn by Hall of Fame second baseman Nellie Fox. But for some teammates, such as huge first baseman Ted Kluszewski, the new design could prove troublesome: "It's a good thing I've got a good broad back. Otherwise they never would have got all the letters of my name on the shirt."

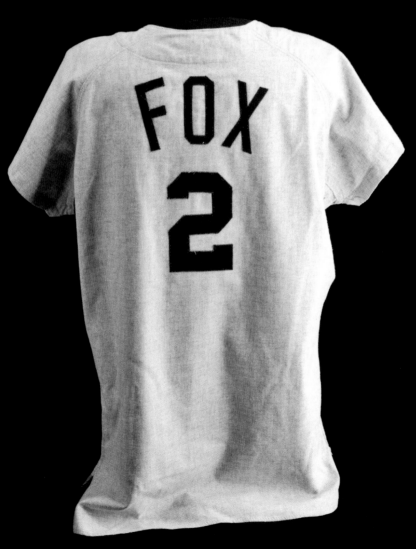

1976 White Sox Uniform with Shorts

While the 1976 Chicago White Sox finished in last place, Bill Veeck, in his second stint as owner of the team, livened things up when he introduced shorts such as this navy blue pair as part of a big league baseball uniform. "I don't have bad-looking legs," said future Hall of Famer Rich "Goose" Gossage when word leaked that the '76 squad might be donning shorts. "If the majority of players went along with wearing them, I suppose I would, too." While collegiate and minor league teams had previously experimented with wearing shorts, Veeck was determined to give it a shot. "Players should not worry about their vanity, but their comfort," Veeck said. "If it's 95 degrees out, an athlete should be glad to put on short pants and forget his bony knees. Hell, I've got a worse-looking knee than most players. It's solid wood." (Veeck did in fact have a wooden leg.) The short-lived experiment would last for only three home games that summer.

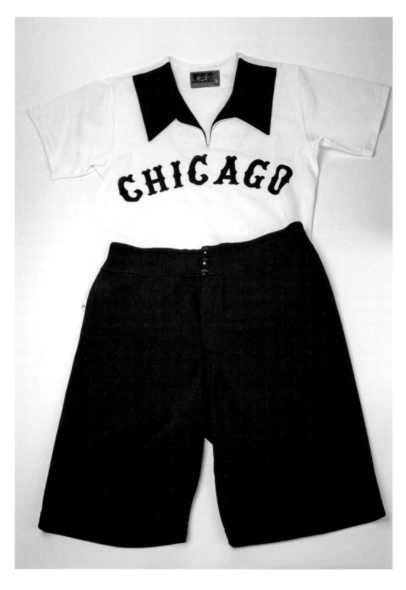

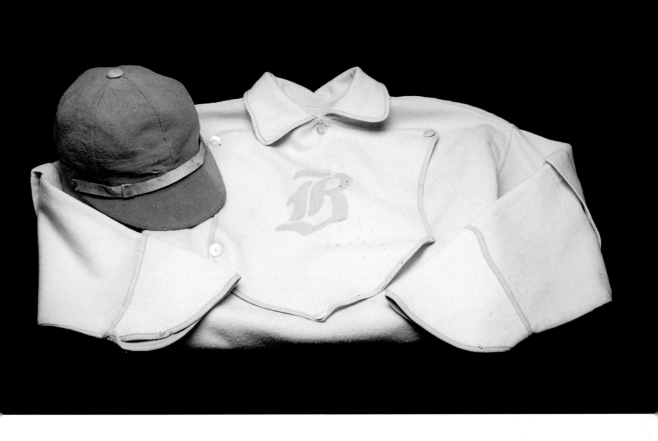

Baraboo, Wisconsin, Uniform

When Legrand Lippitt of the Baraboo (Wisconsin) Base Ball Club donned this uniform in the mid-1860s, he certainly had no idea that his efforts would one day hold a special place in the National Baseball Hall of Fame. Lippitt, a farm laborer, holds no baseball record, nor was he involved in any particularly notable event. Little is known about his skill level, nor do we have a great deal of information about the Baraboo team. Donated by his daughter Alburn in 1939, more than three decades after his passing, this artifact is the oldest baseball uniform known to exist in the Museum's vast collection, and perhaps anywhere. As such, it uniquely represents the earliest days of our National Pastime, an era when the game was played by the common man, a form of recreation that helped develop local pride and camaraderie.

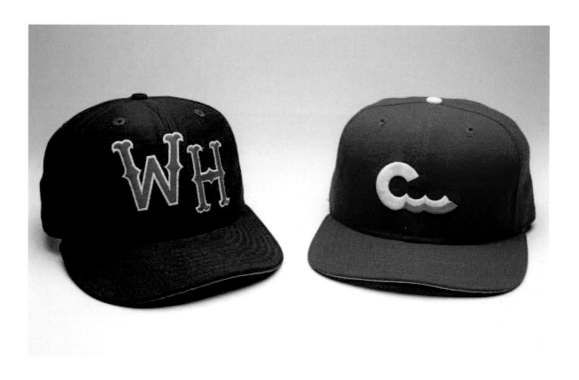

Winter Haven–Clearwater Double No-Hitter Caps

Calling it a pitching duel may not do it justice. Wearing these caps, minor league pitcher Andy Carter of the Clearwater Phillies was able to defeat Scott Bakkum and the visiting Winter Haven Red Sox, 1–0, in the first professional baseball game in four decades without a hit. In the Class A Florida State League game, which took place on August 23, 1992, the only run scored in the seventh inning on a pair of walks and two sacrifice bunts. Carter struck out four, walked two, and hit a batter in nine innings for the win. "It's disappointing to lose," said Bakkum, who whiffed three and walked three in eight innings of work, "but it was a great game. I was happy with the way I pitched. How could I be mad? There were two no-hitters out there."

Tom Seaver and Roberto Clemente Scouting Reports

Tom Seaver's teammate with the 1969 Miracle Mets, Cleon Jones, put it like this: "Tom does everything well. He's the kind of man you'd want your kids to grow up to be like. Tom's a studious player, devoted to his profession, a loyal cat, trustworthy—everything a Boy Scout's supposed to be. In fact, we call him 'Boy Scout.'" Jones almost didn't have the chance to play with him. Seaver was originally signed by the Braves, but Major League Baseball later ruled that he had been signed illegally, and his services were auctioned off in a lottery, which the Mets won. In March of 1965, Tommy Lasorda scouted Tom Seaver for the Dodgers and praised him in his scouting report. In 1952, future Hall of Famer Roberto Clemente, one of the first Latin American players in the big leagues, was scouted and signed by the Dodgers. When Branch Rickey moved from the Dodgers to the Pirates, Pittsburgh was able to acquire Clemente.

SCOUT REPORT Club_____ League_____ Pos. P Age 20
 Hgt. 6 Wgt. 185
Name SEAVER Tom Bats R Throws R
 (Last) (First) (Middle)
Hitting_____ Arm_____
Power_____ Accuracy_____
Running Speed_____ Base Running_____
Fielding_____ Reactions_____
Fast Ball 73 with LIFE
Curve 63 Could improve with Right instructions Aptitude GOOD
Change (F.B.)_____ (Cv.)_____ Aggressiveness GOOD
Control 76 - Attitude_____
Definite Prospect? ✓ "Away"_____ N.P._____
Physical Description (Build, Size, Agility, etc.) Well Built with Good Actions
Remarks: This Boy Showed A Real Good Fast Ball with Good
Life, has Real Good Command of Point of Release.
Boy has Slided Type of Curve But Could improve As
He has Good Arm Action And Should Be Able to Come
up with Good Curve - Boy has Plenty of Desire to
Pitch And Wants to Beat You.
Report By: Tom Lasorda 3/27/65 Date: March 23, 1965

SCOUT REPORT Club SANTURCE League PORTO RICAN Pos. OF Age 18
 Hgt. 5'11" Wgt. 175
Name CLEMENTE ROBERT Bats R Throws R
Arm A+ GOOD CARRY Accuracy A
Fielding A GOOD AT THIS STAGE Reactions A
Hitting A TURNS HEAD - BUT IMPROVING Power A+
Running Speed + Base Running A
Fast Ball_____ Aptitude_____
Curve_____ Aggressiveness_____
Change (F.B.)-_____ (Cv.)-_____ Habits_____
Control_____
Definite Prospect? YES Has Chance?_____ Fill-In?_____ Follow_____
Physical Description (Build, Size, Agility, etc.) WELL BUILT - FAIR SIZE - GOOD AGILITY
Remarks: WILL MATURE INTO BIG MAN.
 ATTENDING HIGH SCHOOL BUT PLAYS WITH SANTURCE.
HAS ALL THE TOOLS + LIKES TO PLAY. A REAL GOOD
LOOKING PROSPECT! HE HAS WRITTEN THE COMMISSIONER REQUEST-
ING PERMISSION TO PLAY ORGANIZED BALL.
Report By: AL CAMPANIS Date: 11/6/52

Tom Seaver Glove from 19-Strikeout Game

Legendary New York Mets pitcher Tom Seaver certainly lived up to his nickname of "Tom Terrific" when he was victorious in a 2–1 two-hitter against the visiting San Diego Padres on April 23, 1970. On the same afternoon he received his 1969 National League Cy Young Award, the 25-year-old right-hander, while sporting this glove on his left hand, struck out 19 before 14,197 cheering Shea Stadium fans to tie the big league record for a nine-inning game while also setting a new mark with 10 whiffs in a row. "When I got a 1-2 count on Al Ferrara in the ninth inning with two out," Seaver said after his 136-pitch masterpiece, in which he retired the last 16 men he faced, "I said to myself, 'Well, I'll never get this close again and I might as well go after it.'" Seaver's 19 strikeouts tied a record that Steve Carlton of the St. Louis Cardinals had set against the Mets the previous year.

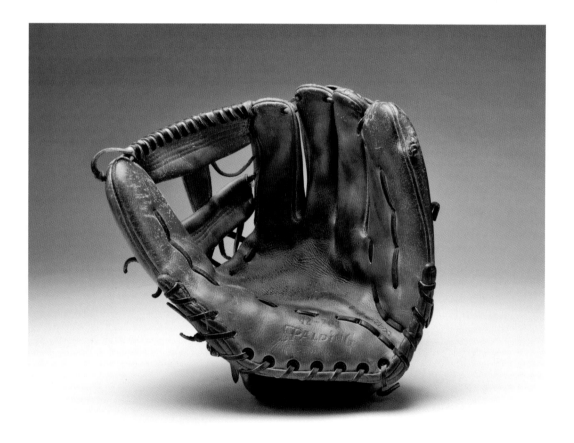

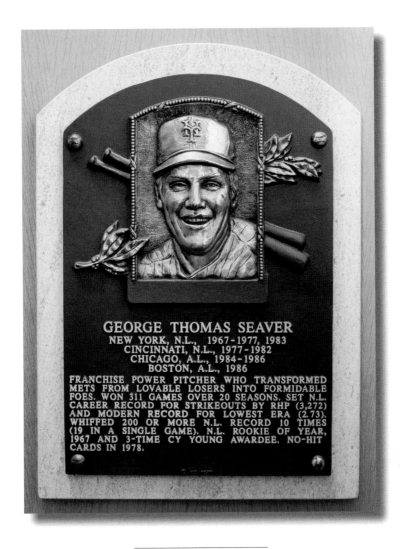

GEORGE THOMAS SEAVER
NEW YORK, N.L., 1967-1977, 1983
CINCINNATI, N.L., 1977-1982
CHICAGO, A.L., 1984-1986
BOSTON, A.L., 1986
FRANCHISE POWER PITCHER WHO TRANSFORMED
METS FROM LOVABLE LOSERS INTO FORMIDABLE
FOES. WON 311 GAMES OVER 20 SEASONS. SET N.L.
CAREER RECORD FOR STRIKEOUTS BY RHP (3,272)
AND MODERN RECORD FOR LOWEST ERA (2.73).
WHIFFED 200 OR MORE N.L. RECORD 10 TIMES
(19 IN A SINGLE GAME). N.L. ROOKIE OF YEAR,
1967 AND 3-TIME CY YOUNG AWARDEE. NO-HIT
CARDS IN 1978.

Tom Seaver Plaque

Since 1983, Matthews International Corporation of Pittsburgh, Pennsylvania, has been the exclusive maker of the Hall of Fame inductee plaques. The company's sculptors begin work within weeks after the new inductees are elected and use photo and video reference to create a clay likeness. Once the likeness is approved, the plaque is crafted and cast in bronze. To preserve the uniqueness of the plaques, only one copy is made, and the molds are destroyed once the finished plaque is accepted by the Hall of Fame. Each plaque is 15.5 inches tall by 10.75 inches wide and weighs 14.5 pounds. The plaque contains the Hall of Famer's likeness and 80 to 100 words of descriptive text. The logo that appears on each Hall of Famer's cap is the Hall of Fame's decision and is based on historical significance.

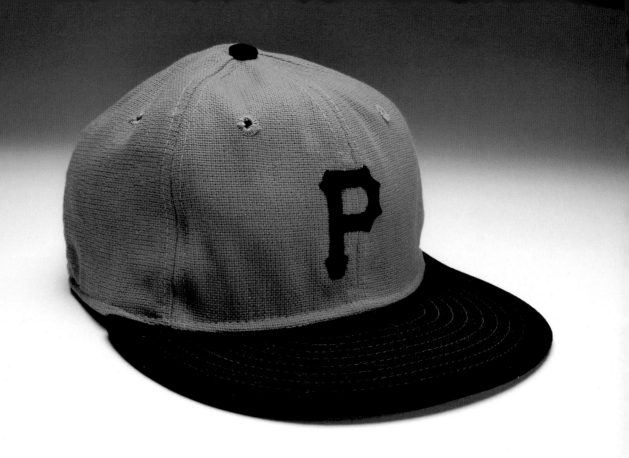

Roberto Clemente Cap

It was the summer of 1972 and nine-year-old Scott MacPherson of Philadelphia was hospitalized, awaiting lung surgery after an ominous shadow was discovered on an X-ray. After a family friend mentioned his situation to members of the visiting Pittsburgh Pirates, Roberto Clemente knew exactly what to do. The story goes that Clemente took the cap off his head and said, "Maybe you can take this to the hospital and it will make him feel better." Young Scott survived his ordeal and the cap took a position of honor in his room. The entire family grieved when Clemente died that winter. MacPherson would donate the cap to the Hall of Fame after a visit in the 1990s, stating, "Roberto Clemente was such a great guy, he died doing such a great thing, so I thought everybody should know this story. It meant a lot to me the way he gave me the hat, but it certainly means a lot to me to know that it's in a place that I think is so great."

Orlando Cepeda 1971 Batting Helmet

"He was one of the toughest hitters I ever faced," said Lew Burdette of Orlando Cepeda, the powerful right-hander who came out of Puerto Rico with a host of other Latino players in the 1950s, all of whom paved the way for the steady stream of talent that now emanates from the Caribbean. A longtime fan favorite who played much of his career with chronic knee pain, Cepeda constructed a Hall of Fame career, earning a Rookie of the Year Award, MVP Award, and seven All-Star selections while playing for six different teams. He wore this helmet while playing with Atlanta toward the end of his 17-year career. As Cepeda said at his Hall of Fame induction, "I am a very lucky person to be born with the skills to play baseball." Anyone who pitched against him would confirm that those skills were put to good use.

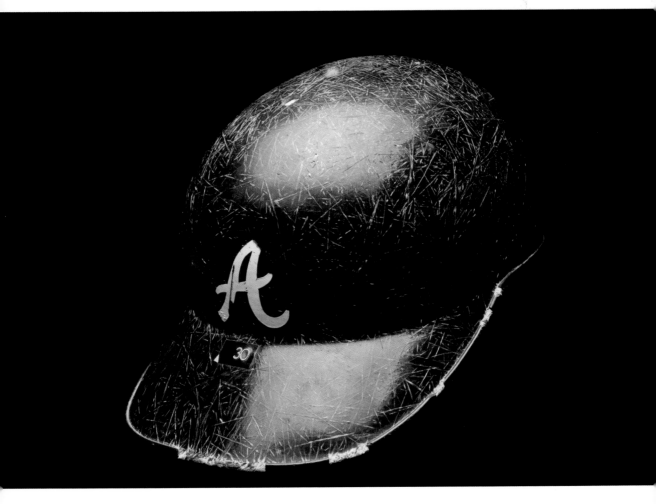

Ray Schalk 1917 World Series Uniform

After beating out the defending American League champion Boston Red Sox for the pennant, the Chicago White Sox faced the New York Giants in the 1917 World Series sporting specially designed red, white, and blue jerseys that featured small American flags on each sleeve and a star-spangled logo in recognition of the country's entry into World War I. This wool home jersey belonged to Chicago's starting catcher, Ray Schalk, a future Hall of Famer who batted .263 in his team's six-game Fall Classic triumph. "It is foolish for a man to say he doesn't feel more nervous in a World Series game than he does in an ordinary day's work," Schalk wrote after the '17 Series was over. "I know I do and will admit it. I don't think I have played as good ball all through the series, as I can play under normal circumstances."

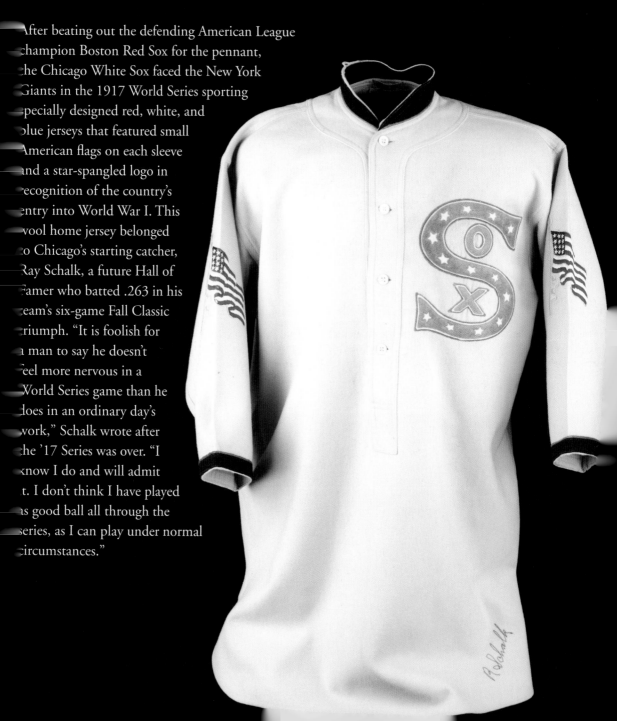

Franklin D. Roosevelt "Green Light" Letter

In the early days of World War II, with the nation wondering what the future would bring, Commissioner Kenesaw Mountain Landis sent a letter of inquiry to President Franklin D. Roosevelt. The letter was short and direct, stating, "Inasmuch as these are not ordinary times, I venture to ask what you have in mind as to whether professional baseball should continue to operate." The president's response came just one day later. FDR made it clear that while many players would be called into service, the game should continue, as it would be in the best interest of the country. Not only would baseball serve as an inexpensive form of recreation for Americans, but it would help take people's "mind off their work even more than be-

THE WHITE HOUSE
WASHINGTON

January 15, 1942.

My dear Judge:-

Thank you for yours of January fourteenth. As you will, of course, realize the final decision about the baseball season must rest with you and the Baseball Club owners -- so what I am going to say is solely a personal and not an official point of view.

I honestly feel that it would be best for the country to keep baseball going. There will be fewer people unemployed and everybody will work longer hours and harder than ever before.

And that means that they ought to have a chance for recreation and for taking their minds off their work even more than before.

Baseball provides a recreation which does not last over two hours or two hours and a half, and which can be got for very little cost. And, incidentally, I hope that night games can be extended because it gives an opportunity to the day shift to see a game occasionally.

As to the players themselves, I know you agree with me that individual players who are of active military or naval age should go, without question, into the services. Even if the actual quality of the teams is lowered by the greater use of older players, this will not dampen the popularity of the sport. Of course, if any individual has some particular aptitude in a trade or profession, he ought to serve the Government. That, however, is a matter which I know you can handle with complete justice.

Here is another way of looking at it -- if 300 teams use 5,000 or 6,000 players, these players are a definite recreational asset to at least 20,000,000 of their fellow citizens -- and that in my judgment is thoroughly worthwhile.

With every best wish,

Very sincerely yours,

Franklin D Roosevelt

Hon. Kenesaw M. Landis,
333 North Michigan Avenue,
Chicago,
Illinois.

fore." This letter giving baseball permission to continue is popularly referred to as "The Green Light Letter," and is among the most historically important documents in the collection.

World War II War Bond Tickets

Ty Cobb likened baseball to war, saying, "I have observed that baseball is not unlike a war, and when you come right down to it, we batters are the heavy artillery." Baseball has had a storied connection to the U.S. military, from Civil War soldiers playing the game during downtime to President Roosevelt's letter authorizing the continuation of Major League Baseball during World War II to Major League Baseball's tributes to the men and women of our armed forces today. During World War I and World War II, to help fund the United States war effort, the government sold securities called War Bonds. During this time, Major League Baseball teams played in exhibitions called War Bond games to help raise money. Some of baseball's most unusual contests were War Bond games, including a rare tricornered baseball game as three teams, the Giants, Dodgers, and Yankees, all competed against each other in one game at the Polo Grounds on June 26, 1944.

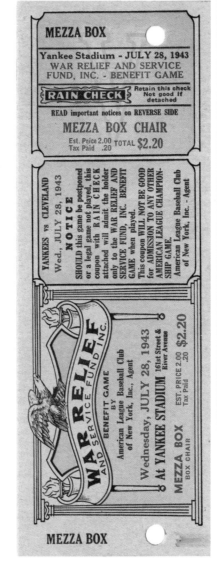

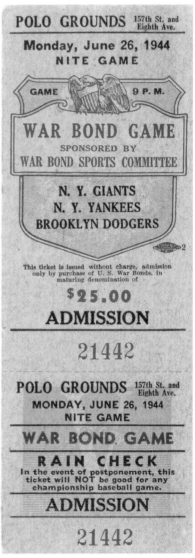

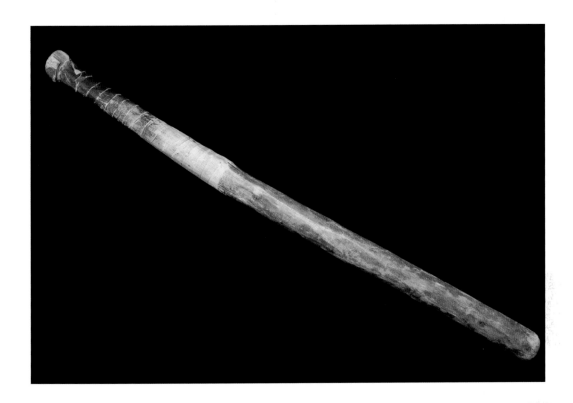

Bad Nauheim Internment Bat

"It's unconstitutional not to play baseball," said Angus Thuermer, who donated this handmade bat to the Hall of Fame. The bat was carved by UPI correspondent Glen Stadler and used by a group of American internees inside Nazi Germany in 1942. Rounded up at the start of the war by the SS, the group of 150 men, women, and children was taken to the former Grand Hotel in Bad Nauheim, Germany, and held for five months before being sent back home. To pass the time, the group developed a four-team baseball league, playing, Thuermer wrote, as "Gestapo guards watched in wonderment." The ball was a champagne cork wrapped in socks and sewn shut with surgical instruments, and the bases were old diplomatic pouches. One of the players was George Kennan, the future architect of U.S. Cold War policy. Thuermer's wife, Alice, encouraged him to donate the bat.

Pete Gray Glove

"War or no war, Gray is a big leaguer. Advise you buy at once." So wrote a scout to the St. Louis Browns management in 1944, after Pete Gray had earned Southern Association MVP honors, batting .333 for the Memphis Chicks, and stealing a league-record 68 bases. This from a natural right-hander who had lost that arm in a truck accident at age six. Gray used this glove as a left- and center-fielder with the Browns in 1945. Gray's fielding technique was a wonder: "I'd catch the ball in my glove and stick it under the stub of my right arm. I'd sort of squeeze the ball out of my glove with my arm and it would roll across my chest and drop to my stomach. The ball would drop right into my hand." Gray would then rifle it in to the infield. He made only seven errors in his one big league season.

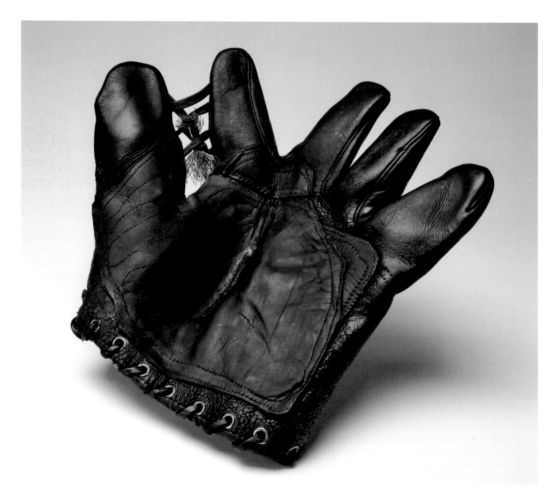

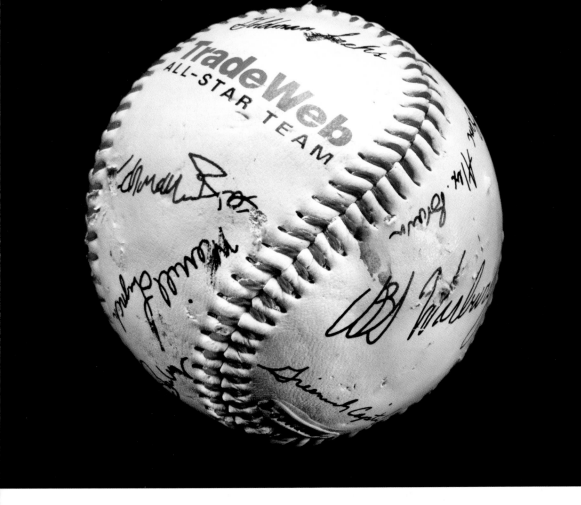

September 11 TradeWeb Baseball

In the shadow of the September 11 tragedies, baseball was instrumental in bringing hope back to the American spirit. During the clean-up of the "Ground Zero" site, a New York City fireman named Vin Mavaro found this "TradeWeb All-Star Team" ball in the rubble. The promotional ball had facsimile signatures from companies that did business with TradeWeb. Mavaro would ultimately return the ball to TradeWeb only to be told to keep it. As luck would have it, all TradeWeb employees made it out of the North Tower alive. "The ball's nicked up, but it's intact and it came through," Mavaro said. "I feel the same about New York City, the Fire Department, and the United States. We're banged up, we took a hit, but we came through."

Curt Schilling 9/11 Cap

"Focus. Just being focused on the task at hand. It's one inning, one out, one pitch at a time. In these situations, it's easier to do when it's the end of the year. This is it. You're playing for all the marbles," says Curt Schilling of pitching. After starting three games in the 2001 World Series in which he went 1–0 with a 1.69 ERA and 26 strikeouts in 21.1 innings, Curt Schilling was named World Series co-MVP with teammate Randy Johnson. In the shadow of the September 11 tragedies, Schilling donned this Arizona Diamondbacks cap. Schilling added his own personal tributes to the cap, writing in white ink NYFD and NYPD on either side of the MLB logo on the rear of the cap. Over the World Series patch on the side of the cap, Schilling wrote "God Bless America."

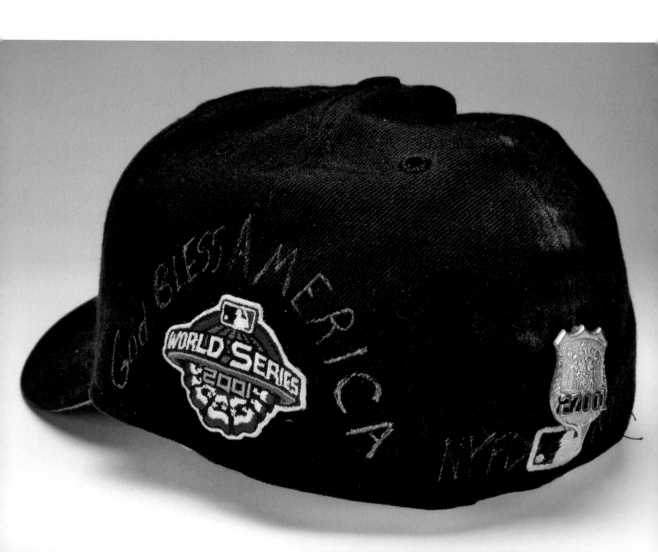

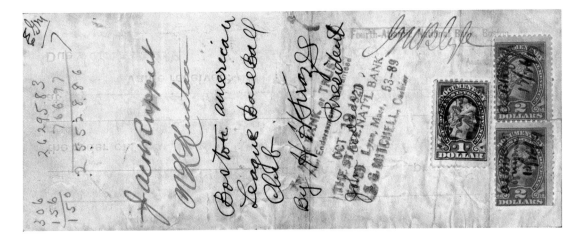

Babe Ruth–Sale Promissory Note

As sportswriter Leonard Koppett once wrote, "When the elements of legend fall into place and the details are fed repeatedly to a public only too eager to believe, nothing can be done to dispel the myth that results." The Curse of the Bambino is firmly embedded in American folklore and an established part of baseball mythology. Any document related to the sale of Babe Ruth from Boston to New York is sure to make Yankee fans smile and Red Sox fans frown (at minimum). This promissory note, dated December 26, 1919, is an essential element to Ruth's legend. Signed by both team owners, Jacob Ruppert and Harry Frazee, notations on the back also include interest calculations and the required five dollars in documentary tax stamps, a revenue-generating device being used by the federal government to help pay for World War I.

Babe Ruth Red Sox–to–Yankees Transfer Agreement

The Curse of the Bambino is a cornerstone of baseball lore and legend. How else to explain the Red Sox' failure to win the World Series for 86 years? One of the game's great franchises, Boston was a five-time World Series champion before the Babe was traded to New York. This document was the formal transfer agreement.

NOTICE—All agreements, whether for the immediate or prospective release of a player, to which a Major League Club is a party, must be forwarded to the Secretary of the Commission for record and promulgation within five days after execution. (See Article V., Section 7, National Agreement, on back of this Agreement.)

UNIFORM AGREEMENT
FOR TRANSFER OF A PLAYER

NOTICE.—To establish uniformity in action by clubs when a player, released by a major league club to a minor league club, or by a minor league club to a major league club, refuses to report to and contract with the club to which he is transferred, the Commission directs the club securing him to protect both parties to the deal from responsibility for his salary during his insubordination by promptly suspending him. Payment, in part or in whole, of the consideration for the release of such player will not be enforced until he is reinstated and actually enters the service of the purchasing club.

TO OR BY A
Major League Club

WARNING TO CLUBS.—Many contentions that arise over the transfer of players are directly due to the neglect of one or both parties to promptly execute and file the Agreement. The Commission will no longer appeals to it to investigate and enforce claims which, if made a matter of record, would not require adjustment. In all cases of this character, the complaining club must establish that it is not at fault for delay or neglect to sign and file the Agreement upon which its claim is predicated. (See last sentence of Rule 10.)

This Agreement, made and entered into this 26th day of December 1919 by and between_____ Boston American League Baseball Club (Party of the First Part)

and _____ American League Base Ball Club of New York (Party of the Second Part)

Witnesseth: The party of the first part does hereby release to the party of the second part the services of Player____ George H. Ruth ____under the following conditions:

(Here recite fully and clearly every condition of deal, including date of delivery; if for a money consideration, designate time and method of payment; if an exchange of players, name each; if option to recall is retained or privilege of choosing one or more players in lieu of one released is retained, specify all terms. No transfer will be held valid unless the consideration, receipt of which is acknowledged therein, passes at time of execution of Agreement.)

By herewith assigning to the party of the second part the contract of said player George H. Ruth for the seasons of 1919, 1920 and 1921, in consideration of the sum of Twenty-five Thousand ($25,000.) Dollars and other good and valuable considerations paid by the party of the second part, receipt whereof is hereby acknowledged.

The parties to this Agreement further covenant to abide by all provisions of the National Agreement and by all Rules of the National Commission, regulating the transfer of the services of a player, particularly those printed on the reverse side of this Agreement.

In Testimony Whereof, we have subscribed hereto, through our respective presidents or authorized agents, on the date above written:

(SEAL)

Witness:_____

BOSTON AMERICAN LEAGUE BASEBALL CLUB

_____ (Party of the First Part)

AMERICAN LEAGUE BASE BALL CLUB OF NEW YORK

Jacob Ruppert Prest (Party of the Second Part)

Corporate name of Company, Club or Association of each party should be written in first paragraph and subscribed hereto. (See Rule 10.)

Club officials are cautioned to carefully read the provisions of the National Agreement and the rules of the National Commission, printed on the back of this Agreement, for their information and guidance.

Babe Ruth Silver Crown

As monarch of the Kingdom of Swat, Babe Ruth was rightly presented with this sterling silver crown in recognition of his record-breaking 1921 campaign. Inside the New York Yankees' clubhouse following the final game of that season's World Series, manager Miller Huggins officiated at the coronation ceremony by placing on Ruth's head the $600 crown presented by admirers. The nine-and-a-half-inch-high token of esteem, inscribed "King Ruth" and engraved with the names of 42 fans, is adorned with 59 baseballs, one for each home run he hit to break his own single-season home run mark of 54 set only one year earlier: nine atop the points, 49 smaller balls around the base, and one ball in relief on the front center. In 1949, the year after Ruth passed away, his estate donated the crown as part of a larger collection.

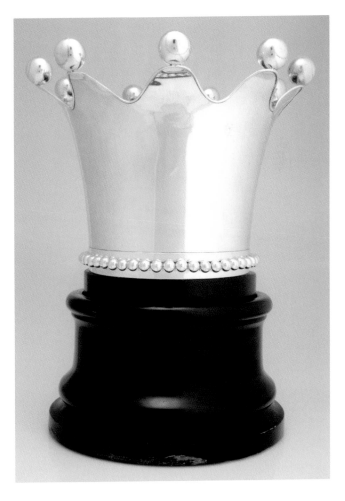

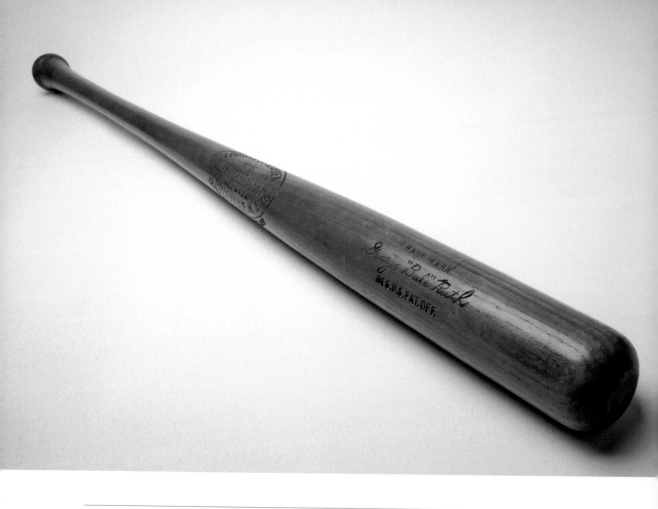

Babe Ruth Signed Bat to President Warren Harding and New York Governor Al Smith

The Babe could do almost anything on the baseball field, but political endorsements proved to be a more daunting challenge. This 33½-inch, 33-ounce Louisville Slugger baseball bat was autographed by Babe Ruth "To President Warren G. Harding April 1923," and "To Governor Alfred E. Smith, June 24 1924." Upon receiving the bat, the governor responded, "I'm going to have a hard time keeping this bat from a couple of boys I know," referring to his two boys, both diehard fans of the Bambino. In 1928 the Babe was asked to join Smith's campaign committee by Franklin D. Roosevelt, chairman of the organization, a request that Ruth eagerly complied with. Ruth's endorsement proved to have minimal impact as Smith lost in a landslide to Herbert Hoover.

Ball Caught by Doug Mientkiewicz to End 2004 World Series

"Back to Foulke. Red Sox fans have longed to hear it. The Boston Red Sox are World Series Champions!" So went the television call on October 27, 2004, when Doug Mientkiewicz gloved the throw from Keith Foulke to end Game 4 of the World Series, ending the franchise's 86-year championship drought. Mientkiewicz celebrated with teammates for 20 minutes before realizing that the historic ball was still in his glove. He asked his wife to put it in her purse for safekeeping. Later, columnist Dan Shaughnessy asked where the ball, which he called "the Hope Diamond of New England sports," was. "I'm glad it ended up where it belonged in the first place," Mientkiewicz noted, of the decision to donate the ball to the Hall of Fame.

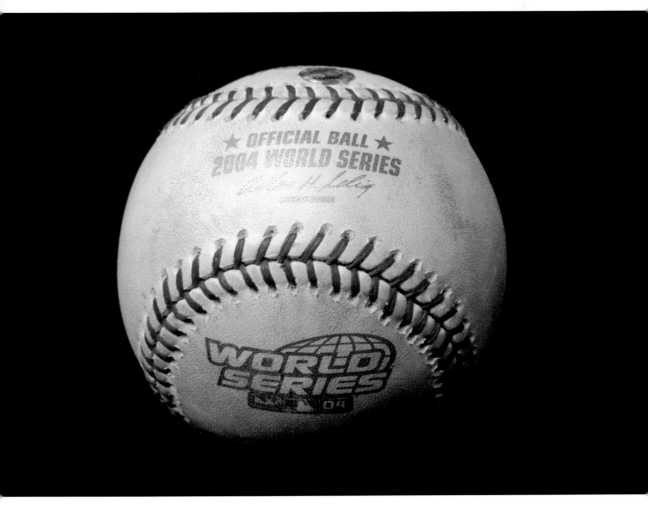

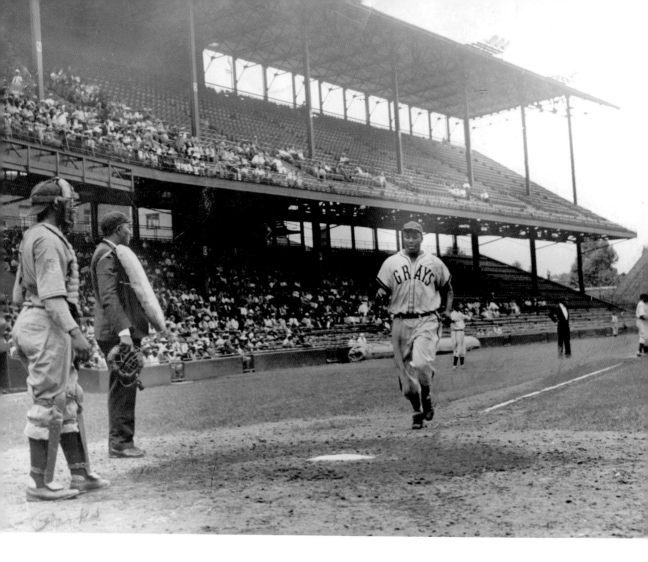

Josh Gibson Heading Home Photo

Josh Gibson heads home after another home run at Washington's Griffith Stadium for the 1942 Homestead Grays. Negro Leagues baseball was not as well-documented as the big leagues, so we will never know Josh Gibson's true career home run total. Called "The Black Babe Ruth," Gibson did hit 107 home runs in 1,825 verifiable Negro Leagues at-bats—along with 100 doubles and 40 triples. His career slugging percentage of .624 would place him fourth all-time, behind Babe Ruth, Ted Williams, and Lou Gehrig—players with whom he did not have the chance to compete. He is reported to have hit .426 against big league pitching during exhibition games, and had a .350 lifetime batting average in the Negro Leagues. Maybe he would have hit more home runs than Ruth in the bigs, as Bill Veeck once noted that Gibson was "at minimum, two Yogi Berras."

Hank Aaron MVP Award

Though he would go on to play for two more decades, Hank Aaron won his lone National League Most Valuable Player Award in 1957. Only 23 years old at the time, and in his fourth big league season, the Milwaukee Braves outfielder led the majors with 44 home runs and 132 RBI, while his .322 average was the fourth best in the Senior Circuit. "This has been a big year for me, but winning this award is the biggest thrill of my life," said Aaron upon receiving the award. "It kinda puts a fellow on the honor roll permanent like, doesn't it?" In one of the closest Baseball Writers' Association of America votes ever, "Hammerin' Hank" edged out St. Louis Cardinals star Stan Musial and Braves teammate Red Schoendienst. Aaron's year also included a pennant-clinching home run on the way to Milwaukee's first-ever World Series title.

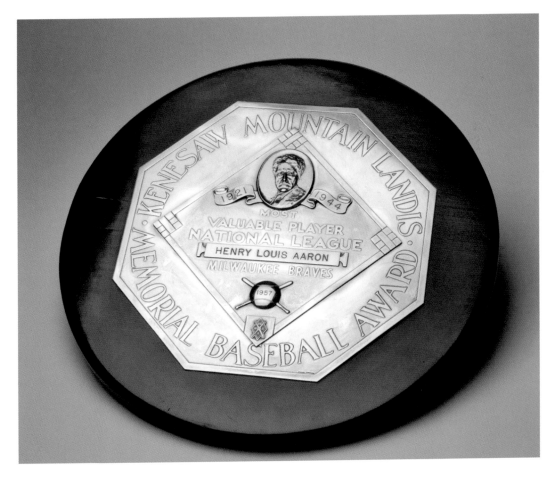

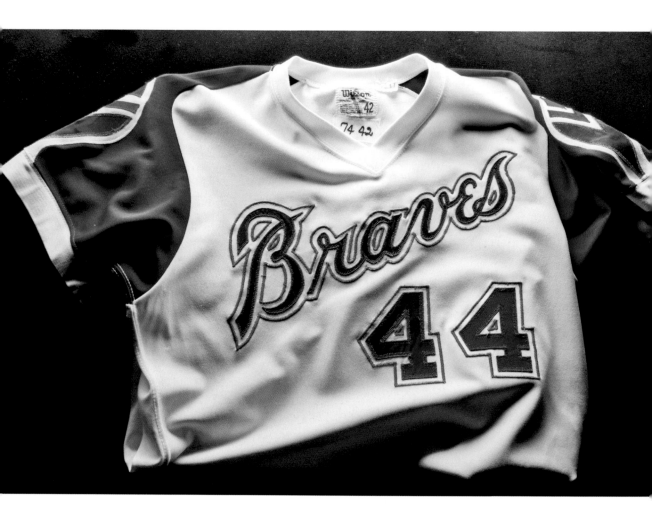

Hank Aaron 715th Home Run Jersey

"There's a drive into left-center field . . . that ball is gonna be . . . outta here! It's gone! It's 715! There's a new home run champion of all time, and it's Henry Aaron!" This call, from 1992 Ford C. Frick Award winner Milo Hamilton, has become embedded in the minds of millions of baseball fans over the last four decades. When he passed Babe Ruth's 714th home run, Hammerin' Hank broke a record that some thought would stand for all-time. He connected for his 715th off Al Downing on April 8, 1974, while wearing this Wilson size 42, white pull-over, Atlanta Braves number 44 jersey. Aaron is one of only three major leaguers to top the 700-home-run mark.

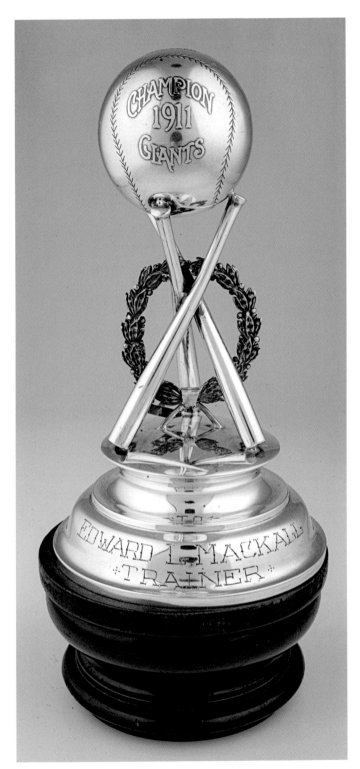

Trophy Given to Giants Black Trainer Ed Mackall

When he eulogized trainer Ed Mackall in 1922, New York Giants manager John McGraw "broke down from emotion and cried like a child," reported the *Chicago Defender*. Mackall had been with McGraw since 1899, when, as manager of the Baltimore Orioles, McGraw lured him away from his position as athletic trainer at Johns Hopkins University. A "colored" man, Mackall "possessed unusual skill in treating the physical ailments of the baseball players and a peculiar knack of working out the sore kinks from high-priced pitching arms of the twirlers on the Giants team." When the Giants won the 1911 pennant, each member of the team was given a trophy like this one. It appears likely that McGraw took his own trophy, had it engraved to his friend, and presented it to him. Mackall's funeral was attended by the entire Giants team, as well as many other players. "To them," wrote Frank Graham in the *New York Sun*, "he was not only trainer, but guide, philosopher, and friend."

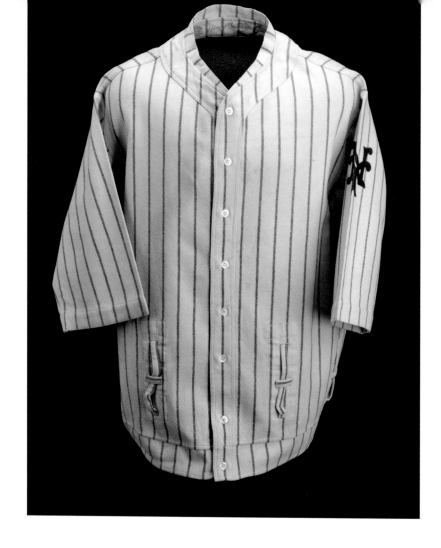

John McGraw Jersey, circa 1915

"There has been only one manager, and his name is John McGraw," said Connie Mack, "the Tall Tactician," of baseball's "Little Napoleon." For McGraw, the game was simple: "Learn to know every man under you, get under his skin, know his faults. Then cater to him—with kindness or roughness as his case may demand." McGraw took this philosophy and, through force of character, used intimidation, fear, kindness, and encouragement to win 2,763 games during his 33 years at the helm, mostly with the New York Giants. McGraw wore this jersey while displaying his genius in New York, whose National League franchise captured ten pennants and three World Series titles during his tenure. As stated by Grantland Rice, "His very walk across the field in a hostile town was a challenge to the multitude." Perhaps McGraw summed it up best when he said, "There is but one game and that game is baseball."

Christening Bottle from Liberty Ship *John J. McGraw*

World War II provided for the greatest expansion of shipbuilding that mankind had ever seen. Along with the increase in ship numbers, shipwrights saw vast improvements in construction technologies. For the Allied forces, one of the greatest symbols of wartime industrial improvements was the Liberty Ship, a mass-produced cargo vessel that kept the troops supplied throughout the war. Between 1941 and 1945 over 2,750 Liberty Ships were built, vessels that would sail to every corner of the world. Each ship was given a name, and any group raising more than $2 million in War Bonds could submit a proposal. This christening bottle, broken across the bow when a new ship was launched, is for the SS *John J. McGraw,* which joined the fleet in 1943. Americans chose to honor our National Pastime by including several Hall of Fame inductees on the list of Liberty Ships, such as the SS *Lou Gehrig* and SS *Christy Mathewson.*

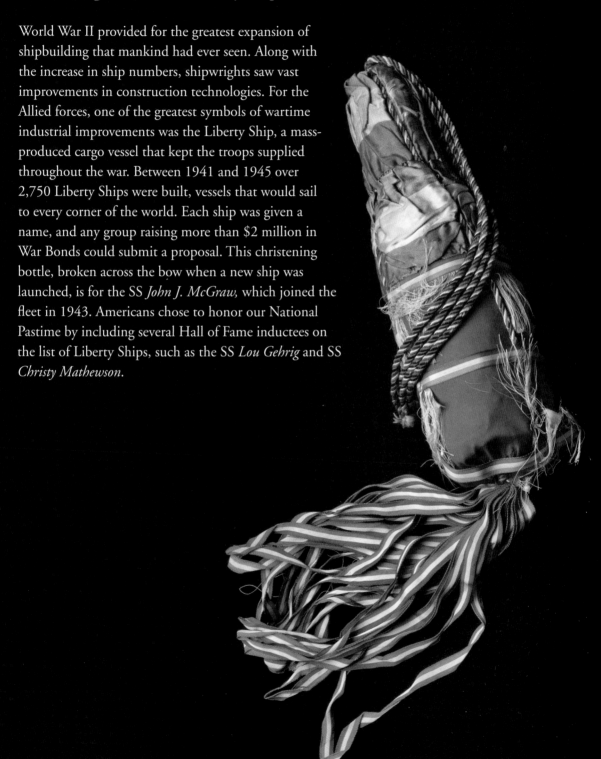

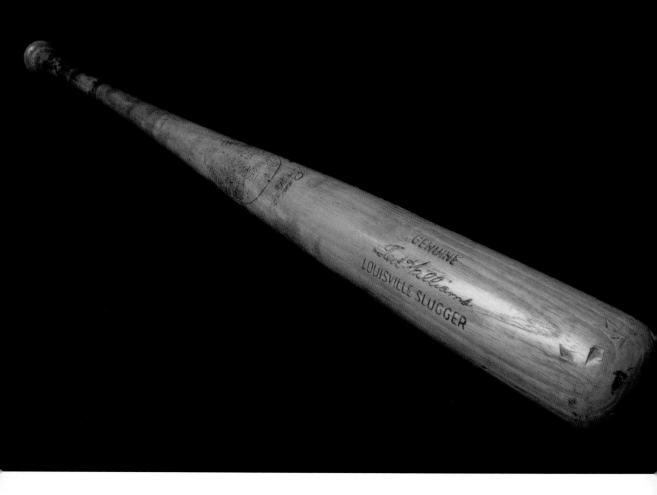

Bat Used by Ted Williams for His 521st and Final Home Run

"We Want Ted," chanted 10,454 Fenway fans after Williams used this bat to club a solo home run to deep center field in what would prove to be the last at-bat of his storied career on September 28, 1960. Williams batted with eloquence in 1960, hitting homers in his first at-bat of the season and in his last. Along the way, he passed the 500 mark and moved past Mel Ott into third place all-time, behind only Babe Ruth and Jimmie Foxx. He also hit .316 at age 42. In a remarkable essay on the game, John Updike wrote of Williams's refusal to respond to the chants, tip his cap, or take a curtain call despite a long ovation. After the game, it was announced that Williams would not accompany the team to its final series, in Yankee Stadium. Updike closed by addressing Williams's decision: "So he knew how to do even that, the hardest thing. Quit."

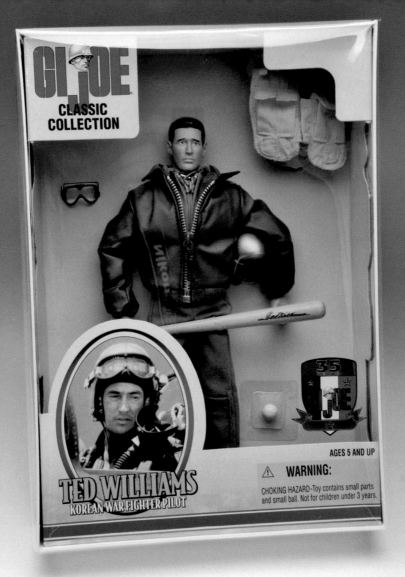

Ted Williams Action Figure

Ted Williams was an American hero. The last player to hit .400 in a season, Williams served in both World War II and the Korean War as a fighter pilot. Vin Scully remarked upon Williams's death, "It was typical of him to become a Marine Air Corps pilot and see action and almost get shot down. He was a remarkable American as well as a remarkable ballplayer." Former player and manager Lloyd McClendon pondered what Williams's career numbers would have looked like had he not lost time serving in two wars, saying, "He is a man who lost five years of service time serving his country. What he could have done with those years in the prime of his life . . . it would be awesome to really put those numbers together. He would have probably been the greatest power hitter of all-time." In 1999, the year he was chosen for Major League Baseball's All-Century team, Hasbro produced a 12-inch action figure of Williams wearing a Korean War fighter pilot's uniform.

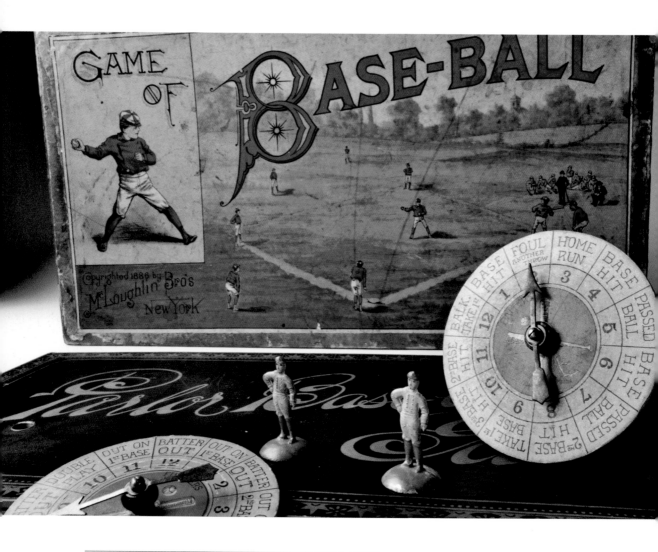

Baseball Board Game—Game of Base-ball

Since baseball's earliest days, fans have been clamoring for ways to take America's pastime off the ballfield and home with them. Regardless of available technology, or lack thereof, fans have passionately searched for ways to simulate the game. In 1886, the McLoughlin Brothers, one of the most important early game manufacturers, produced the Game of Base-ball. This game was innovative in that it used two spinners instead of one, providing the players with a more realistic experience. It was also unique in that it was the only McLoughlin game to include metal figures to represent the players. Due to its uniqueness and the all-around sturdiness of the game, there were more copies of this game saved than others of the era.

The "Live Oak Polka" Sheet Music

The "Live Oak Polka," published in 1860, was Rochester, New York's answering salvo in a battle of civic pride fought on the baseball field between the ball clubs of Buffalo and Rochester, beginning in the late 1850s. Player J. Randolph Blodgett of the Niagara Base Ball Club of Buffalo had written baseball's first song, "The Base Ball Polka," in 1858, impishly dedicating it to the Flour City Base Ball Club of Rochester. Rochester's Live Oak Base Ball Club responded with its own anthem two years later, written by local music professor John H. Kalbfleisch, for whom the piece was also known as Opus No. 7. The cover of the "Live Oak Polka" is considered one of the most beautiful and significant lithographic illustrations of baseball during the Civil War era. Buffalo had the Eries and the Niagaras, and Rochester the Flour City, the Live Oak, the University, and the Lone Star clubs. Crowds as large as 2,500 were observed attending games in Rochester locations such as Franklin Square, Jones Square, and the university campus.

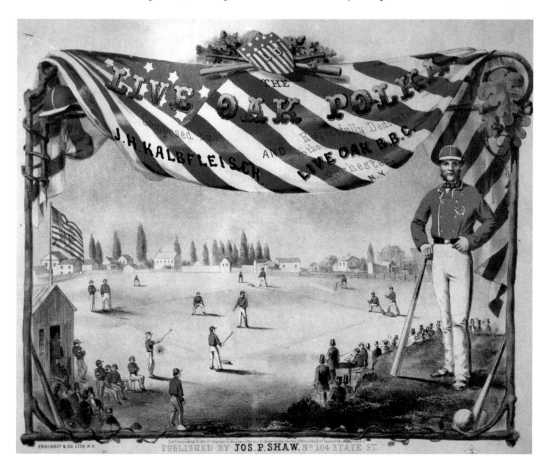

Cy Young Trophy

Boston Red Sox pitcher Cy Young was celebrated with a benefit game before a home crowd on August 13, 1908. With almost 20,000 fans packing the Huntington Avenue Baseball Grounds, the Red Sox took on a team made up of players from other American League squads. Not only did the 41-year-old Young walk away with the proceeds from the gate, an estimated $6,000, but he was presented with a pair of floral arrangements, a travel bag, and three loving cups, including this one given by the players of the American League. "Yesterday's demonstration at the American league baseball park in honor of 'Cy' Young, the incomparable pitcher, was something more than a gathering of enthusiastic lovers of the great American game," reported the *Boston Daily Globe*. "It was indicative of the widespread public esteem in which Mr. Young is held for qualities which, while contributing in so great a degree to the success of the ballplayer, are the foundation of the character of the man and the citizen."

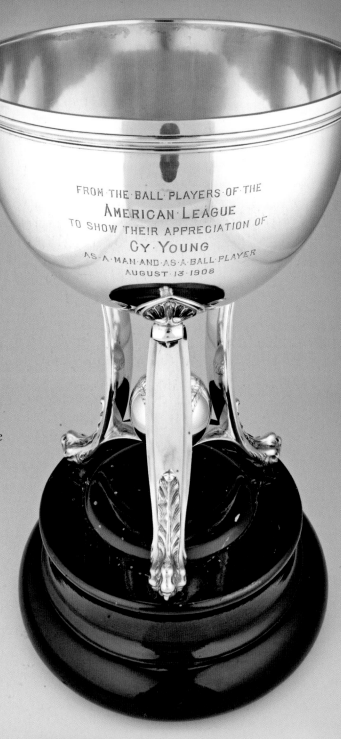

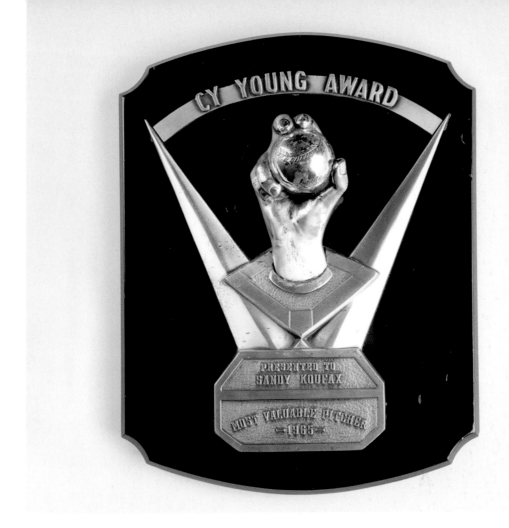

Sandy Koufax Cy Young Award

Thanks to a 1965 regular season in which he led the majors with 26 wins, 27 complete games, eight shutouts, a 2.04 ERA, and 382 strikeouts—the most in a single season since the pitching distance increased to 60 feet 6 inches in 1893—Los Angeles Dodgers southpaw Sandy Koufax was presented by unanimous vote this Cy Young Award. "To have this kind of a year and win this sort of an award after wondering at times last spring whether I'd be able to pitch once a week or at all, it adds up to the most gratifying season I've ever had," said the 29-year-old Koufax, who was suffering from an arthritic elbow at the time that would ultimately end his career one year later. For "Dandy Sandy," this would be his second of three Cy Young Awards, an honor established in 1956 and presented to only a single big league pitcher until 1966, when it was awarded to the best pitcher in each league.

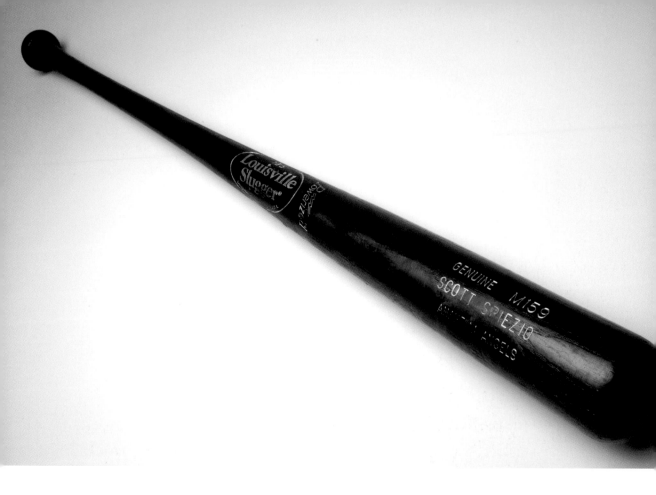

Scott Spiezio 2002 World Series Bat

With an excited Rally Monkey on the video scoreboard and the pulsating sound of ThunderStix reverberating throughout Edison Field, Anaheim Angels first baseman Scott Spiezio used this bat to pull a three-run, seventh-inning home run into the right-field corner off San Francisco Giants reliever Felix Rodriguez in Game 6 of the 2002 World Series. Spiezio's clutch hit, coming on a 3-2 count with the Angels down 5–0, was the start of what became a thrilling 6–5 victory, the biggest comeback in Fall Classic history for a team facing elimination. "I didn't know it was gone when I hit it," Spiezio said afterward. "I was praying. I was saying, 'God, please just let it go over the fence.' It seemed like it took forever. It wasn't perfect, but I got enough of it to get it to go out." The Angels would win Game 7 to capture the first World Championship in franchise history.

World Series Rally Monkey

"Ultimately, the Rally Monkey is the belief that we can come back," stated Angels entertainment manager Peter Bull during the 2002 playoffs, in which the Angels did just that, coming from behind in all three rounds against the Yankees, Twins, and Giants. In the World Series, the Angels trailed three games to two after a 16–4 drubbing in Game 5. Returning home for the final two games, the Angels were down 5–0 in Game 6. But with the assistance of the Rally Monkey, they came back to win the final two games—and the franchise's first World Series Championship. The Rally Monkey was born in June 2000, when, trailing late in a game, scoreboard operator Dean Fraulino played some footage from *Ace Ventura, Pet Detective,* which featured a monkey jumping up and down and the words "Rally Monkey." The Angels went on to win, and a new tradition took hold. Soon, fans could buy their own officially licensed Rally Monkey in the ballpark.

Bill Mazeroski 1960 World Series Helmet and Bat

It is the dream of every kid who's ever grown up in America: to hit a game-winning home run in the bottom of the ninth inning of Game 7 of the World Series. Until October 13, 1960, no kid had ever seen his dream come true. Then Bill Mazeroski stepped to the plate, leading off the ninth with his Pirates and the visiting Yankees tied at 9–9. Mazeroski swung at the second pitch from Ralph Terry and lined it over Yogi Berra and the left-field wall, then completed a joyful romp around the bases, waving his batting helmet in his hand. On the way to the locker room, Mazeroski gave the helmet to home plate umpire Bill Jackowski, who donated it to the Hall of Fame in 1989. Mazeroski donated his bat the same year.

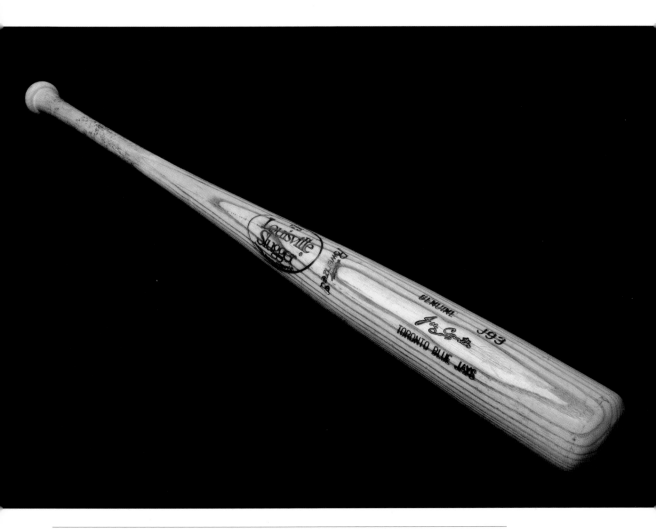

Bat Used by Joe Carter for Home Run to Win 1993 World Series

"This is the biggest day in my career. When I hit the ball, it went through the lights, so I lost it for a while. I wasn't sure if it would be out. These are the kinds of moments you dream about." Indeed, every kid in America dreams about hitting a home run to end the World Series, but only two men have ever done it—Bill Mazeroski in 1960 and Joe Carter in 1993. Carter had ended the 1992 World Series as well, catching a ball at first base to give Toronto—and Canada—its first World Championship. The only thing that could top that thrill was blasting a line drive home run to win the Series. Said Carter, "They haven't made that word up yet to describe what the feeling is. After the ball went over the fence, it's something you can't believe."

Craig Counsell World Series–Winning Shoes, 1997

Young Craig Counsell, playing in just his 70th major league game, scored the winning run in the bottom of the 11th inning as the Florida Marlins beat the Cleveland Indians to win the World Series. Counsell was wearing these shoes when he registered the run all kids dream about, the game-winner in extra innings in Game 7 of the World Series. Four years later, as a member of the 2001 Arizona Diamondbacks, Counsell would again figure in a World Series–winning rally in the seventh game. "To have won two World Series, to have played in two Game Sevens of World Series . . . you realize you are blessed for sure," said the spunky Counsell, who played 16 years in the big leagues, for the Rockies, Marlins, Dodgers, Diamondbacks, and his hometown Milwaukee Brewers. The versatile Counsell played over 500 games at second, over 400 at shortstop, and over 300 at third base.

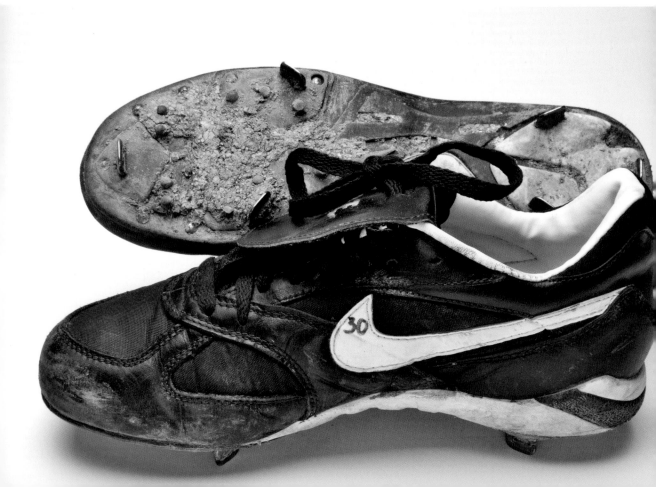

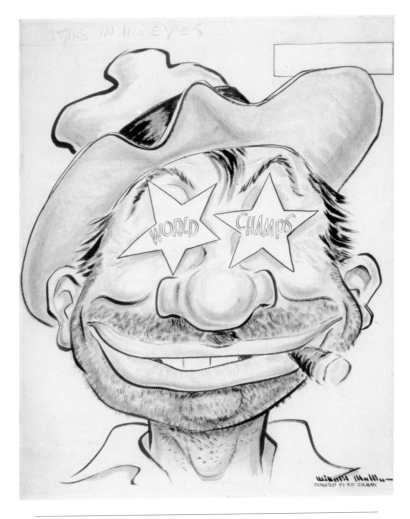

Willard Mullin 1955 "Stars in His Eyes" Cartoon

In 1937, *New York World Telegram* cartoonist Willard Mullin hopped into a cab outside Brooklyn's Ebbets Field, and the driver asked, "How did our Bums do today?" In an instant, the lovable Brooklyn Bum was born. He would become the face of the franchise, appearing on Dodger yearbooks and other publications. Mullin drew over 10,000 sports cartoons in a career that spanned from the 1920s to the 1970s. The Bum epitomized the Dodgers—who often won the pennant but could never beat the Yankees in the World Series—until 1955, when this image was drawn in the wake of Brooklyn's seven-game Series victory. Mullin was an eight-time winner of the Sports Cartoonist Award from the National Cartoonists Society, and in 1954 won the organization's highest honor, the Reuben Award as cartoonist of the year. Upon his retirement in 1971, the NCS named him Sports Cartoonist of the Century.

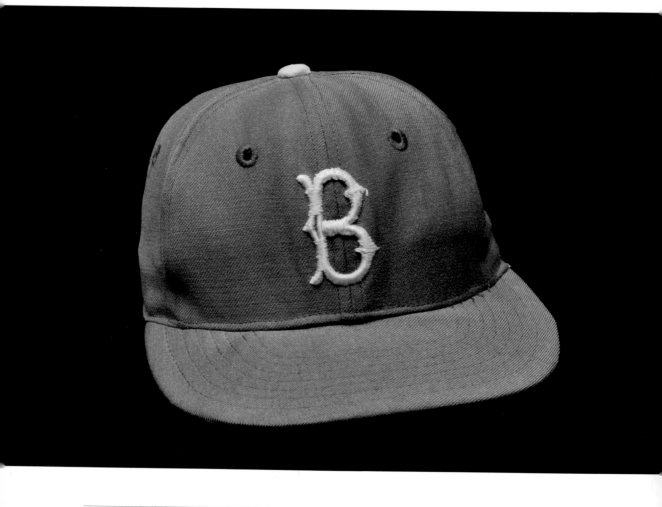

Jackie Robinson World Series Cap

The Brooklyn Dodgers were the best team in the National League in 1941, 1947, 1949, 1952, 1953, and 1955. The exciting "Bums" teams featured Pee Wee Reese, Carl Furillo, Duke Snider, Gil Hodges, and Roy Campanella in the field, and Ralph Branca, Don Newcombe, Carl Erskine, and Johnny Podres on the mound. These colorful characters were beloved in Brooklyn, even though in nearly every one of those years they lost a subway series to the New York Yankees. The exception was the 1955 Series, when the boys from Brooklyn finally got it done, beating the Yankees in seven games, including the finale at Yankee Stadium. When the Dodgers won, fans stormed the field, and one of them picked Robinson's cap off the ground. He wrote to Robinson a few days later, offering to return the cap, but Jackie wrote back and told him it was his to keep. The fan later gave it to the Hall.

Roy Campanella World Series Bat

On October 5, 1955, legendary baseball columnist Shirley Povich wrote, "Please don't interrupt, because you haven't heard this one before. Brooklyn Dodgers, champions of the baseball world. Honest." It was Brooklyn's first World Series Championship after falling short in 11 previous appearances in the Fall Classic, including five to the Yankees. Roy Campanella, winner of the National League Most Valuable Player Award that season, used this Hillerich & Bradsby Louisville Slugger model C188 bat in the Fall Classic. Campanella clubbed two home runs and drove in four, including three in the pivotal Game 3. Peter Vecsey wrote about the day the Dodgers finally won: "In Brooklyn that day, it was the Liberation of Paris, Vee Jay Day, New Years Day all rolled into one."

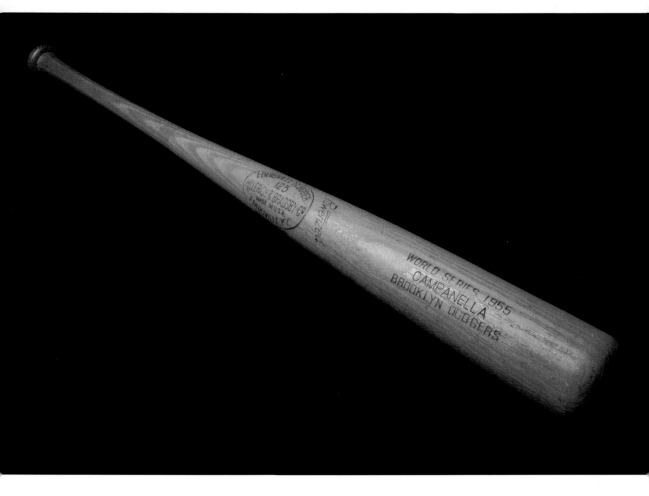

Yogi Berra Catcher's Mitt

There have been just 23 perfect games to date in the history of Major League Baseball, but only one has happened during the World Series. In the 1956 Fall Classic, Don Larsen, who had only 30 major league victories at the time, hurled perfection and became a legend by beating the Brooklyn Dodgers in Game 5 by the score of 2–0. The game was played before 64,519 fans, although many more now claim to have been in attendance. Hall of Famer Mickey Mantle later called it "the biggest game I've ever played in." Larsen's catcher was Hall of Famer Yogi Berra. At the time, Berra, at age 31, was in the prime of his career. Yogi wore this catcher's mitt during the 1956 World Series, including the historic perfect game.

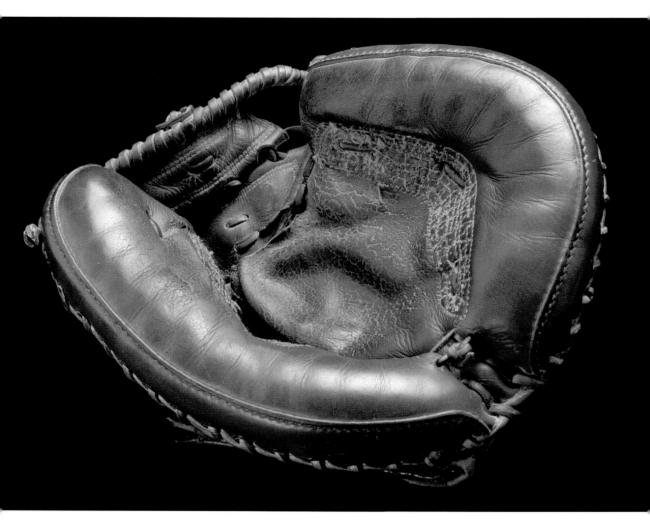

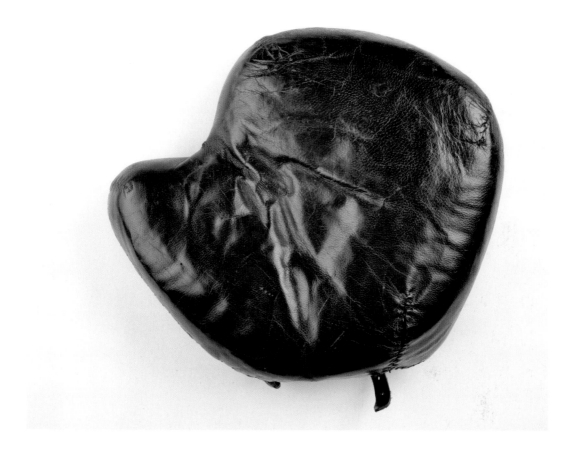

Joe Gunson First Catcher's Mitt

Early baseball catchers had a nearly impossible job—catching swift tosses without the benefit of any hand protection. Accordingly, they began wearing gloves during the 1860s and 1870s. But they didn't wear mitts (short for mittens) until the 1880s. At first, catchers wore identical gloves on both hands, cutting the fingers off from the throwing hand to get a better grip on the ball. Joe Gunson, catcher for the Kansas City Blues of the Western Association, had a tough situation early in the season of 1888—he had a split finger and a doubleheader the next day. So Gunson built himself a mitt—later seeking a patent unsuccessfully, due to the fact that other catchers were also innovating mitts at the same time. Gunson gave this prototypical mitt to the Hall of Fame in 1939.

Fred Thayer Catcher's Mask

Fred Thayer, the captain of the Harvard baseball team, designed this first catcher's mask around 1876, basing it on masks worn by Harvard's fencers. The first catcher to wear the mask was either Henry Thatcher, in 1876, or his successor as Harvard backstop, James Tyng, in 1877. Whoever was first, the mask quickly caught on throughout the baseball world. Amateur players adopted the mask before professionals, a fact commented upon by writer Henry Chadwick: "Plucky enough to face the dangerous fire of balls from the swift pitcher, they tremble before the remarks of the small boys of the crowd of spectators, and prefer to run the risk of broken cheek bones, dislocated jaws, a smashed nose or blackened eyes, than stand the chaff of the fools in the assemblage."

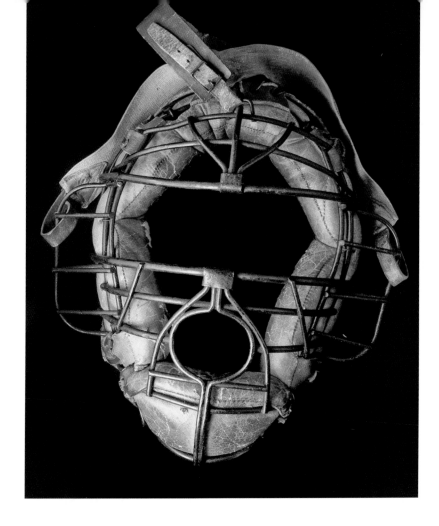

Mickey Cochrane Catcher's Mask

Catcher Mickey Cochrane was a fiery player who had few peers when it came to the mechanics of working behind the plate. A career .320 hitter in 13 big league seasons with the Philadelphia Athletics and Detroit Tigers, he played on five pennant winners and three World Series championship teams before a 1937 beaning ended his career prematurely. This circa 1933 catcher's mask belonged to the two-time American League MVP backstop nicknamed "Black Mike" due to his fierce competitive spirit. "This day, the A's got beat in 15 innings," recalled umpire Bill McGowan. "They lost the game when a kid shortstop booted a ball. Everybody was leaving the field except Cochrane. He stood there throwing his mask into the dirt. I told him to calm down. Mickey said, 'Nuts! What kind of players are they bringing into this league? He boots a ballgame away and he ain't even mad about it.'"

Inflatable Chest Protector

Hall of Fame catcher Bill Dickey coined the phrase "tools of ignorance" to refer to the shin guards, helmet, mask, mitt, and chest protector that a catcher needs to wear. Catchers' gear has evolved greatly from the addition of turn-of-the-century chest protectors to the 1990s introduction of the hockey goalie–style catchers' masks. This inflatable chest protector, circa 1905, was manufactured, primarily out of rubber and canvas, by the Spalding Sporting Goods company and was used by Ira Bush, a member of the Wilbur Feds semipro team.

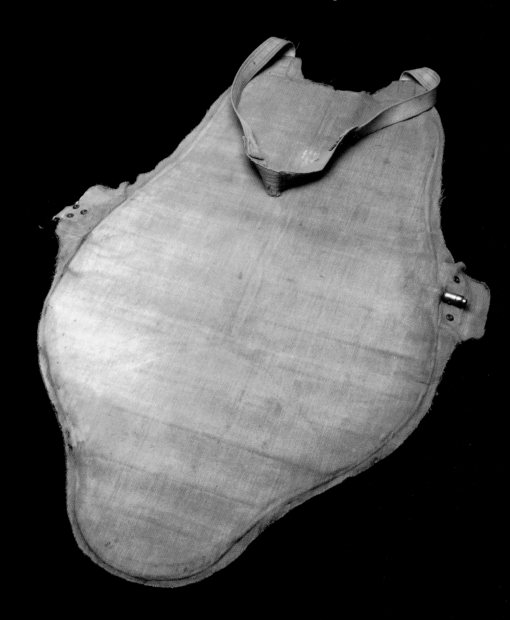

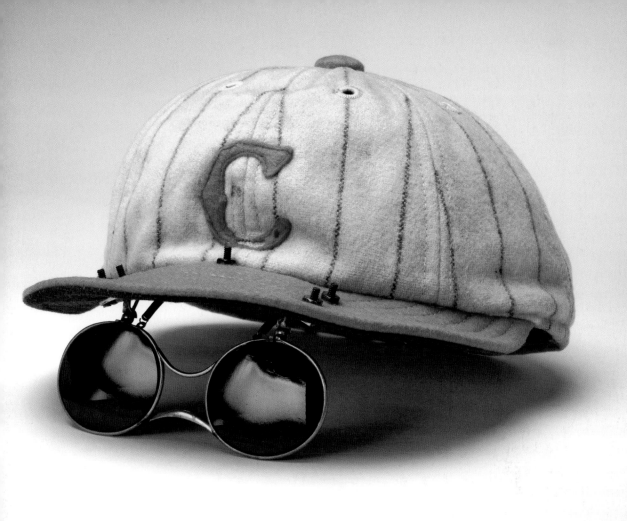

Edd Roush Sunglasses and Cap

Longtime teammate Heinie Groh said of Edd Roush, "He was far and away the best outfielder I ever saw." Roush was a terrific batter, baserunner, and fielder who patrolled center field, primarily for the Reds and Giants in the 1910s and 1920s. Roush led the Reds to their first World Series Championship in 1919, the infamous "Black Sox" Fall Classic. In describing his motivation, Roush said, "I didn't expect to make it all the way to the big leagues; I just had to get away from those damn cows." This white Reds baseball cap, with sunglasses attached, was worn by Roush during his final season in the major leagues, 1931.

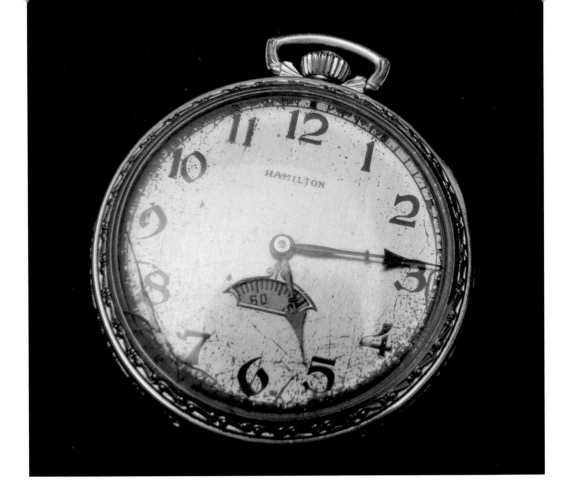

Hank Greenberg MVP Watch

Detroit Tigers first baseman Hank Greenberg was one of the game's most powerful hitters throughout the 1930s and into the mid-1940s. In 1935, in only his third season as a regular, the 24-year-old was presented this white gold pocket watch by *The Sporting News* in recognition of his being named the American League's Most Valuable Player by the St. Louis–based publication. As a result of Greenberg's hard-hitting campaign, in which he led all of baseball with 170 RBI, tied for the lead in home runs with 36, and finished with a .328 batting average, the Motor City star joined Babe Ruth (1923) and Carl Hubbell (1933) as only the third player to receive first-place selections from all eight voting committee members. Greenberg would help the Tigers capture the 1935 World Series title.

Hank Greenberg's War Department ID Card, 1944

Captain Henry Greenberg served in the military twice. He was drafted by the army in 1941, hitting two homers in his final game before induction. He served honorably until December 5, when he, along with other soldiers above the age of 28, was released due to his age. After the bombing of Pearl Harbor, he reenlisted, volunteering to serve in the Army Air Corps. In 1944, he requested an overseas assignment, and was sent to India and China with a group of B29 Superfortress bombers. He homered in his first game back with the Tigers in July 1945, and then hit a grand slam to clinch the pennant on September 30 of that year. Greenberg, a hero to his fellow Jewish Americans, once said, "When I hit a home run, I felt that I was hitting it against Hitler."

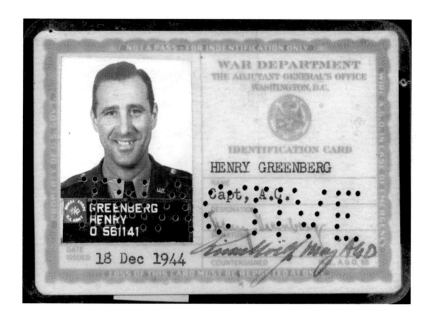

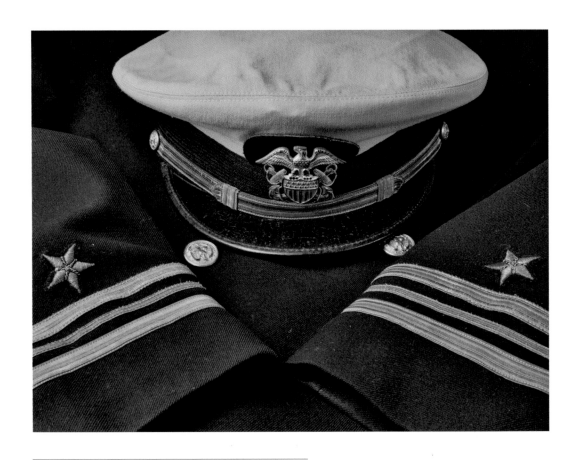

Charlie Gehringer Navy Jacket and Cap

Satchel Paige called Charlie Gehringer the best white hitter he ever faced, and Lefty Gomez said, "He hits .350 on opening day and stays there all season." There was no questioning Gehringer's ability or integrity on the field. Ty Cobb remarked of the quiet, no-nonsense player, "He'd say hello at the start of Spring Training and good-bye at the end of the season, and the rest of the time he let his bat and glove do all the talking for him." Gehringer was also no-nonsense off the field and, like many of his contemporaries, served his country in World War II. In the United States Navy from 1943 to 1945, he wore this U.S. Navy dress jacket and cap, donated to the Hall of Fame by Mrs. Charlie Gehringer in 1997.

Civil War Baseball Lithograph

Although baseball wasn't invented by future Civil War hero Major General Abner Doubleday in Cooperstown, New York, in 1839, baseball still has a connection to the Civil War. This lithograph, by Otto Boetticher, depicts Union prisoners of war playing a game of baseball in Salisbury, North Carolina, in 1863. At the time, baseball was still a few years away from becoming a professional game, but it was already on its way to becoming our National Pastime, and to pass the time between battles, soldiers sometimes engaged in the sport.

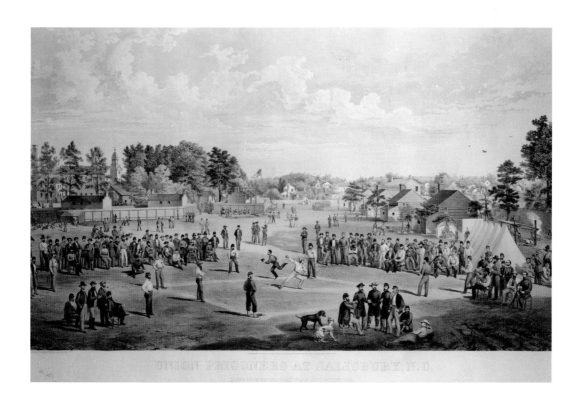

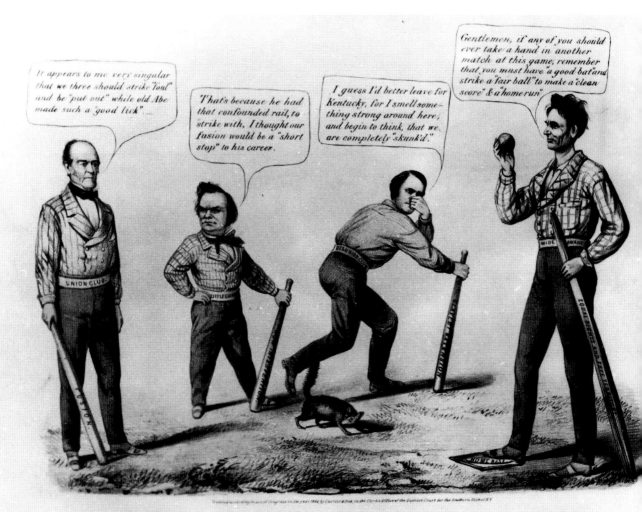

THE NATIONAL GAME. THREE "OUTS" AND ONE "RUN".
ABRAHAM WINNING THE BALL.

Abraham Lincoln Lithograph

The Great Emancipator. Illinois Rail-Splitter. Father Abraham. These are some of the terms used to describe Abraham Lincoln, the sixteenth president of the United States of America. This pro-Lincoln Currier & Ives political cartoon titled "The National Game. Three 'Outs' and One 'Run.' Abraham Winning the Ball" was published in September 1860 and uses baseball's terminology as a metaphor for the upcoming presidential election. It features Lincoln, Union Party candidate John Bell, Northern Democratic Party candidate Stephen Douglas, and Southern Democratic Party candidate John Breckenridge.

Currier & Ives Lithograph

In January 2012, historian John Thorn stunned the baseball world by changing our understanding of one of the icons of early baseball imagery. This 1866 Currier & Ives lithograph is titled "The American National Game of Base Ball: Grand Match for the Championship at the Elysian Fields, Hoboken, N.J.," and is one of the most popular and most often reproduced images of nineteenth-century baseball. It was thought to have depicted an 1865 match between the Atlantic Club of Brooklyn and the Mutual Club of New York. Thorn showed that the teams depicted in the lithograph did not properly match any game played at the Elysian Field that year and stated, "It turned out to be something else entirely: a fantasy game, one that the baseball world desired but that never was played." Thorn, who is Official Historian to Major League Baseball, noted wryly, "As such, it would be history's first instance of fantasy baseball."

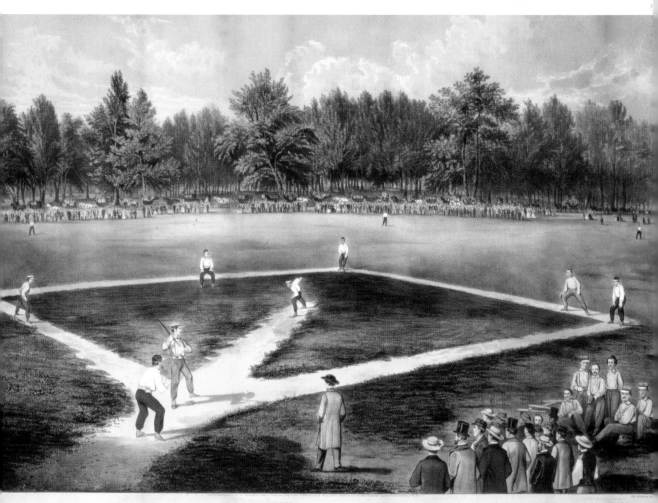

THE AMERICAN NATIONAL GAME OF BASE BALL.
GRAND MATCH FOR THE CHAMPIONSHIP AT THE ELYSIAN FIELDS, HOBOKEN, N.J.

Edith Houghton Japanese Tour Jersey

"I guess I was born with a baseball in my hand. I enjoyed it more than anything." So said centenarian Edith Houghton recently, reflecting on a long and varied career in baseball. Houghton wore this jersey while touring Japan with the all-girls Philadelphia Bobbies team in 1925, at the tender age of thirteen. The Bobbies took their name from the hairstyle popular in the 1920s, and ranged up and down the mid-Atlantic, playing both men's and women's teams for much of that decade. Houghton had joined up at age 10. She later played for a number of other women's teams, and scouted for the Philadelphia Phillies after World War II service in the Waves—where she played baseball, of course. The Japan tour lasted from September to December 1925, and featured games against Japanese collegiate men's teams—and though records are spotty, the Bobbies posted a 3–2 record in games for which the outcome is known.

Annabelle Lee Peoria Redwings Uniform, 1950 Season

It was many years ago, that Annabelle "Lefty" Lee grew up in a baseball-loving family in California. Her father, Bill, played in the Pacific Coast League with the Hollywood Stars, and her mother played softball. Her nephew, Bill Lee, also a lefty, pitched 14 seasons for the Red Sox and the Expos. Annabelle, named after an Edgar Allan Poe poem that her dad loved, played from 1944 to 1950 in the All-American Girls Professional Baseball League as a pitcher and first baseman. She wore this uniform in 1950 while a member of the Peoria (IL) Redwings. She also played for the Minneapolis Millerettes, for whom she pitched the league's first perfect game; the Fort Wayne (IN) Daisies; and the Grand Rapids (MI) Chicks. Her nephew remembers her fondly as "the woman who taught me to pitch." The knuckleball pitcher and switch-hitter was poetry in motion, compiling a career ERA of 2.25.

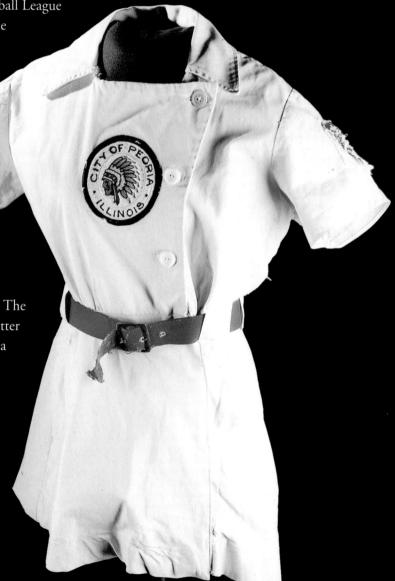

Suitcase Used by Vivian Kellogg of the Fort Wayne Daisies, 1944–50

"Whenever we got to a town, we would do the laundry. Actually, we just lived out of a suitcase, but it was fun!" said Vivian Kellogg, first baseman for the Fort Wayne Daisies from 1944 to 1950. "Kelly" carried this suitcase for seven years, through long road trips, spring training journeys across the South, even a training trip to Cuba. A steady cleanup hitter and fine fielder, Vivian hit a lot of doubles and drove in a lot of runs. She spent her first season with the Minneapolis Millerettes, where poor attendance led the team to abandon its home ballpark for the second half of the season, earning the nickname "Orphans," before moving to Fort Wayne the next year.

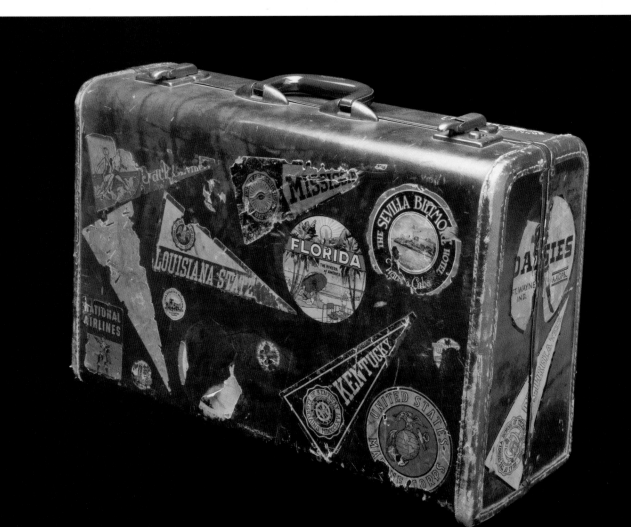

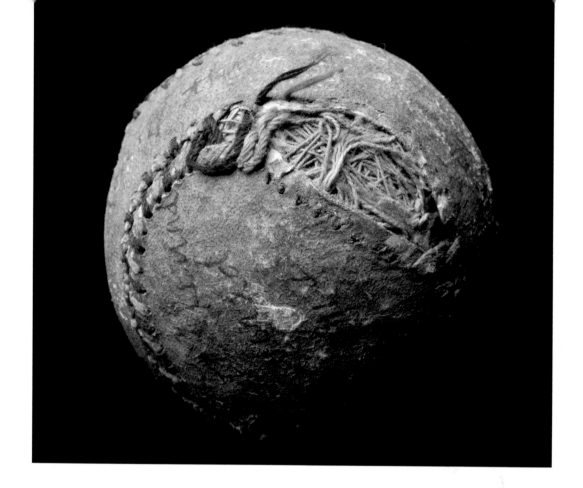

Ted Sullivan World Tour Ball

In the fall and winter of 1913–14, a world tour to spread the gospel of baseball among foreign nations that lasted nearly five months took place with members of the Chicago White Sox and New York Giants. After a barnstorming tour of America, which began in mid-October, a group of 67 players, officials, and wives left for Japan on November 19. By the time the traveling party arrived in New York City on March 6, having visited five continents and 13 countries, it had traveled some 38,000 miles. Along with the players, this ball made the entire trip, thanks to Ted Sullivan, a former big league player and manager who, as a White Sox employee, was managing director of the tour. "If we can carry out our missionary program," said White Sox owner Charles A. Comiskey, "in 10 or 20 years we may have a real World's series in which all the nations of the world can enter teams. The game has the backbone to make it live and be popular wherever introduced."

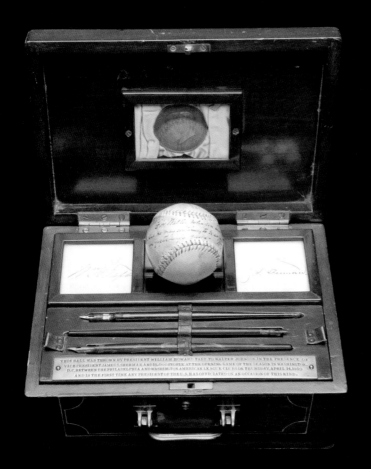

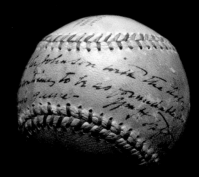

Presidential First-Pitch Baseball

Opening Day in 1910 combined two things that were relatively new and innovative but that we consider commonplace in modern Opening Day festivities—presidents and film. In an era before the commissioner, league presidents were baseball's top authority figures, and American League president Ban Johnson invited United States president William H. Taft to attend Opening Day in Washington to throw out the ceremonial first pitch. This marked the initiation of what is now an honored American tradition. It was also one of the first instances of the event's being captured on film, a relatively new technology. This inscribed ball was thrown by President Taft to Washington Senators pitcher Walter Johnson, who kept it in a decorative box as part of his personal collection. It was later donated to the Hall of Fame by members of his family.

Giant Glove Worn by Nick Altrock

Nick Altrock played 19 seasons in the major leagues, and was a dominant left-handed pitcher for three of them, from 1904 to 1906, with the White Sox, winning 62 games. He helped his team defeat the heavily favored Cubs in the 1906 World Series. But inside the heart of this ballplayer there lived another passion—for clowning, pantomime, and comedy. As his playing career waned, Altrock began clowning in the coaching box and during pregame events, and took on a succession of gifted partners, including Germany Schaefer and Al Schacht. Altrock and Schacht worked together as clowning coaches for the Washington Senators from 1919 to 1933, developing 150 different hilarious pantomime routines, which were great for the Senators' attendance. The pair also appeared frequently on the vaudeville stage. Altrock used this giant baseball glove to lampoon the sport he loved, and donated it to the Hall of Fame in 1961.

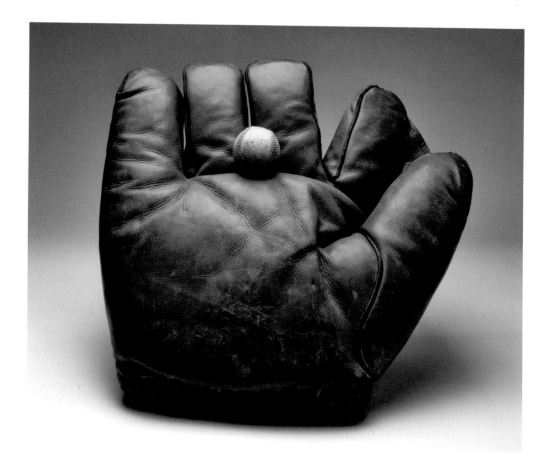

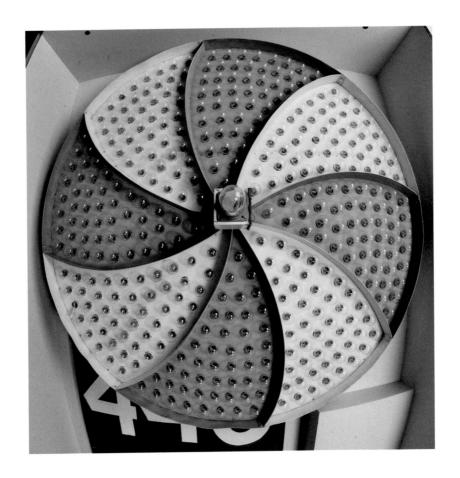

Comiskey Park Pinwheel from Exploding Scoreboard

"The best promotional gimmick I have ever come up with has been the exploding scoreboard at Comiskey Park." So said White Sox owner Bill Veeck, the greatest showman the game of baseball has ever known. Inspired by a scene in a William Saroyan play where a man hits a tremendous jackpot on a pinball machine, Veeck's scoreboard, installed in 1960, was a riot of color, sound, fireworks, and smoke. Veeck felt that the home run had become so commonplace that it needed to be celebrated. The scoreboard's pinwheels never lit up or spun exactly the same way. In fact, they did not spin at all, only giving that appearance by the use of moving lights, but along with the fireworks emanating from ten mortars, every home run was a joyous event. Sometimes it even played music from a huge speaker system, blasting out the *William Tell Overture* or the "Hallelujah Chorus" from Handel's *Messiah* after a White Sox home run, in what Veeck described as "glorious" and "a thing of sheer exultation."

The ageless pitching marvel Satchel Paige wore this jersey for the St. Louis Browns in 1952. Paige was an All-Star that year, for the first time, at the age of 46. Paige went 12–10, tying Bob Cain for the team lead in victories, while posting an ERA of 3.07. Most of his appearances were in relief—he led the league in games finished, and earned 10 saves. In six starts, he pitched three complete games and two shutouts. No other major league teams would sign Paige due to his age, but owner Bill Veeck knew that he could still pitch—he'd been a key contributor on Veeck's Cleveland Indians World Championship team of 1948. After one more year with the Browns, Paige pitched in Triple A from 1956 to 1958, and again in 1961. He made a final major league appearance with the A's in 1965, and pitched his last game in the Carolina League in 1966—forty-one years after he threw his first professional pitch.

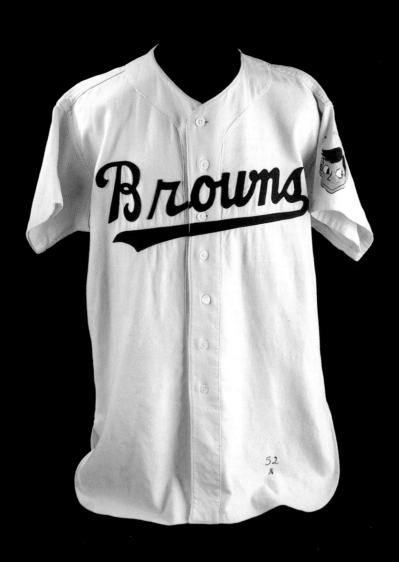

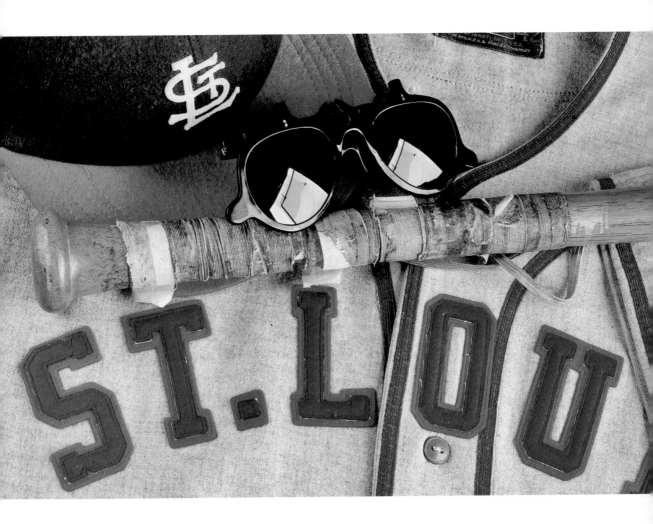

Cool Papa Bell Sunglasses, Cap, Jersey, and Bat

According to Satchel Paige, "If Cool Papa had known about colleges or if colleges had known about Cool Papa, Jesse Owens would have looked like he was walking." Although hyperbole was the mainstay in Paige's narrative on Negro Leagues baseball, it is no exaggeration to say that Cool Papa Bell was among the fastest athletes ever to wear a baseball uniform. After making his professional debut with the St. Louis Stars in 1922, Cool Papa would play for no fewer than 11 teams, playing in three different countries, and everywhere he went the fans would talk about his speed. Paige liked to say that Bell was "so fast he could turn off the light and be under the covers before the room got dark!" His overall skills went beyond baserunning, as he was often among the leading hitters wherever he played, and was also known as a solid outfielder. Bell was elected to the Baseball Hall of Fame in 1974, among the first group of Negro Leagues players to be so honored.

Rickey Henderson Shoes

"Now I can go out there and relax a little more," said a relieved Rickey Henderson, the Oakland A's 23-year-old left-fielder who, while wearing these shoes, had just stolen his 119th base in 1982. The theft, his first of four against the host Milwaukee Brewers at County Stadium on August 27, surpassed the modern single-season mark St. Louis Cardinals star Lou Brock had set in 1974. With 41,600 fans on hand, pitcher Doc Medich walked Henderson with two out and the bases empty in the third inning. After four throws to first, Medich's first offering to batter Wayne Gross was a pitchout, Henderson's headfirst slide barely beating catcher Ted Simmons's throw. "It's a great honor for me to be in the same category as a great player like Lou Brock," said Henderson during an in-game ceremony, which the former record holder attended. After the game, Medich, the winning pitcher in the 5–4 victory, said, "I hold no grudges because he did it against me; I was glad to be out there."

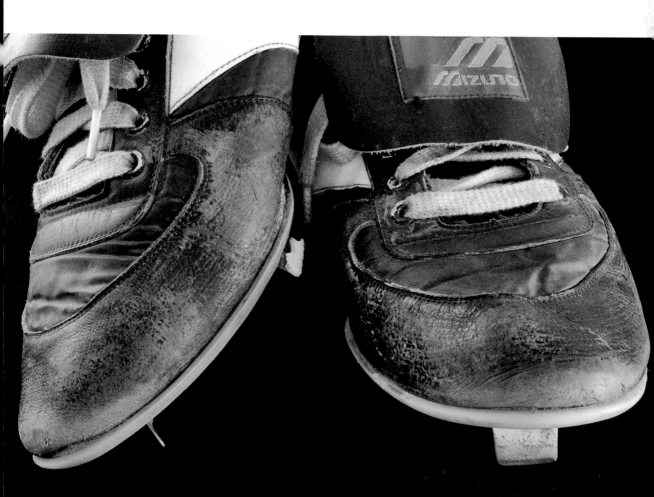

King Kelly Baserunner Medal

Michael Joseph "King" Kelly was one of baseball's early superstars, establishing himself as the game's number-one drawing card in the 1880s. After success with both the Cincinnati Reds and Chicago White Stockings, his $10,000 sale to the Boston Beaneaters in 1887 is considered the National Pastime's first "big-money" deal. Before the start of the right-fielder's first season in Boston, the *Boston Globe* newspaper announced that it would present a gold medal to the best baserunner on the team. Using a formula not strictly based on stolen bases, the *Globe* would present 29-year-old Kelly (who would swipe 84 in that year), a daring baserunner who inspired the immortal cry "Slide, Kelly, Slide," this medal in a ceremony after the season. "On the ball field I have been treated like a king," Kelly said after being presented the medal, "and off the ball field I was adopted by Bostonians, and educated, so to speak, until now I feel that my education is complete."

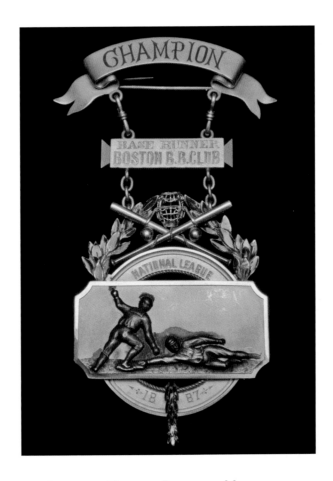

BROOKLYN **ROBINSON** JACK R.

BATS - RIGHT
THROWS - RIGHT

Date	Pos.	A.B.	R.	H.	T.B.	2 B.	3 B.	H. R.	Sacrifice Hits	Bases on Balls	Hit by Pitcher	Runs Batted In	Stolen Bases	Strike Outs	P.O.	A.	E.	P.O.	A.	E.	Hit Into Double Play	Double Plays
April 15	1B	3	1						1						11						1	1
17	✓	3	1	1	1					2					10	1						1
18	✓	4	2	2	5			1				1			8							1
19	✓	4	1	3	4	1				1				1	4	1						1
22	✓	4	1	2	2								1		12		1					
23	✓	4	2	1	1					1				1	11							
24	✓	4	1												10							2
26	✓	3							1	1					9							1
27	✓	4	1							1				1	10	2						2
29	✓	3	2						1	1					9	1						3
30	✓	4													4							3
May 1	✓	4		1	2	1			1					1	9							1
6	✓	5	1	2	2							1		1	8	1						1
7	✓	5		1	1										12						1	1
8	✓	4		1	1										8	1	1					2
9	✓	5	2	2	3	1							1		8	2						2
10	✓	4	1	1	1										13	2						3
11	✓	4	1	1	1										10							1
11	✓	3	1	1	1							1			9	1						1
12	✓	2	2	1	1				1	1		1	2		9							2
13	✓	4	1	1	1					1					3							
14	✓	4									1				13							
15	✓	5		2	2										6							2
16	✓	4		2	2					1			1		3	1						1
17	✓	4		2	2						1				6	2						
18	✓	4								1				2	12	1	1					1
19	✓	4	1							1					11							
21	✓	4	1							1					9							1
23	✓	4		1	1					1		1			9							2
24	✓	3	1							1		1			13	2	1					
25	✓	4	2	3	6			1				1			5							
27	✓	4	1							1					6	1						
28	✓	4		2	2	1				1		1			16							2
29	✓	4	1	1	1										10							1
30	✓	4		1	1					1					6							1
30	✓	4											1		13							
31	✓	3	1	1	2	1				1	1	1	1	1	5							
June 1	✓	3	1	2	2					1			1		11							
2	✓	4							1						13	1						
3	✓	3	2	1	1					1					11	1					3	
3	✓	4	1	2	2	1									6							1
4	✓	3								1					7							
5	✓	4	1	3	6			1		1	1				15							2
6	✓	5		2	2							2			9							
Totals		**169**	**35**	**47**	**61**	**5**	**0**	**3**	**7**	**20**	**7**	**11**	**8**	**10**	**402**	**22**	**4**				**2**	**46**

Jackie Robinson 1947 Day-by-Day Sheet

Back when there were no computers and without the benefit of today's technology, Major League Baseball used handwritten ledger books to maintain the official statistics for every player. Known as the *Official Average Volumes*, but routinely referred to as the "day-by-days" in the baseball research world, these documents are an important tool for those trying to rebuild the statistical history of baseball. After every game, the official scorekeeper was responsible for sending in a tally sheet of the statistics, which were transferred by hand on a team-by-team, player-by-player, day-by-day basis, with all column totals and averages calculated and noted in pencil. The amount of work involved was tremendous, but without these documents, researchers would have a difficult time studying certain elements of the game. This image shows the 1947 National League page for Jack R. Robinson, the year he broke the color barrier and helped to open the game to everyone.

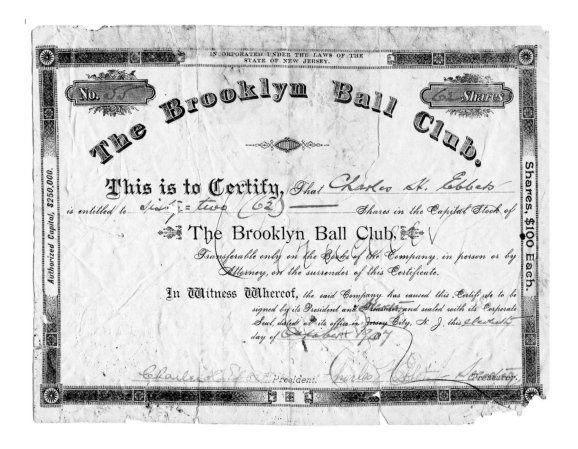

Brooklyn Ball Club Stock Certificate

Charles Hercules Ebbets was involved in the game of baseball for more than four decades, working his way up the ladder from ticket taker to the turn-of-the-last-century owner of Brooklyn's National League team. He was in the midst of acquiring the big league team when this certificate for 62 shares in Brooklyn Ball Club stock, at a cost of $100 per share, was issued on October 11, 1907. The "Squire of Flatbush," as he was affectionately known to Brooklyn fans, became president of the ball club in 1898, and eventually, thanks to purchasing stock in the club, gained total ownership control in 1909. When he passed away in 1925 at the age of 65, National League president John Heydler remarked, "Mr. Ebbets was probably the best beloved man in baseball, not only in his own league but in other leagues as well. He was highly regarded everywhere and stood for the best interests of the game."

Ebbets Field Brick

Home to their beloved Dodgers, Ebbets Field lives only in the memories of Brooklyn fans everywhere. Opened in the spring of 1913 and named after club owner Charlie Ebbets, the ballpark was located in the Flatbush section of the borough, built on the site of an old dump called Pigtown. The brick, concrete, and steel structure was home to the Dodgers until their departure for Los Angeles in 1958. Whether it was Hilda Chester and her cowbell or the Dodgers Sym-phony Band, the fans created a rousing atmosphere to support the team that Roger Kahn later immortalized as *The Boys of Summer*.

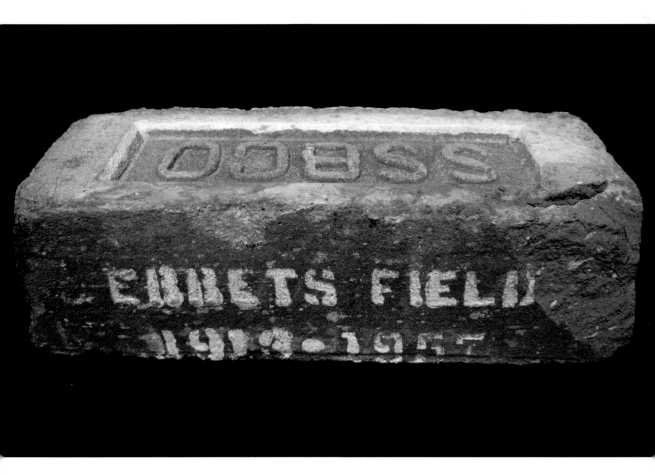

Shea Stadium 1969 Home Plate Half

"There's a fly ball out to left. Waiting is Jones . . . the Mets are World Champions! Jerry Koosman is being mobbed! Look at this scene!" was the call by Curt Gowdy as the New York Mets completed an improbable worst-to-first run to capture the 1969 World Series Championship. At the conclusion of Game 5 at Shea Stadium, the Mets faithful mobbed the field to celebrate with Jerry Koosman, Donn Clendenon, Tom Seaver, Tommie Agee, Tug McGraw, and the rest of the "Miracle Mets." It was during this melee that a fan of the Mets removed one half of home plate from the field. That half of home plate ended up finding a permanent home in the collection of the National Baseball Hall of Fame.

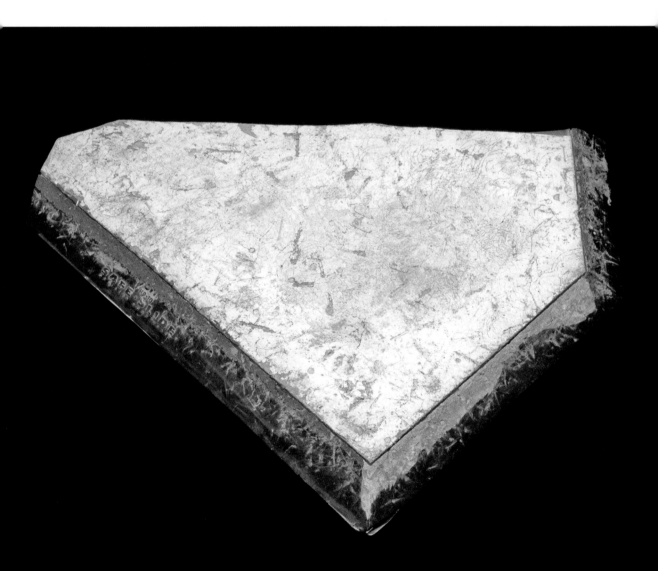

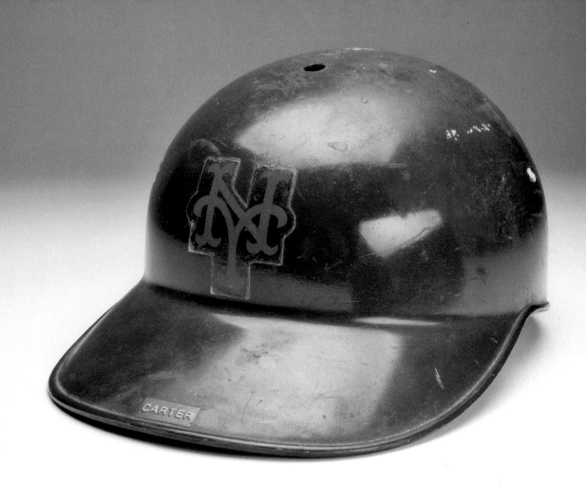

Gary Carter World Series Helmet

Known as "The Kid," Gary Carter was the spiritual and on-field leader of the mid-to-late-1980s New York Mets teams. Hall of Famer Tom Seaver said of Carter, "Nobody loved the game of baseball more than Gary Carter. Nobody enjoyed playing the game of baseball more than Gary Carter. He wore his heart on his sleeve every inning he played. For a catcher to play with that intensity in every game is special." The moment he might most be remembered for occurred in Game 6 of the 1986 World Series. With two outs and nobody on, down by two in the bottom of the tenth, and with the Mets facing elimination, The Kid's single sparked perhaps the greatest comeback in postseason history as the Mets went on to win the game 6–5. It was while wearing this helmet that Gary Carter caught all seven games of the Mets' victorious 1986 Fall Classic. Mets teammate Keith Hernandez recalled, "He was a human backstop back there. . . . He was running on and off the field after three outs. This guy played in some pain and it was hustle, hustle, hustle."

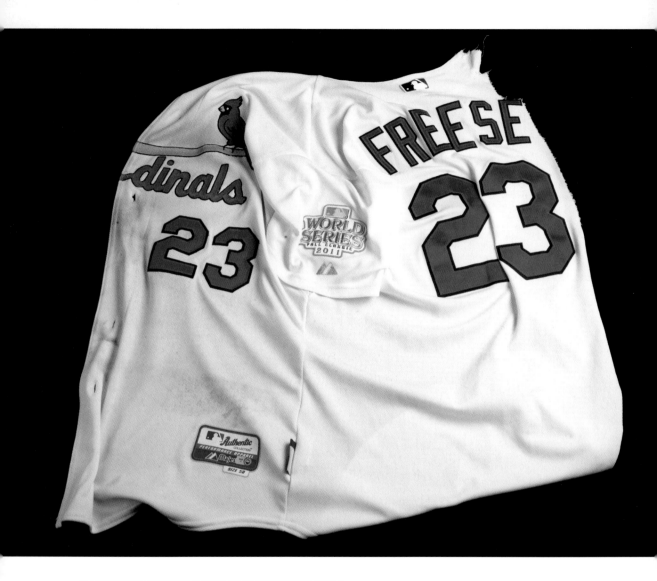

David Freese Torn World Series Jersey

In 2011, the St. Louis Cardinals, down to their last strike on two occasions, added another World Series championship to their history as the most decorated National League franchise. As Game 6 came to a close, the Cardinals staved off World Series elimination in one of the most improbable comebacks in Series history. Down by three going into the bottom of the eighth, the Cardinals put up three runs in the next two innings to tie the game at seven. Then in the bottom of the eleventh, third baseman David Freese capped the comeback with a game-winning home run off Rangers reliever Mark Lowe. As Freese crossed the plate scoring the decisive run, he was mobbed by his teammates, who tore his jersey off in celebration.

1900 Championship Trophy

The series was billed as the "world's championship" of 1900, pitting the top National League team during the regular season, the Brooklyn Superbas, against the second-place finisher, the Pittsburgh Pirates. The winner of the best-of-five series, to be played at Pittsburgh's Exposition Park, would receive this silver trophy in the shape of a punch bowl, valued at $500, donated by the *Pittsburgh Chronicle-Telegraph*. On October 18, after winning the fourth and deciding game of the series, Brooklyn players decided to honor Joe "Iron Man" McGinnity, a 28-game winner during the regular season, who led the team against Pittsburgh with two complete-game wins. "As a mark of appreciation and acknowledgement that to his brilliant work on the rubber the success of the club was largely due," reported the *New York Times*, "the team by unanimous consent decided to turn over to Pitcher McGinnity the handsome trophy cup, it to be his personal property forever." Brooklyn management also gave McGinnity $100 extra for his fine mound work.

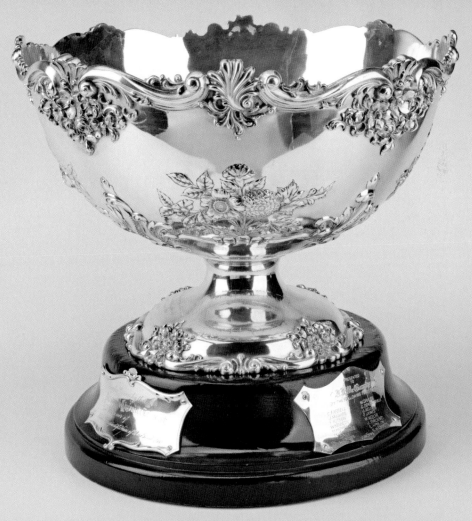

1888 Hall Cup

Not only did the National League's New York Giants vanquish the American Association's St. Louis Browns for the 1888 world championship, but the victors also received an impressive memento, this Hall Championship Cup. The gift of Thomas H. Hall, the New York–based manufacturer of "Between the Acts" cigarettes, the 18-inch-high Tiffany & Co. trophy, standing on an ebony base, is composed of 106½ ounces of silver and was, at the time, valued at $1,000. In accepting the Hall Cup at St. Louis' Grand Opera House, Giants manager Jim Mutrie said, "I also wish to assure the patrons of baseball and all persons who, by taking an intelligent interest in it, have elevated the game, that we appreciate their kindness and shall always do our best to continue to deserve their good opinion. The people of St. Louis have placed us under many obligations by making our stay here pleasant and agreeable, and the members of the Brown Stocking team we shall always count among our friends."

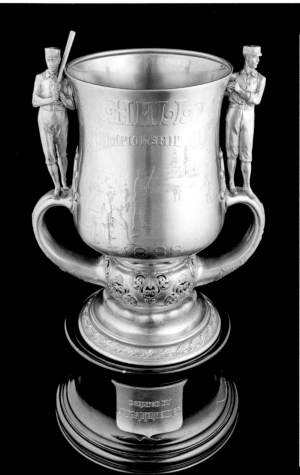
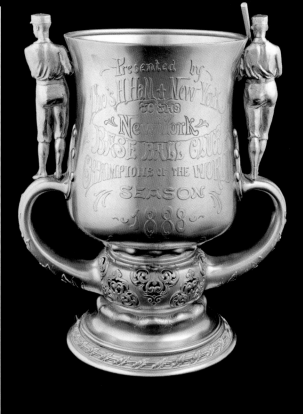

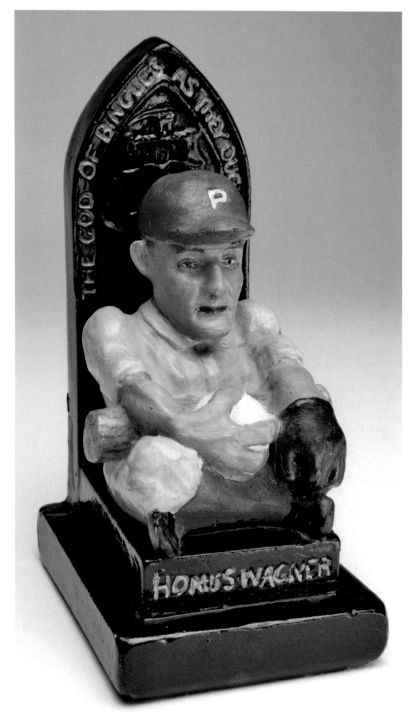

Honus Wagner Billiken

Hall of Fame manager John McGraw recalled, "I name Wagner first on my list, not only because he was a great batting champion and baserunner, and also baseball's foremost shortstop—but because Honus could have been first at any other position, with the possible exception of pitcher. In all my career, I never saw such a versatile player." Not only was Wagner versatile—he played every position except catcher at the major league level—but he was a wonderful human being. Historian Bill James said of him, "He was a gentle, kind man, a storyteller, supportive of rookies, patient with the fans, cheerful in hard times, careful of the example he set for youth, a hard worker, a man who had no enemies and who never forgot his friends. He was the most beloved man in baseball before Ruth." Sold as a souvenir during the 1909 World Series, this plaster billiken statuette is an excellent representation of what Honus Wagner meant to fans of the game.

Honus Wagner T206 Card

Beautiful, sublime, mysterious, rare, and valuable—all of these adjectives have been used to describe the 1909 Honus Wagner T206 baseball card, and yet none can fully capture the essence of this iconic piece of cardboard. The Wagner card has been described as the "Mona Lisa of baseball cards," and as the "Holy Grail of card collecting." Copies of this card in excellent condition have sold for figures between one and three million dollars. Amazingly, the Wagner is not the rarest of all baseball cards—several other cards would qualify for that distinction. But the Wagner was very hard to find in card collecting's early days, and a mystique grew up around it that remains today, despite the principle of supply and demand. Ironically, the card is so celebrated that fans today know more about it than about Wagner himself, who still ranks in the top 10 all-time in hits, singles, doubles, triples, and stolen bases.

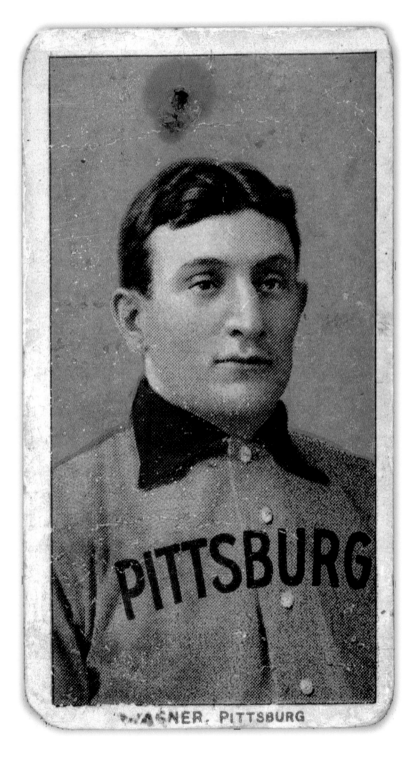

Turkey Red Baseball Cards

A most-sought-after relic of the early days of baseball cards, the 1910–11 Turkey Reds are considered among the most artistic and attractive ever produced. Classified by collector extraordinaire Jefferson Burdick as the T3 set, these cards were produced as premiums by Turkey Red brand cigarettes. As cabinet cards measuring five and three-quarter by eight inches, they were too big to be included in the cigarette packages and could be obtained only by redeemable coupons included in each pack. The cards use studio poses transferred onto heavy stock cardboard and printed with a variety of brightly colored inks, which gave them a stunning presentation. In addition to their beauty as art, they also included 23 Hall of Famers. Today, these cards are considered to be one of the most collectible sets from the Tobacco Card Era.

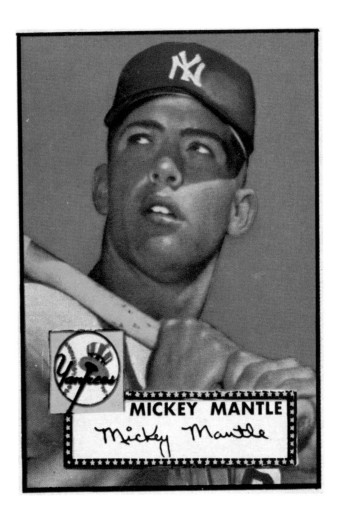

First Topps Baseball Card of Mickey Mantle, 1952

Mickey Mantle began to make good on his incredible potential for the New York Yankees in 1952. That same year, Topps chewing gum company of Brooklyn revolutionized the baseball card, adding full-color team logos on the front and statistics on the back. The cards were so popular that Topps issued a second series, at World Series time, which featured card number 311, Mickey Mantle (.311 was also Mantle's batting average that year). "We learned that kids don't buy baseball cards at World Series time because football is starting," reminisced Sy Berger, longtime Topps executive. Because the unsold cards were taking up expensive warehouse space, Topps hired a boat and dumped them off the New Jersey coast. "I don't know how many cards there were, but it was enough to make you a millionaire," Berger recalled. Most of the "high-number" cards from the second series thus became quite valuable, but none more so than the Mantle "rookie card," which can approach $30,000 in excellent condition.

Mickey Mantle 565-Foot Home Run Bat

Considered at the time one of the longest home runs ever hit, the wallop young slugger Mickey Mantle of the visiting New York Yankees put on a baseball against the Washington Senators' Chuck Stobbs on April 17, 1953, remains a memorable accomplishment. A switch-hitter, the 21-year-old Mantle, batting right-handed against the left-handed Stobbs, came to bat in the fifth inning and sent the second pitch he saw over Griffith Stadium's 55-foot-high left-field wall, coming to rest outside the ballpark an estimated 565 feet away. Mantle connected using this borrowed bat from teammate Loren Babe, which he preferred when batting right-handed (Johnny Mize's bat was his favorite when batting lefty). "I think I have benefitted more by the publicity than Mickey," Stobbs said a few years later. "It may even have made a better pitcher out of me—at least against Mantle. I know that a home run is always on my mind when I'm facing him and I'm sure it's on his mind, too."

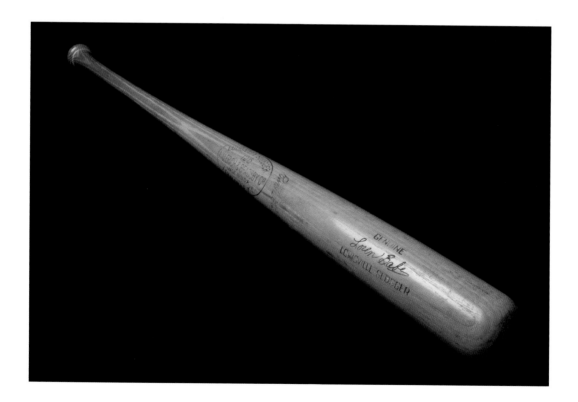

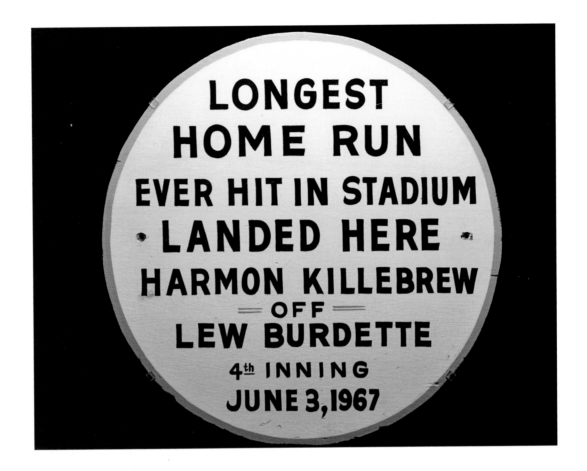

LONGEST
HOME RUN
EVER HIT IN STADIUM
· LANDED HERE ·
HARMON KILLEBREW
= OFF =
LEW BURDETTE
4th INNING
JUNE 3, 1967

Harmon Killebrew Sign

While longtime Minnesota Twins star Harmon Killebrew hit 573 career home runs in the big leagues, it's likely none traveled farther than his June 3, 1967, shot off a knuckleball from veteran California Angels pitcher Lew Burdette. According to contemporary reports, the ball traveled approximately 520 feet, but there is no official statistic for home-run distance. "Two pitches before," said Angels catcher Tom Satriano, "Killebrew had missed a knuckleball by three feet. I felt we had him set up for it again. Instead he got every bit of it." The fourth-inning tape-measure homer, his 11th of the season, was the first ever hit into the upper-left-field stands of Minnesota's Metropolitan Stadium. "I don't know what kind of pitch it was," Killebrew said after the game. "It had a strange spin, but then Burdette throws a lot of strange pitches." This 20-inch round plywood sign, once stolen and returned more than a decade later, was attached to the seat where the ball landed. "That shot is liable to start a border war with Canada," joked Angels manager Bill Rigney.

Levi Meyerle Commemorative Bat

"That's all he left. We found the things when he moved from one house to another long ago and asked him if he still wanted them, but he said he didn't. Now we want you to have them," said Walter Meyerle, grandnephew of Levi Meyerle. With this introduction, the family of "Long Levi" donated a collection of artifacts related to his career. The gift included a set of contracts and certificates for his amateur and professional teams, as Meyerle was one of the players who transitioned with the game as it grew from an amateur club sport to a professional operation. This commemorative bat celebrates his batting championship and home run title in 1871. As noted by Alfred H. Spink in *The National Game*, "A big, stout fellow was Levi Meyerle, the third baseman of the Athletics of Philadelphia in 1871 and they were champions. Meyerle was a fair fielder, but his best asset was his ability to hit the ball hard."

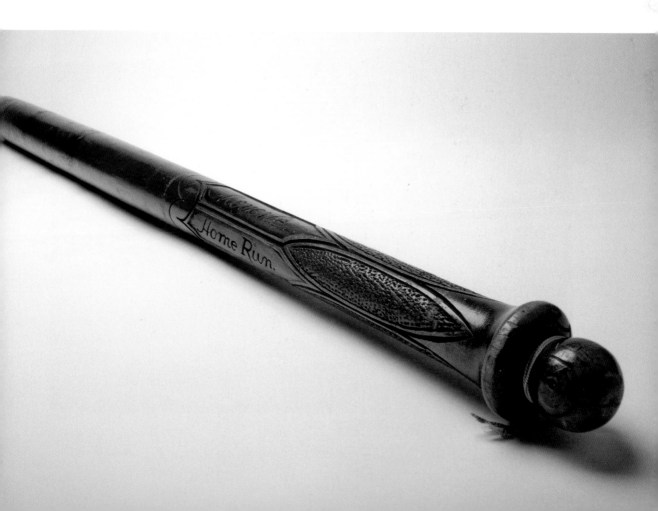

Jimmie Foxx Home Run Ball

A feared slugger throughout the 1930s, playing for the Philadelphia Athletics and Boston Red Sox, Jimmie Foxx's final big league stop was a return to where it all began, the City of Brotherly Love. With wartime player shortages, the 37-year-old first baseman hooked on with the Phillies in 1945, where the "Best of Belting," the game's active leader in home runs, would collect the final seven of his career total of 534. "I'm not thru," said Foxx upon signing with the Phils. "My legs are as good as ever." Among Double X's final victims was this ball, the fifth round-tripper of that last campaign that he belted off Cincinnati's Vern Kennedy in a 4–3 win at Shibe Park on August 19. Interestingly, the power hitter who won three MVP Awards and a Triple Crown would fulfill a dream and pitch in nine games in '45 before finally calling it a career.

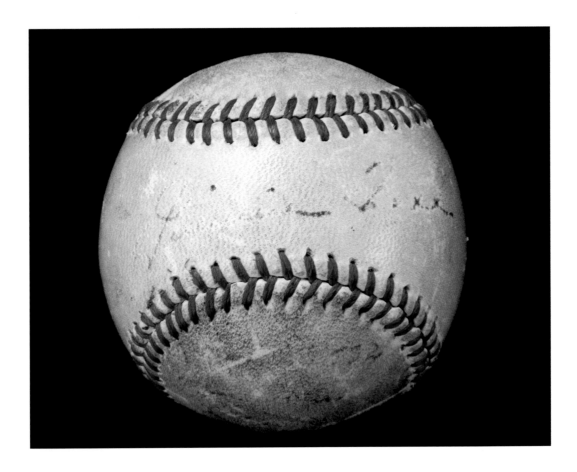

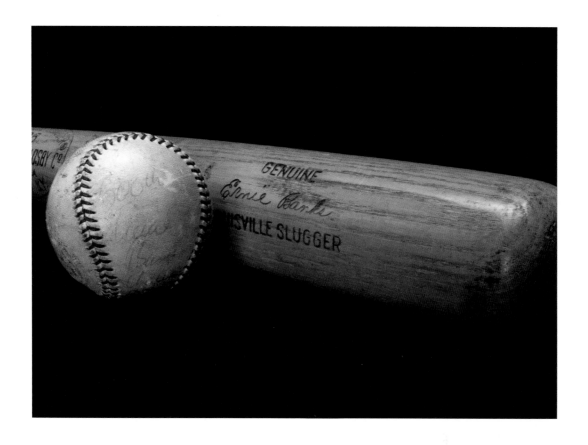

Bat and Ball Used by Ernie Banks to Hit His 500th Career Home Run

May 12, 1970, was a rainy, dreary day in Chicago, on which there would certainly be no base-ball played. But the ever-sunny Ernie Banks was in search of home run number 500, and, as if by magic, the clouds dried up enough to allow a day game at beautiful Wrigley Field. Banks may have uttered his signature line, "Let's Play Two!" The ageless and enthusiastic Banks used this bat to homer in the second inning, a solo shot off Atlanta's Pat Jarvis. The line drive to the left-field bleachers was not just his 500th homer but also his 1,600th RBI. Both milestones put Banks into select company, joining opponent Hank Aaron as the ninth man to hit 500 round-trippers and the twelfth to reach 1,600 RBI. Ron Santo singled in the 11th inning to win the game for the Cubs—and the sun was shining.

Reggie Jackson 500th Home Run Helmet

California Angels slugger Reggie Jackson connected for his 500th career home run 17 years to the day after he hit his first big league home run, and both came at Anaheim Stadium. For the milestone wallop, while wearing this batting helmet, the 38-year-old was the lone bright spot in a 10–1 loss to the Kansas City Royals on September 17, 1984. "I think 500 homers is a ticket to the Hall of Fame. I was very, very elated when I was going around the bases," Jackson said afterward. "It was one of my happiest home runs. I just wish we would have won the game." Jackson became the 13th player in major league history to collect 500 homers when he hit Bud Black's first seventh-inning pitch into the second deck in right field. "It was a fastball right down the middle," Black said. "He crushed it. It didn't bother me. I would have felt bad if it were a grand slam and we were ahead 3–0."

Ken Griffey Jr. 500th Home Run Helmet

It was a Father's Day to remember when Cincinnati Reds center fielder Ken Griffey Jr., with his dad in the stands, slugged his 500th career home run on June 20, 2004. In the 6–0 win over the St. Louis Cardinals, the left-swinging Griffey, while wearing this batting helmet, led off the sixth inning by driving a 2-2 fastball from Matt Morris an estimated 393 feet into Busch Stadium's right-field seats. "Never in my wildest dreams did I think I'd ever accomplish this," said the 34-year-old Griffey, the 20th player—and sixth youngest at the time—to reach the milestone. "All the aches and pains I've had this year were gone for like two minutes. It was awesome." After his memorable home run, Griffey embraced his father, a former teammate with the Seattle Mariners. "It was a nice Father's Day present, but it's an easy way to get out of giving me something," Griffey Sr. joked. Griffey Jr. would retire with 630 homers.

Jackman Brothers Scrapbook

This scrapbook, created in 1912 by Pittsburgh's David and Alan Jackman, both in their late teens, had begun a decade earlier when they cut out pictures of ballplayers. With more than 1,500 images collected, the lads decided to organize their baseball heroes into a scrapbook. Eventually, the brothers attempted to get signatures at Pittsburgh's Forbes Field. "The book was sort of a pass for us; they let us in free," said Alan Jackman. "Then we went from one bench to the other getting all the signatures." The pair also attended games in Detroit and Cleveland for the American League autographs they needed. In all, more than 460 signatures grace the pages, including those of more than three dozen Hall of Famers.

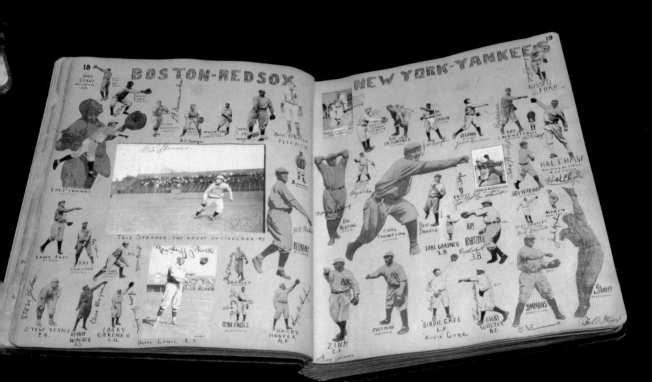

Cal Ripken Shoes

In the midst of perhaps his finest offensive season, Cal Ripken Jr.'s star shone the brightest at the 1991 Midsummer Classic. The longtime Baltimore Orioles shortstop wore these shoes while earning Most Valuable Player Award honors during the 62nd All-Star Game, held at Toronto's SkyDome. After singling to center in the first inning, Ripken slugged a three-run, 416-foot home run into the second deck in center in the third inning against former O's team-mate Dennis Martinez of the Montreal Expos to lead the American League to a 4–2 victory over the National League. "I've been swinging the bat very well of late and I think that's the key—coming into a game hot," said Ripken. "I hit the ball very hard tonight and I was pretty sure the home run was out. When you have a few hits and a homer, it's a lot easier to have fun."

Dennis Martinez Jersey

"I was blank—there was nothing in my mind," was how Montreal Expos pitcher Dennis Martinez explained his feelings after he tossed a 2–0 perfect game against the host Los Angeles Dodgers on July 28, 1991. "I had no words to say. I could only cry. I didn't know how to express myself. I didn't know how to respond to this kind of game." The 36-year-old right-hander, a native of Nicaragua, was wearing this road jersey before 45,560 fans at Dodger Stadium when he pitched the 15th perfect game, and first by a Latin American player, in big league history. The game's 27th and final out came when pinch-hitter Chris Gwynn sent a line drive to the right-field gap that center-fielder Marquis Grissom hauled in. "I don't think anybody wanted the ball hit to them," Grissom said. "I was so overexcited out there, I was just thinking, 'Please, no line drives, nothing hard. I don't want to be the one to ruin history.'"

Bob Gibson Glove

Billed as "The Year of the Pitcher," the 1968 season for Bob Gibson was among the best in the game's history. Standing atop pitching mounds throughout the National League, the intimidating St. Louis Cardinal wore this Carl Yastrzemski model glove on his left hand during a campaign that saw him finish with a 22–9 record, 13 shutouts, 28 complete games in 34 starts, 268 strikeouts, and only 62 walks in 304⅔ innings, and a 1.12 ERA, which ranks as the third-best since 1900. "The thing that stands out more than anything else is that I lost nine ball games," Gibson said. "How did I do that?" After a season in which Gibson captured the National League's MVP and Cy Young Awards, a new rule lowering the height of the mound from 15 inches to 10 was instituted in 1969.

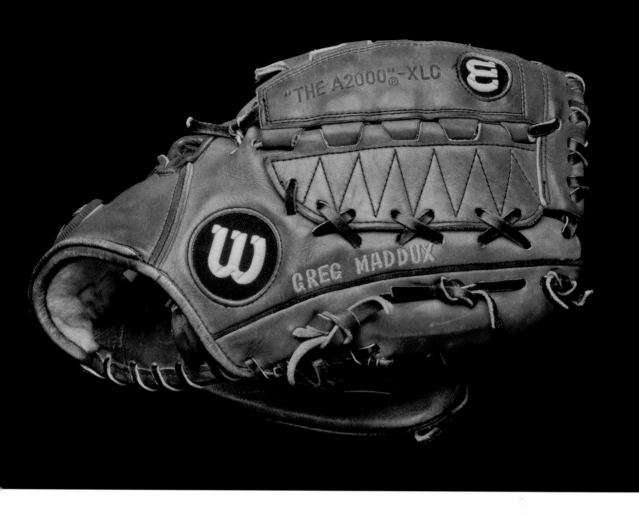

Greg Maddux Glove, 1995 World Series

Greg Maddux had arguably his most dominant season in strike-shortened 1995, winning 19 of the 144 games the Atlanta Braves played, while losing only two. Maddux rolled that year to an unprecedented fourth consecutive Cy Young Award, leading the league in wins, winning percentage (.905), ERA (1.63), complete games, shutouts, innings pitched, and WHIP. A master of control, location, speed changes, and strategy on the mound, Maddux also used fielding and situational hitting to his advantage. As a ground-ball pitcher, Maddux knew that his fielding ability could help him get outs, and thus win games. In more than 5,000 career innings pitched, he made just 53 errors. He used this glove in the 1995 World Series, in which he won Game 1 on a two-hit complete game over the Indians. Throughout his career, his fielding excellence earned him a record 18 Gold Gloves—the most by any player at any position.

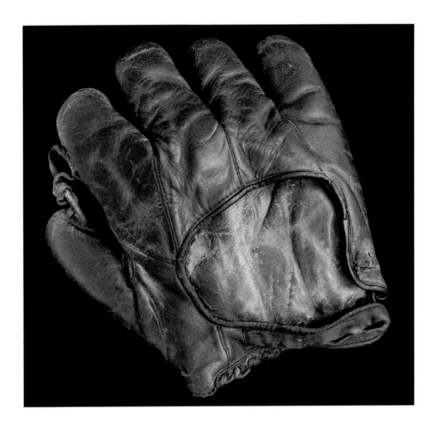

Lefty Grove World Series Glove

Lefty Grove, considered by many to be the greatest southpaw hurler of all-time, ended his 17-year big league career, split between the Philadelphia Athletics and the Boston Red Sox, with a 300–141 record, for a phenomenal winning percentage of .680. "Just to see that big guy glaring down at you from the mound," said fellow Hall of Famer Joe Cronin, "was enough to frighten the daylights out of you." During the 1929 World Series, the lanky left-hander, known for his devastating fastball, wore this glove while helping the A's capture the Championship in five games over the Chicago Cubs. Though Grove was in the midst of a stretch where he won at least 20 games for seven consecutive seasons, his only action during the '29 Fall Classic was six and one-third innings of scoreless relief. Known as a fierce competitor, Grove, when asked for the secret of his success, replied, "No secret. They tell me to pitch and I say, 'Gimme the ball.'"

Jersey Worn by Rogers Hornsby for 1932 Cubs

Player-manager Rogers Hornsby wore this home jersey for the Cubs in 1932, his final season with the team. The two-time Triple Crown winner, who had hit an unbelievable .402 over the five-year period from 1921 to 1925 for the Cardinals, joined the Cubs in 1929. He won his second MVP Award that year, and the Cubs brought home the pennant. In 1930, he became player-manager. Though he hit .350 for the Cubs in his four-year stint, he was playing little and hitting poorly in 1932, and his hot-tempered style rubbed someone in the organization the wrong way. On August 2, following a loss to the Dodgers in Brooklyn, Hornsby was dismissed as both a player and a manager. The Cubs were five games out, in second place. The team went 37–18 over the rest of the season and clinched the pennant under the amiable Charlie Grimm.

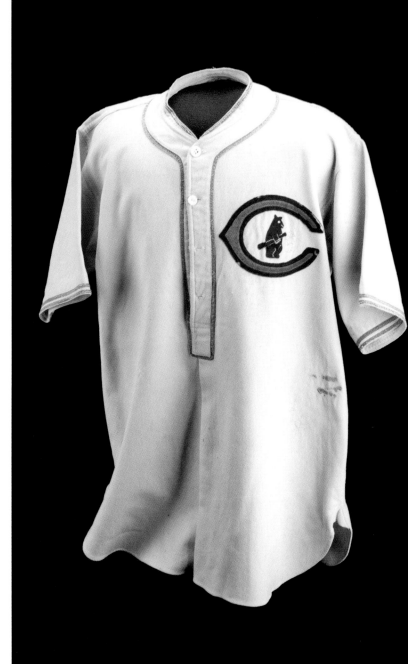

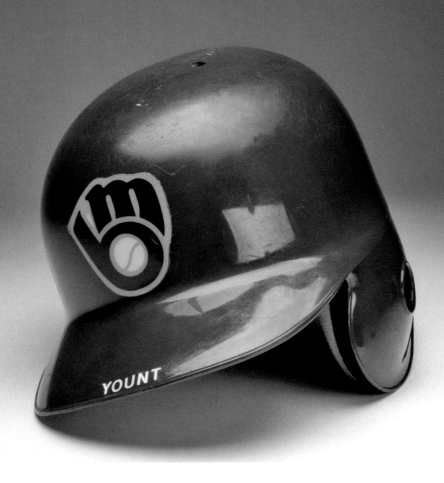

Robin Yount Batting Helmet

Milwaukee Brewers center-fielder Robin Yount capped off a wonderful 1989 season by being named the American League Most Valuable Player for the second time in the decade. "It's always nice to be recognized," said the 34-year-old Yount after the MVP announcement, "but I want everyone to realize that this award is also for my teammates, the organization and the great fans of Wisconsin." The big-leaguer wore this helmet while hitting .318 with 21 home runs, 103 RBI, 101 runs scored, and 19 stolen bases. "His accomplishments speak for themselves," said Brewers manager Tom Trebelhorn, "but I don't think individual awards mean anything to Robin." Yount had been a shortstop when he captured the honor in 1982, thus joining Stan Musial and Hank Greenberg as the only players to win MVP Awards at two different positions.

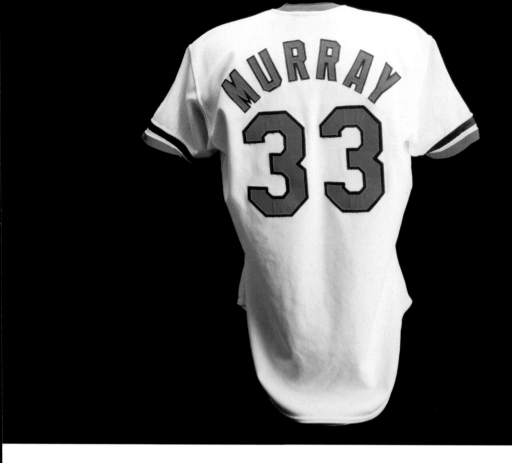

Eddie Murray 1983 Jersey

Known as a man of few words, Eddie Murray used his bat and glove to make plenty of statements on the baseball diamond. A stalwart defensive player at first base, he became known as "Steady Eddie" for his calm demeanor and consistent hitting for the Baltimore Orioles between 1977 and 1988, when he averaged 28 home runs and 99 RBI per season. He wore this jersey in 1983, one of his best seasons, when he hit .306 with 111 RBI and 33 home runs. He also helped lead the Birds to a World Series Championship against Philadelphia. Upon his induction to the Hall of Fame in 2003, Murray summed up his philosophy by saying, "I was never one much on words. For me to focus a lot on the individual, that's not the way I learned to play the game. Baseball's a team game. You win as a team, you lose as team. You also do so many things together, but it is not an 'I' thing."

Tony Gwynn 3,000-Hit Shoes and Batting Helmet

Needing only one base hit to become the 22nd player to reach 3,000, longtime San Diego Padres outfielder Tony Gwynn instead collected four to help his team to a 12–10 win against the host Montreal Expos on August 6, 1999. "When you talk about 3,000 hits, you talk about passion and a love for the game," Gwynn said. "I love playing the game. I thought 2,000 was a pretty good one, but for a contact hitter this is the ultimate." Gwynn accomplished his historic milestone—while wearing these shoes and this batting helmet—with a first-inning single off rookie pitcher Dan Smith before 13,540 fans at Olympic Stadium. Among the crowd that saw the first big league player to collect his 3,000th hit outside the United States was Gwynn's mother, Vendella, who was celebrating her 64th birthday.

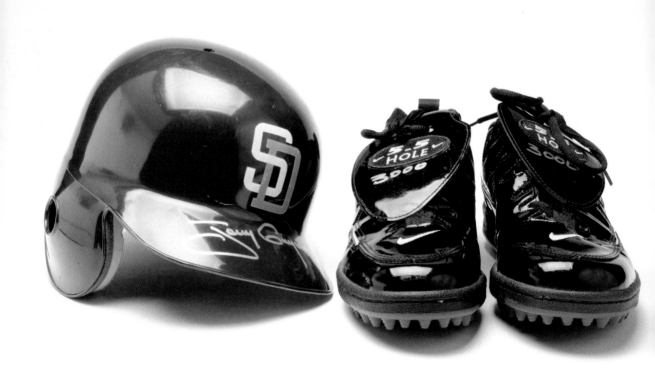

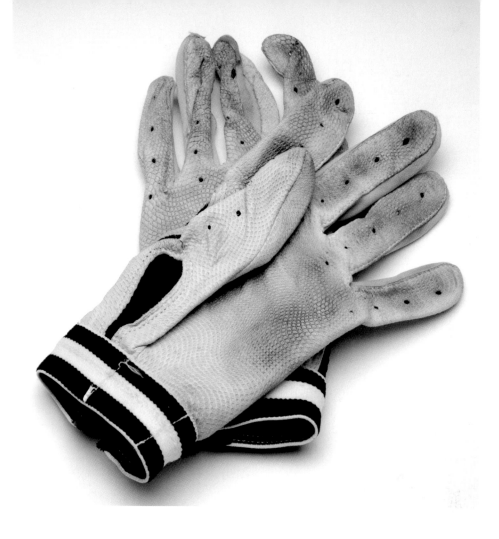

Wade Boggs 3,000-Hit Batting Gloves

Entering the game three safeties shy of the 3,000-hit mark, Wade Boggs of the Tampa Bay Devil Rays collected singles in the third and fourth innings before reaching the milestone with a surprising home run over the right-field fence in the sixth inning of a 15–10 loss to the Cleveland Indians at Tropicana Field on August 7, 1999. Boggs, never known as a home-run threat, was wearing these batting gloves against pitcher Chris Haney when he became the 23rd player to reach 3,000 career hits, and the first to do so with a homer. "Right when it left the bat, I said, 'Oh, my God, it's a home run and I'll never get that ball back,'" Boggs said. Boggs did get the ball back from the fan who had it, in exchange for an autographed bat and a signed jersey.

Paul Molitor Hitting-Streak Bat

When his 39-game hitting streak, the fifth-longest in modern major league history, finally came to an end, Milwaukee Brewers designated hitter Paul Molitor said, "Someday when I'm retired I'll look back on this. I'm very happy at what has happened. The fact that it's in the top five streaks makes you realize you're pretty fortunate." While the streak ended in an 0 for 4 game against the visiting Cleveland Indians on August 27, 1987, this 34-inch, 32-ounce bat was used by the 31-year-old Molitor the previous day against the Indians. "Being realistic," said Molitor, "whether the moment is a day away, five hours away, or a week away, it's going to happen. The streak will end. I'm just enjoying it while it lasts." During the streak, which began on July 16, Molitor batted 68 for 164, for a .415 batting average.

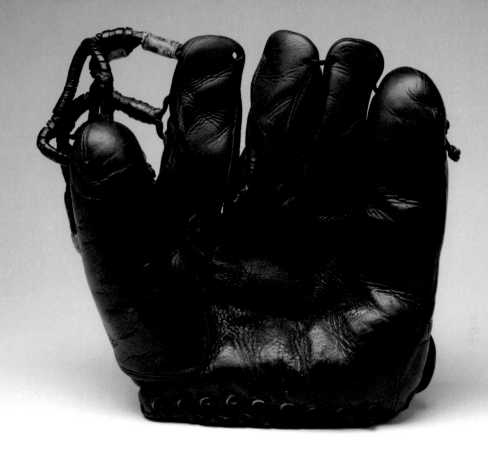

Joe DiMaggio Glove

Ballplayers are fond of their gloves, and many have what they call their "gamer," the glove primarily used by a player in games that count. This Rawlings leather fielder's glove was the gamer used by Joe DiMaggio in the 1938 and 1939 Championship seasons and in the subsequent World Series against the Cubs and Reds, respectively. Joe DiMaggio was a graceful fielder who played the game the right way. Teammate Yogi Berra said of him, "I wish everybody had the drive he had. He never did anything wrong on the field. I'd never seen him dive for a ball, everything was a chest-high catch, and he never walked off the field." In every inning of every game Joe DiMaggio gave it his all because, as he put it, "There is always some kid who may be seeing me for the first or last time. I owe him my best."

Sam Jackson Bat

Though born in England, Samuel Jackson would eventually make a name for himself in America's National Pastime. This bat was awarded to the 21-year-old Jackson, a member of the amateur Tri-Mountain Club (Boston's first baseball club, founded in 1857), for the most runs scored in a game (five) against the Excelsior Club of Boston in a 24–5 victory on May 21, 1870. The 38-inch-long, 25-ounce wooden bat, donated by Jackson's daughter in 1960, has twine wrapped around the handle; painted with gold on a black background it reads, "AWARDED TO SAMUEL JACKSON, FOR BEST SCORE IN GAME WITH EXCELSIORS." The five-foot-five, 160-pound Jackson would make his big league debut the next year as a second baseman with the Boston Red Stockings.

Kirby Puckett Six-for-Six Game Bat

"When I'm swinging well, I can hit anything. I'm just trying to get a good pitch to hit and swing hard," said Minnesota Twins center-fielder Kirby Puckett after batting six for six in a 10–6 win against the host Milwaukee Brewers on August 30, 1987. In fact, with the six hits he collected with this 34-inch, 32-ounce Louisville Slugger and the four from the previous day, Puckett tied a big league record set by Pittsburgh's Rennie Stennett in September 1975 for most hits in two consecutive nine-inning games. Puckett's six-hit game included two home runs for the second day in a row. "You put together today with what he did last night," said Milwaukee's Paul Molitor, "that's a two-day performance that might not be able to be matched."

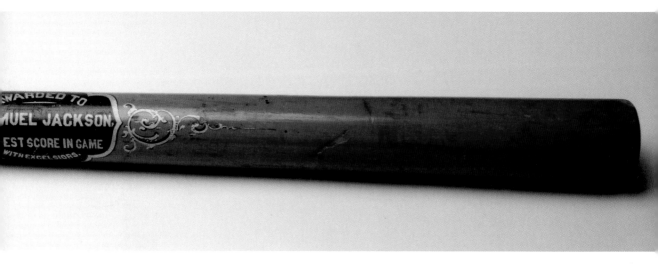

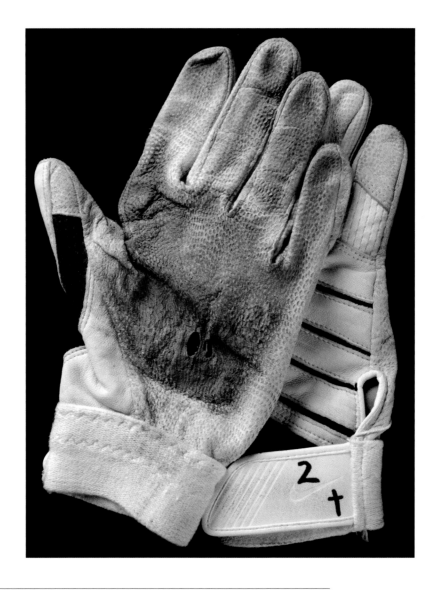

Troy Tulowitzki Hitting-for-the-Cycle Batting Gloves

"That night he was locked in. You knew he was going to have good night," noted Todd Helton of Troy Tulowitzki, who batted for the cycle (single, double, triple, and home run) and picked up seven RBI on August 10, 2009, in an 11–5 win over the Chicago Cubs in Denver. He wore these batting gloves while joining the select group of players who have hit for the cycle in the major leagues. His manager, Jim Tracy, commented, "That's a pretty good career for some guys, just a tremendous offensive performance."

Troy Tulowitzki Unassisted-Triple-Play Jersey and Cap

The unassisted triple play, the rarest of the rare, is an event that has occurred only 15 times during baseball's modern era. For Colorado Rockies rookie shortstop Troy Tulowitzki, his was Lucky 13 on the list. On April 29, 2007, he turned three against the Atlanta Braves in the seventh inning of a 9–7 win. The game was tied when Kelly Johnson and Edgar Renteria both singled to put men on first and second. Chipper Jones then hit a line drive to Tulowitzki, who stepped on second to get Johnson and then tagged Renteria for the third out, which was followed by an automatic reaction throw to first. "It all happened so fast. I just wanted to make sure. I guess I was trying to be the first person to ever get four outs," said Tulowitzki to the *Denver Post* after the game. "Tulo" was wearing this jersey and cap when he became the second Colorado Rockies player to record the rare unassisted triple play.

HENRY CHADWICK

EDITOR

SPALDING'S OFFICIAL BASE BALL GUIDE

RESIDENCE AT

"THE GLEN"

HOWARD AVE. AND HALSEY ST.

BROOKLYN, N. Y.

MEMBER NEW YORK PRESS CLUB

Henry Chadwick Business Card

Henry Chadwick, sometimes called the "Father of Modern Baseball," is often credited with dubbing baseball "America's National Pastime." Chadwick was a sportswriter, historian, and one of baseball's first statisticians. He is credited with popularizing the box score, devising the symbol K to represent strikeouts, and devising formulas to determine batting average and earned-run average. According to Chadwick, "Base Ball, to be played thoroughly, requires the possession of muscular strength, great agility, quickness of eye, readiness of hand, and many other faculties of mind and body that mark the man of nerve." Chadwick was inducted into the National Baseball Hall of Fame in 1938, and his legacy remains alive as the Society for American Baseball Research has established the Henry Chadwick Award to honor those researchers and historians who have made significant contributions to our understanding of the game and its history.

Baseball Clock, American Clock Company, 1873

Henry Chadwick said, "It was not long before I was struck with the idea that base ball was just the game for a national sport for Americans," but he was not naïve enough to think that baseball was simply invented one day by chance in rural upstate New York. "Most Americans think Abner Doubleday invented the game but he had little or nothing to do with cricket." A pioneer of the game in the nineteenth century, Chadwick argued that baseball evolved from other stick and ball games like rounders and cricket. Many would argue that the baseball rules he helped develop for the New York Knickerbocker club in the 1840s are the basis for the modern rules of the game. Chadwick is the figure on the top left of this clock made by the American Clock Company in 1873. The figure across from Chadwick is Alexander Cartwright, another Knickerbocker pioneer.

"Nowhere in American life is the color line more firmly drawn than in baseball." So wrote King Solomon White in *Sol White's Official Base Ball Guide* 1907 (also titled *History of Colored Base Ball* on the cover), the first book about African-Americans and baseball. A hard-hitting infielder, White played with integrated minor league teams in the 1880s before the color line was drawn, and returned to the euphemistic "organized baseball" as late as 1895. He also played for, captained, and managed African-American teams from 1887 to 1926. Along the way, he studied at Wilberforce University and became the first historian of black baseball, penning his guide in 1907. Only three copies survive in libraries today. White saw the color line erased by Jackie Robinson in 1947—when the 69-year-old White lived in nearby Harlem. He had called it in the guide: "Some day the bar will drop and some good man will be chosen from out of the colored profession that will be a credit to all and pave the way for others to follow." Sol White was inducted into the Hall of Fame in 2006.

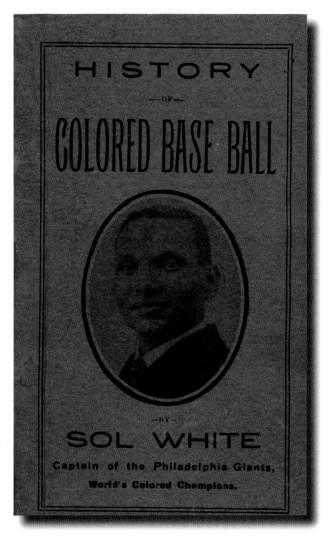

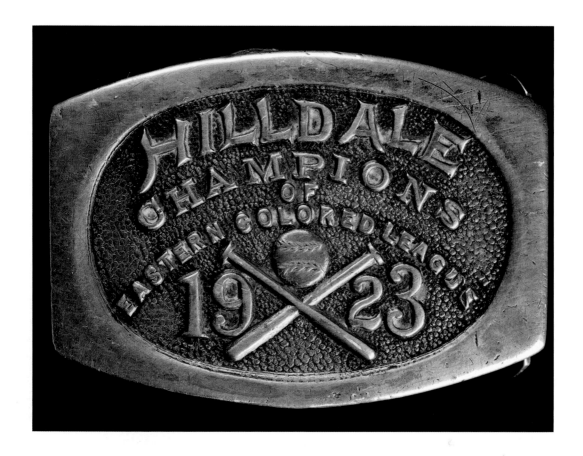

Sterling Silver Belt Buckle: "Hilldale Champions of Eastern Colored League 1923"

The Hilldale Daisies of Darby, Pennsylvania, were one of the premier African-American baseball clubs of the early twentieth century. They became charter members of the Eastern Colored League in 1923 and laid waste to the league, compiling a 32–17 record in league play, with an overall record for the year of 137–43–6. For their efforts, players received these sterling silver belt buckles. Led by several Hall of Famers, including shortstop John "Pop" Lloyd, third baseman Judy Johnson, and catchers Biz Mackey and Louis Santop, the club won 17 consecutive games in June, recorded 18 shutouts, and scored nearly seven runs per game. Following the season, the Hilldales went 6–0 against two barnstorming teams made up of their major league neighbors the Philadelphia Athletics. The *Philadelphia Inquirer* then sang the praises of the Hilldales' "Million Dollar Outfield," consisting of George Johnson, Otto Briggs, and Clint Thomas.

Commissioner Bowie Kuhn called it "a historic day for baseball." Frank Robinson of the Cleveland Indians made his debut as the big leagues' first black manager in a 5–3 triumph over the visiting New York Yankees on April 8, 1975. In a storybook ending, the 39-year-old Robinson, who would serve as the team's player-manager that season, walloped a first-inning home run, the 575th of his career, over the left-field wall before an appreciative Opening Day crowd of 56,204. "I really can't explain how I feel," Robinson said afterward. "It's just tremendous. I've been a manager before, but this is where it's at." Attending the game and throwing out the first pitch was Rachel Robinson, widow of Jackie Robinson, the player who broke baseball's modern color barrier in 1947: "I'm proud, proud, proud to be here. I've wished Jackie could be here and I'm sure in many ways he is."

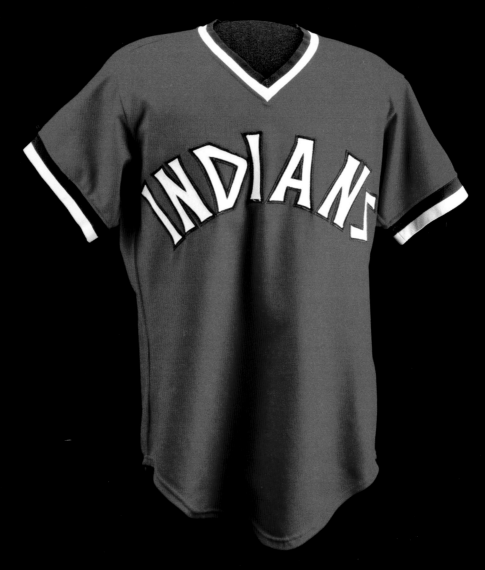

Sam Kissam Silver Ball

The mid-nineteenth-century Knickerbocker Base Ball Club of New York played an important role in the game's history. They are generally acknowledged as the first organized team. This commemorative silver baseball and two silver miniature bats were presented to Samuel H. Kissam in 1879 to celebrate his milestone 25th year as a member of the gentleman's club. Donated by Kissam's daughter in 1962, the six-inch-long bats, resting inside a decorative leather box, are engraved on the barrel "S.H. Kissam," while the ball, with a circumference of nine and three-eighths inches, reads, "Presented to Samuel H. Kissam by a fellow member to commemorate his twenty fifth anniversary of membership in the Knickerbocker Base Ball Club. And as a remembrance of an unbroken and warm friendship on 1854, the green fields of Hoboken 1879, and also attesting his many sacrifices and kindnesses which will be cherished forever by your loving and grateful friend. GOD BE WITH YOU."

Eckford Trophy Ball Case

Baseball teams are still referred
to as "clubs" and locker rooms
as "clubhouses." This language
stems from the game's amateur
era, when it was played by social
clubs like the Eckford Club of
Brooklyn. When a team won, it
kept the game ball as a trophy.
An 1896 article recalls: "At the
close of every game won, the
ball was gilded. The names of
both nines, the score, and date
[were] painted on each ball."
The balls were then mounted in
this trophy case and displayed
by the club. "It is customary for
a stranger to the club to have
them shown and their value
explained." The Eckfords placed
more than 160 trophy balls in this
case. When the professional era
dawned in 1869, the Eckfords,
named after shipbuilder Henry
Eckford, disbanded as a team, but
remained a social club until the
1960s.

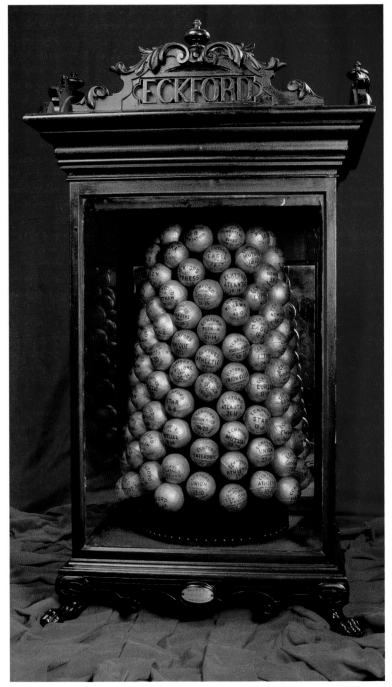

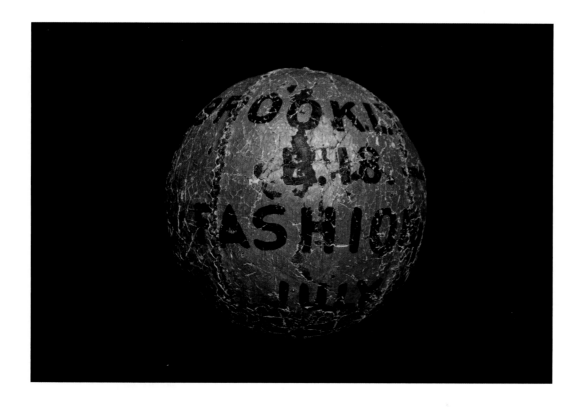

Fashion Race Course Trophy Ball

The place to be on July 20, 1858, was the Fashion Race Course on Long Island, where the first ever "All-Star Game" was being held. Featuring representatives from all the leading Brooklyn clubs playing against their counterparts from New York—then separate cities—the much-anticipated match drew an estimated 8,000 spectators, including 400 to 500 ladies. People came by carriage, omnibus, rail, and ferry, with extra departures required to handle the crowd. The game marked a milestone in baseball history, the first time that fans were charged for the privilege of attending a baseball game. Tickets were ten cents each. As was the custom of the day, the winning team "gilded" the ball and painted the date and the score. This game, the first of three such matches, was won by New York, 22–18. Brooklyn took the second game in August, and New York won the final game.

THE FIRST BASE.
6

"WAKE UP, WAKE UP, MY DUCK LEGGED MAN,
AND STIR YOUR SOLID PEGS."

Base Ball as Viewed by a Muffin

Have you ever heard an announcer state that a player "muffed" the ball after missing an easy defensive opportunity, and wondered about the origin of the term? In the early days of baseball, a third-string player, what we call a benchwarmer today, was designated as a "muffin." Muffins were an active part of the game, and they were known for making plenty of errors. Special "muffin matches" would be set up, thereby allowing everyone in the club to participate. The phrase was so common that it was used in the title of the 1867 *Base Ball as Viewed by a Muffin*. This is one of the earliest illustrated books about baseball, and only a handful of copies are known to exist. While the word "muffin" has disappeared from the lexicon of baseball, we pay tribute to these pioneer players every time we use the term "muff" to describe a dropped ball or missed easy throw.

PLAN OF THE EAGLE BALL CLUB BASES.

1. Umpire Desk.
2. Catcher.
3. Home and Striker's Stand.
4. Pitcher
5. First Base.
6. Second Base.
7. Third Base.

OUTSIDE RANGE

INSIDE RANGE.

SCALE—FORTY-TWO PACES.

BL-24756

1854 *Eagle Base Ball Club Rule Book*

Dating from a time when every team represented a private gentlemen's club, each with its own set of by-laws and rules, this small booklet is among the oldest published items in the museum's collection. The contents include the internal governing rules of the club, along with its rules for playing the game. As each club had slightly different rules, they would normally meet before playing a game to verify which set of regulations were in effect for that match. The evolution into a single set of rules accepted by multiple teams was an important part of baseball history that made league play and comparative statistics possible. Regardless of the rules used, each team would operate out of its own clubhouse, a traditional term still used today. While football and basketball teams have locker rooms, baseball teams still have the clubhouse.

1859 Photograph of Knickerbockers and Excelsiors

"On motion of Mr. [Fraley] Niebuhr, the Secretary was empowered to have the photograph of the 1st Nines of the 'Excelsiors' and 'Knickerbockers' framed at a cost of $10." So read the minutes of New York's Knickerbocker Club in August 1859. It was this entry that allowed researchers John Husman and Tom Shieber to confirm the original date of this historic image as August 2, 1859, making it the oldest known on-field baseball photograph. It was taken at the home grounds of the Excelsiors near Court Street in Brooklyn. The visiting Knickerbockers suffered a 20–5 loss in the game. The image was first published in Albert Spalding's *America's National Game* in 1911, but was misidentified and dated as an 1858 image. Future Hall of Fame inductee Harry Wright, sixth player from the left side, served as catcher for the losing Knickerbockers.

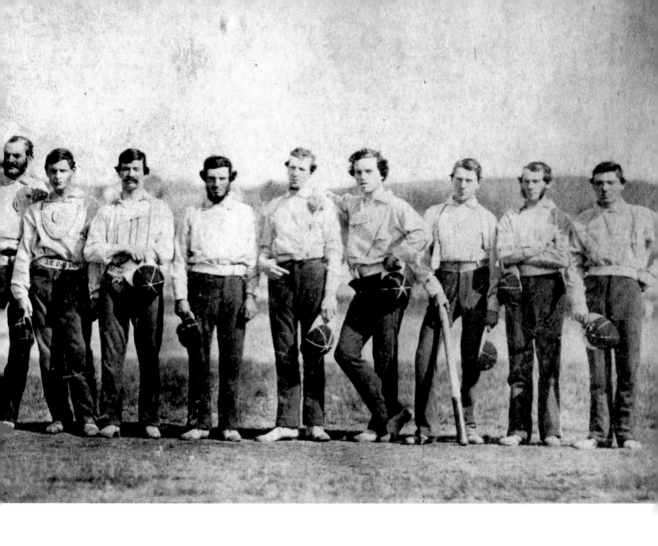

ACKNOWLEDGMENTS

The National Baseball Hall of Fame and Museum wishes to thank the following key contributors to this book:

Freddy Berowski
Bill Francis
James L. Gates Jr.

Milo V. Stewart Jr., photographer
Tim Wiles

We would also like to acknowledge the following individuals for their contributions:

Fran Althiser
Jenny Ambrose
Mary Bellew
Daniel Bennett
Karen Berry
Sara DeGaetano
Liam Delaney
Clay Ezell
Mike Fink
Sean Gahagan
William Haase
Diane Hock

Bradford Horn
John Horne
Jeffrey Idelson
Jennifer Joel
Patricia Kelly
Susan MacKay
Scot Mondore
Craig Muder
Mary Quinn
Brooks C. Robinson
Helen Stiles
Erik Strohl

INDEX

Gibson, Josh, 108
Glavine, Tom, 19
Goldberg, Herman, 80
Gomez, Lefty, 136
Gossage, Rich "Goose," 88
Gowdy, Curt, 154
Graham, Archibald "Moonlight," 47
Graham, Frank, 111
Graves, Abner, 4
Gray, Pete, 100
Greenberg, Hank, 134–35, 178
Griffey, Ken, Jr., 54, 169
Griffey, Ken, Sr., 169
Grimm, Charlie, 177
Grissom, Marquis, 173
Groh, Heinie, 133
Gross, Wayne, 149
Grove, Lefty, 176
Gunson, Joe, 129
Gwynn, Chris, 173
Gwynn, Tony, 180
Gwynn, Vendella, 180

H

Haddix, Harvey, 11
Hamilton, Milo, 110
Hammaker, Atlee, 39
Haney, Chris, 181
Harding, Warren G., 106
Harwell, Ernie, 76
Haydn Quartet, 29
Helton, Todd, 186
Henderson, Rickey, 149
Hernandez, Keith, 155
Heydler, John, 152

Hindermeyer, Harvey, 29
Hitler, Adolf, 80, 81, 135
Hoak, Don, 11
Hodges, Gil, 126
Hodges, Russ, 75, 76
Hofheinz, Roy, 32
Hoover, Herbert, 106
Hornsby, Rogers, 70, 72, 177
Houghton, Edith, 140
Houston Astrodome, 32
Hubbell, Carl, 71, 134
Huggins, Miller, 86, 105
Husman, John, 198

J

Jackman, Alan, 170
Jackman, David, 170
Jackowski, Bill, 122
Jackson, Reggie, 168
Jackson, Sam, 184
Jackson, "Shoeless" Joe, 35
James, Bill, 159
Janssen, Fran, 25
Jarvis, Pat, 167
Jeter, Derek, 84
John J. McGraw, SS, 113
Johnson, Ban, 144
Johnson, George, 191
Johnson, Judy, 191
Johnson, Kelly, 187
Johnson, Randy, 19, 102
Johnson, Walter, 9, 36, 144
Jones, Chipper, 187
Jones, Cleon, 91
Jones, Sam, 22